From Blast to Pop

From Blast to Pop

From BLAST TO POP

Aspects of Modern British Art, 1915–1965

Catalogue by Richard A. Born

with an essay by Keith Hartley

The David and Alfred Smart Museum of Art
The University of Chicago

Catalogue of an exhibition at the
David and Alfred Smart Museum of Art,
The University of Chicago,
17 April–15 June 1997, and national tour.

The exhibition and related programming
have been supported in part by grants from
The John Nuveen Company and the Pritzker
Foundation. Additional support for the project
has been received through a grant from the
Illinois Arts Council, a state agency.

A portion of the Museum's general operating
funds for the 1996–97 fiscal year has been
provided through a grant from the Institute of
Museum Services, a Federal agency that offers
general operating support to the nation's
museums.

Library of Congress Catalogue Card Number:
97-65940
ISBN: 0-935573-18-6

Photography credits: Photography by Tom
Van Eynde (unless otherwise noted); Jerry
Kobylecky Museum Photography, Chicago:
pls. 11, 12, 13, 24, 37, 55, 58, 64, 71, 88, figs. 1, 3,
5, 6, 10–13, 25–29, 31–35, 37, 39–41, 43, 64

Editor: Kimerly Rorschach
Design: Joan Sommers Design, Chicago
Printing: CS Graphics, Singapore

CONTENTS

PREFACE AND ACKNOWLEDGMENTS

The Smart Museum of Art is very pleased to present this exhibition devoted to British modernism. While most American audiences are familiar with the names of Virginia Woolf, T.S. Eliot, Winston Churchill, and the Beatles—to name just a few of the towering figures in the history of twentieth-century British culture—the work of contemporary artists such as Helen Saunders, William Turnbull, Eduardo Paolozzi, and John Bratby is still virtually unknown in this country. Featuring paintings, drawings, prints, and sculpture by such artists, along with works by their more famous contemporaries Henry Moore, Barbara Hepworth, and Jacob Epstein, *From Blast to Pop: Aspects of Modern British Art, 1915–1965* is drawn almost entirely from the Smart Museum's own collection. The core of this collection was established at the Museum's founding in 1974, with the gift of the Joel Starrels, Jr. Memorial Collection, which includes a number of important pieces by Hepworth and Moore, and a rare collage-drawing by Saunders. This concentration was greatly enriched by gifts from the artist Sylvia Sleigh—herself represented in this exhibition—from the collection of her late husband Lawrence Alloway, the renowned art historian and critic, who was assistant director of London's Institute of Contemporary Arts during its seminal years 1955–59. Additional bequests and gifts from Don Ludgin, constituting the Mary and Earle Ludgin Collection, and Joan and Stanley M. Freehling further strengthened the Museum's representation of this fascinating period in British art.

The Museum is grateful to those who contributed to the success of this project, which has been so skillfully and sensitively given expression by our curator Richard A. Born. We would like to acknowledge Keith Hartley, Assistant Keeper of the Scottish National Gallery of Modern Art, for the essay he has written for the catalogue. We thank Rhoda Pritzker, Neva Krohn, and one anonymous lender, who generously agreed to part with their treasures to enrich the exhibition. We are also grateful to Caroline Cracraft of the British Consulate General, Chicago, Mary and Roy Cullen, Richard Francis, Richard Gray, Sandy Karuschak, Charles Newell, Alice Schreyer, Liz Siegel, and Sue Taylor, who offered support and counsel on a variety of issues associated with the show. Sylvia Sleigh provided indispensable advice and encouragement; the exhibition could not have been conceived without her. We are grateful to the Pritzker Foundation, which helped to fund the printing of this catalogue. Finally, we thank The John Nuveen Company, whose financial support made possible the exhibition, catalogue, and related interdisciplinary programming, and Nuveen Vice President Lorna C. Ferguson, whose enthusiasm for this project has energized us all.

Kimerly Rorschach
DIRECTOR

From Blast

Keith Hartley

The insularity of England[1] (both geographically and temperamentally) has tended to work against the development of a consciously international avant-garde during this century. The situation was made worse by two world wars which broke off contacts with the Continent and in the case of Vorticism nipped in the bud what promised to be England's greatest contribution to early modernism. Before the First World War London was just beginning to come to terms with and, to some extent, even to enjoy the buzz of artistic innovation and experimentation (no doubt heightened by a feverish sense of impending catastrophe), but the horror and magnitude of the slaughter in the trenches put an end to this spirit of adventure and ushered in a period of traditional values, at least in the visual arts. A brief comparison between two manifesto statements, the first published in 1914 in the Vorticists' review *Blast*, the second issued in 1920 by the newly formed Seven and Five Society, makes this change abundantly clear. Wyndham Lewis, the self-styled leader of the Vorticists, trumpets his

disdain for tradition and his Nietzschean mission to create a new individualistic art, in the opening salvo of *Blast*:

Long live the great art vortex sprung up in the centre of this town!

We stand for the Reality of the Present —not for the sentimental Future, or the sacripant Past.

We want to leave Nature and Men alone.

We do not want to make people wear Futurist patches, or fuss men to take to pink and sky blue trousers.

We are not their wives or tailors.

The only way Humanity can help artists is to remain independent and work unconsciously.

WE NEED THE UNCONSCIOUSNESS OF HUMANITY—their stupidity, animalism and dreams.

We believe in no perfectability except our own.

Intrinsic beauty is in the Interpreter and Seer, not in the object or content.

We do not want to change the appearance of the world, because we are not Naturalists, Impressionists or Futurists (the latest form of Impressionism), and do not depend on the appearance of the world for our art.

WE ONLY WANT THE WORLD TO LIVE, and to feel its crude energy flowing through us.[2]

How different Lewis's pugnacious rhetoric is from the timid, openly unambitious "common sense" of the Seven and Five manifesto:

The "SEVEN AND FIVE" desire to explain that they are not a group formed to advertise a new "ism". They feel that the gladiators of the present warring sects are often concerned more with the incidental politics and temporary eddies of art than with its essential realities.

A periodic explosion is essential in Art as in all other forms of organized activity, to blow away the crust of dead matter that time inevitably accumulates.

The "SEVEN AND FIVE" are grateful to the pioneers, but feel that there has been of late too much pioneering along too many lines in altogether too much of a hurry, and themselves desire the pursuit of their own calling rather than the confusion of conflict.

The object of the "SEVEN AND FIVE" is merely to express what they feel in terms that shall be intelligible, and not to demonstrate a theory nor to attack a tradition.

Individual members have their own theories of Art, but as a group the "SEVEN AND FIVE" has none.

Each member is free to develop his own individuality: all that the group asks is that he shall do that, and not try to exploit someone else's.

Their desire is to group together men who do not attempt to achieve publicity by mere eccentricity of form or colour, but believe that to be sincere is not necessarily to be dull.[3]

Unfortunately, much of English art in the early twenties was precisely that: dull, unadventurous, and satisfied merely to consolidate the modest Post-Impressionism that Roger Fry and the Bloomsbury Group had promulgated before the war. The bold abstractions and barbed rhythms of Vorticism held no attractions for a younger generation, and even the Vorticist artists themselves (with a few notable exceptions) blunted their sharp edges and produced more recognizable, figurative works. The considerable prewar achievements of the Vorticists and of those artists closely associated with them, such as Jacob Epstein and David Bomberg, were largely ignored and even forgotten until the 1950s, with the result that the earlier forward artistic momentum was lost.

We stand for the **Reality** of the **Present**—not for the sentimental Future, or the sacripant Past. **WE ONLY WANT THE WORLD TO LIVE,** and to feel its crude energy flowing through us.

It was not until the late 1920s and the 1930s in particular that a new period of creative invention and group dynamic was achieved, when Ben Nicholson succeeded in changing the Seven and Five Society from an exhibiting body of lukewarm modernists to a proselytizing body of progressive and largely abstract artists (including his wife Winifred Nicholson, his future wife Barbara Hepworth, and Henry Moore). After this the pace of change and interaction quickened noticeably as new groupings and exhibiting bodies were created under the impact of recent developments in France and Germany in particular. Again it is instructive to look at the manifesto-statements of the two most important of these new groupings, *Unit One* founded in 1933, and *Circle*, that took the form of a publication in 1937.

In a letter to *The Times* on 12 June 1933, Paul Nash, a progressive landscape artist, whose work had recently undergone a dramatic change under the joint impact of

Individual members have their own theories of Art, but as a group the "SEVEN AND FIVE" has none.

Constructivism and Surrealism, and who was the main mouthpiece of *Unit One*, informed the public of the group's founding and explained what it stood for:

During the last five years a very definite change has taken place. The ingenious and agreeable exercises in formalised naturalism, "Post-Cézannism" and "Derainism" have ceased to be of the first interest; they no longer hold our attention. A desire to find again some adventure in art seems more and more cogent to our sculptors and painters and, now, to our architects. This seems to suggest, as well as any explanation, the meaning of "the contemporary spirit". It is the adventure, the research, the pursuit in modern life.... But the pursuit is not vaguely directed. It seems today to have two definite objects for the mind and hand of the artist. First, the pursuit of form; the expression of the structural purpose in search of beauty in formal interaction and relations apart from representation. This is typified by abstract art. Second the pursuit of the soul, the attempt to trace the "psyche" in its devious flight, a psychological research on the part of the artist parallel to the experiments of the great analysists. This is represented by the movement known as Surréalisme.

The first part of this passage is an implicit rebuke of all that Bloomsbury stood for; the second shows very clearly in what direction *Unit One* artists such as Hepworth, Moore, Nicholson, Edward Wadsworth, and Nash himself were looking for inspiration. In England, at least at this stage in the early 1930s, Constructivist abstraction and Surrealism could happily exist side by side, indeed could find a happy synthesis in the work of individual artists. Moore's abstracted figures owe their compositional strength and multivalent imagery to these two traditions. The main point to be made is that innovation and a new sense of creative energy were springing up in England because artists (and some critics) were prepared to be open to outside influences, were not content with insular traditions alone.

Circle was very different from *Unit One*. To begin with it was a publication rather than an artists' group or exhibiting society. Secondly it was almost exclusively Constructivist in its orientation. And thirdly it included foreign artists and architects (Naum Gabo, Walter Gropius, László Moholy-Nagy, Piet Mondrian) as well as English ones (Hepworth, Moore, Nicholson). The main aim of the publication was to establish an international context for English abstract art and modernist architecture, along the lines of the Paris-based *Abstraction-Création*:

We have ... tried to give this publication a certain direction by emphasising, not so much the personalities of the artists as their work, and especially those works which appear to have one common idea and one common spirit: the constructive trend in the art of our day.[4]

Several of the foreign artists and architects, including Gabo, Gropius, Moholy-Nagy, and Mondrian,[5] had fled (or were to flee) to London when it became difficult for them to work in Germany or France after the Nazis came to power. At long last it seemed that London might develop into a center for international modern art. Not only had it attracted leading Constructivists, but it also staged major exhibitions of Surrealism[6] (in 1936) and German art[7] (in 1938, a riposte to Hitler's notorious *Degenerate Art* exhibition of 1937). But the hope was to be short-lived. By the time the war broke out in 1939 (or shortly thereafter) most of the major foreign artists and architects had left for other countries, mainly the United States. With the war, many English artists turned inwards upon themselves. A neo-Romantic strain, never far from the surface in much English art, became dominant, as artists looked back to William Blake and Samuel Palmer and escaped the city to hidden, unspoiled parts of the countryside (such as Pembrokeshire in the far south-western tip of Wales),[8] in

search of inspiration. The resultant art, particularly that of Graham Sutherland, could be powerful, a strange hybrid of pastoral and gothic horror, but it was narrow and self-consciously parochial; certainly it did not seem likely to launch England into the world of international modernism after the war.

It may therefore seem surprising that British[9] art was so well received after the war and held in such high international esteem. There are several reasons for this, but two are worth highlighting. First, the Arts Council and British Council (both newly founded)[10] did an enormous amount to promote certain artists, Moore in particular, at home and abroad.[11] It was largely through British Council-sponsored exhibitions, most notably those held in the British Pavilion at the Venice Biennale, that foreign attention and foreign collectors were drawn to British artists.[12] The second reason for this success was that, unlike after the First World War, those

In England, . . . in the early 1930s, Constructivist abstraction and SURREALISM could happily exist side by side, indeed could find a happy synthesis in the work of individual artists.

artists who had led the prewar avant-garde did not retreat into obscurity or regress into producing a toned-down version of their former work. Although artists such as Hepworth, Moore, and Nicholson were perhaps no longer as innovative as they had been, they were still strong role-models and "teachers" (in the broadest sense) for the next generation of artists. Thus, the St. Ives school of abstract artists could continue to grow around the central figures of Hepworth and Nicholson, and the so-called "geometry of fear" sculptors (Kenneth Armitage, Reg Butler, Lynn Chadwick, Geoffrey Clarke, and Bernard Meadows)[13] could flourish in the shadow of Moore. Herbert Read made pointed reference to this in his catalogue essay on these sculptors when they showed at the 1952 Venice Biennale:

The nine sculptors whose work is shown in the British Pavilion this year are not members of an organised group. They are individuals participating in a general revival of the art of sculpture, and they are related to each other only by some obscure instinct which has touched them all to life. Henry Moore is in some sense no doubt the parent of them all, and a single work of his, more recent than anything yet shown by him at Venice, stands at the entrance of the Pavilion to give an orientation for the surprising developments that will be found within.[14]

Mention was made earlier of the *International Surrealist Exhibition* held in London in 1936. This not only presented some of the finest works by European Dadaists and Surrealists (including Pablo Picasso) but also introduced work by the fledgling English Surrealist movement.[15] This group (if one excludes Moore and Roland Penrose) was to produce nothing of the stature or significance of the best of their continental colleagues. Nevertheless Surrealism was to leave an indelible mark on British art—*after* the war. This came, first of all, in the shape of Francis Bacon's work, which is unthinkable without the example of Picasso's grimacing figures in interiors,[16] or Jacques-André Boiffard's close-up photographs of mouths and other parts of the body,[17] or more generally, of Surrealism's metamorphic treatment of the body.[18] Yet, although highly gregarious socially, Bacon was no *chef d'école*. He may have inspired many artists, some of whom have since been associated with what R.B. Kitaj has termed the "School of London",[19] but he was not part of any movement or group activity in the postwar years. One *could* argue that in the long run he has helped to

bring about a sea-change in our perception of modernism, by implicitly challenging formalist assumptions about the inevitability of what Michael Fried called "the gradual withdrawal of painting from the task of representing reality . . . in favor of an increasing preoccupation with problems intrinsic to painting itself."[20] Bacon's preoccupation with imagery, his use of photographs, above all his attempt to capture the reality of material fact (be it the body or one of the objects that impinge on our daily lives), all run counter to the formalist paradigm set up by such critics as Roger Fry and Clive Bell before the First World War and extended and developed by Clement Greenberg and Fried after the Second World War.

Of course not all of Bacon's innovations can be traced back to Surrealism, but the general tenor of his work, the sense of shock and dislocation, can be related to that movement's attempt to unsettle emotions and dislodge thought-patterns through strange juxtapositions and hybrid creations. In his pioneering essay on British Pop art, Lawrence Alloway acknowledged that Bacon's use of photographic imagery was one of the contributory influences on the development of a Pop aesthetic.[21] He might equally have said that Surrealism was even more crucial an influence for those artists and writers who formed the Independent Group at the Institute of Contemporary Arts in the early 1950s[22] and who represented what Alloway called the first phase of Pop art in Britain.[23] Indeed, Eduardo Paolozzi, who perhaps more than any other Independent Group artist was responsible for kindling an interest in contemporary, popular iconography (advertisements, comics, science fiction magazines, films),[24] called himself a Surrealist and openly acknowledged that his collages had a Surrealistic origin.[25] He had spent the years 1947–49 in Paris where he had got to know, among others, Alberto Giacometti and Tristan Tzara (and his library), and seen Mary Reynolds's collection of material by Marcel Duchamp (including the walls that he had covered with images from magazines).[26] William Turnbull, like Paolozzi originally from Scotland, also spent the years 1947–50 in Paris and likewise got to know Giacometti. He too was an inveterate collector of images from popular magazines. Both Paolozzi and Turnbull had trained at the Slade School of Art in London

[T]he interest of the **Independent Group** artists in Surrealism was eclipsed by their enthusiasm for American **POPULAR CULTURE.** For them American films, advertising, science fiction, **COMICS,** and the **mass media** in general represented **modern** popular culture at its most **LIVELY** and sophisticated.

where they had met a third member of the future Independent Group, Nigel Henderson. Henderson came from a very different background than Paolozzi and Turnbull. His mother, Wyn Henderson, had managed Peggy Guggenheim's gallery in London from its opening in 1938 to the outbreak of the war. He had therefore come into contact with the international avant-garde (especially the Surrealists) before going to art school, and on one occasion even helped Duchamp install his exhibition at the gallery.[27] Henderson became an important source of knowledge for younger members of the Independent Group—particularly those artists (Richard Hamilton, Paolozzi, and Turnbull) who attended the Slade School with him—pointing them in certain directions and providing them with introductions to artists in Paris. It was Henderson who

. . . [I]t is clear that VORTICISM was conceived as a very specifically English movement, a type of ART befitting the country that spawned the Industrial Revolution.

showed Hamilton Duchamp's *Green Box* and thereby helped kindle Hamilton's life-long interest in Duchamp.[28] Another member of the Independent Group, the writer and critic Toni del Renzio, had an even closer link with Surrealism. During the Second World War he had been a member of the British Surrealist group, a close associate of E.L.T. Mesens (the Belgian Surrealist who ran the London Gallery) and founding editor of the Surrealist magazine *Arson*.[29] It was del Renzio who provided much of the intellectual backbone and knowledge of the mass media of the Independent Group's discussions, having studied philosophy and been fashion art editor for women's magazines before joining the staff of the Institute of Contemporary Arts. In the second session of Independent Group discussions he gave talks on fashion, advertising, and, significantly, on the "Dadaists as non-Aristotelians".[30]

A mention should also be made, in this context, of Roland Penrose. Although not a member of the Independent Group, he was one of the founders of the Institute of Contemporary Arts, its deputy chairman for its crucial early years, providing much of the impetus for its first few exhibitions and some of the funds to keep it afloat. Penrose was a key figure in the British Surrealist group. He had been largely responsible for the *International Surrealist Exhibition*, held in London in 1936, and knew all the major Surrealists personally. Perhaps just as important for the Independent Group artists, indeed for many artists working in London in the postwar years, was the fact that Penrose owned a fabulous collection of Surrealist art and a library well-stocked with rare books and catalogues published by the Surrealists. The sort of things that would have interested the Independent Group artists especially were early collages and the collage-novels of Max Ernst and an air-brushed painting by Man Ray, *La Volière* (Scottish National Gallery of Modern Art, Edinburgh, 1919) which uses the techniques of advertising artwork to achieve a sleek and sophisticated depiction of everyday objects.[31]

But the interest of the Independent Group artists in Surrealism was eclipsed by their enthusiasm for American popular culture. For them American films, advertising, science fiction, comics, and the mass media in general represented modern popular culture at its most lively and sophisticated. Here they tended to part company with Penrose and, more especially, Herbert Read, both of whom were attached to and identified with high European culture. Admittedly the Surrealists, including Penrose, were fascinated by aspects of popular culture, but really only insofar as it represented the upsurgence of irrationality and a transgression of normative behavior. They were drawn to the low-tech, often more traditional ends of popular culture and not to the high-tech sophistication of Madison Avenue. In any case they did not make popular culture a central part of their aesthetic as did the Independent Group and later the Pop artists.

In recent years there has been considerable interest (not least in the United States) in the range of aesthetic views expounded by the Independent Group artists and writers (and to some extent taken up by the later Pop artists), because they seem to make such a radical break with the largely formalist aesthetic of High Modernism, looking forward to many of the pluralist ideas of today. In terms of British art and its

... the Vorticist aesthetic links the ENGLISHNESS of their art with mechanical forms—both in form and content. This is its most surprising and REFRESHING aspect because traditionally English art had been perceived as BUCOLIC and lacking in metropolitan toughness.

attendant aesthetic theories, it is worth comparing the ideas of the Independent Group with what went before to see just how innovative they were, but also to see what surprising affinities there are with Vorticism. Indeed, in the catalogue of the important exhibition *This is Tomorrow* (1956) that included most of the Independent Group artists, there is a list of "hates" ("taste, duty, toeing the line") and "loves" ("abuse, confusion, disregard for ordinary decencies") that recalls the "blasted" and "blessed" lists of the Vorticist publication *Blast* (1914).[32] The catalogue was a conscious salute to Wyndham Lewis, who concurrently was being given his first retrospective at the Tate Gallery.[33] Vorticism had been largely ignored since the First World War, but now its aggressive urbanism and its recognition of the realities of modern life seemed highly relevant once again.

Published in the summer of 1914, the first issue of *Blast* acted as a sort of manifesto for the Vorticist group, which included Henri Gaudier-Brzeska, Lewis, Ezra Pound, William Roberts, Helen Saunders, and Edward Wadsworth.[34] Indeed, at least one of the pieces in the publication is actually called a manifesto, and is signed by all the artists and writers involved, although it clearly owes most of its formulation to Lewis. From this manifesto it is clear that Vorticism was conceived as a very specifically English movement, a type of art befitting the country that spawned the Industrial Revolution. In the sixth paragraph of *MANIFESTO* (No. 2) the Vorticists boast:

1. The Modern World is due almost entirely to Anglo-Saxon genius,—its appearance and its spirit.
2. Machinery, trains, steam-ships, all that distinguishes externally our time, came far more from here than anywhere else.
3. In dress, manners, mechanical inventions, LIFE, that is, ENGLAND, has influenced Europe in the same way that France has in Art.
4. But busy with this LIFE-EFFORT, she has been the last to become conscious of the Art that is an organism of this new Order and Will of Man.

Having acknowledged that France had up to now set the pace in developing new art forms embodying the spirit of the industrial age that England was largely responsible for creating, the Vorticists go on to say that they as Englishmen were now in the best position to give fullest expression to this impulse:

1. Once this consciousness towards the new possibilities of expression in present life has come, however, it will be more the legitimate property of Englishmen than of any other people in Europe.
2. It should also, as it is by origin theirs, inspire them more forcibly and directly.
3. They are the inventors of this bareness and hardness, and should be the great enemies of Romance.
4. The Romance people will always be, at bottom, its defenders.
5. The Latins are at present, for instance, in their "discovery" of sport, their Futuristic gush over machines, aeroplanes, etc., the most romantic and sentimental "moderns" to be found.

Lewis and the Vorticists were at pains to distinguish themselves from the Futurists, who had recently attempted to railroad them into that movement.[35] But the differences were real and not merely reactive or tactical, for they were as much opposed to the Post-Impressionism of Fry's Bloomsbury Group: "To be done with terms and tags, Post-Impressionism is an insipid and pointless name invented by a journalist," as Lewis put it in a catalogue introduction to *The Camden Town Group and Others* show at the Brighton Public Art Galleries (1913).[36] They were more sympathetic toward Cubism and its structural integrity (described by Lewis in the same catalogue as "chiefly, the art, superbly severe and so far morose, of those who have taken the genius of Cézanne as a starting point and organised the character of the works he threw up in his indiscriminate and grand labour") but ultimately wanted an art that reflected the modern machine age both in its forms and in its subject matter. Again Lewis put it graphically in his 1913 catalogue contribution: "All revolutionary painting today has in common the rigid reflections of steel and stone in the spirit of the artist, that desire for stability as though a machine were being built to fly or kill with...."

Several points should be made about this "nationalist" aesthetic of the Vorticists. It is not narrowly chauvinistic or insular. It does acknowledge recent artistic developments on the Continent: "We have made it quite clear that there is nothing Chauvinistic or picturesquely patriotic about our contentions."[37] It sees itself as specifically North European as opposed to "Romance": "We assert that the art for these climates, then, must be a northern flower."[38] Here the Vorticists are echoing the ideas of the German art historian Wilhelm Worringer, whose book *Abstraction and Empathy* (1908)[39] argued for the basic distinction between abstract "geometrical" and organic "vital" art and the different psychologies that gave rise to them. Worringer asserted (in a wild generalization that was to bedevil German art history in particular for many years to come) that the artists of Northern Europe tended to favor "geometrical" art whereas those of the Mediterranean countries favored "vital" art.[40] These ideas had been avidly taken up in 1911 by the philosopher T.E. Hulme, who was one of the chief supporters of Bomberg and Epstein and thus one of the main conduits of aesthetic theory to the future Vorticists.[41] The idea of a specifically Northern, geometrical art was a welcome theoretical support to the Vorticists in their desire to differentiate themselves from the Futurists and Cubists.

Most importantly, the Vorticists' aesthetic links the Englishness of their art with mechanical forms—both in form and content. This is its most surprising and refreshing aspect because traditionally English art had been perceived as bucolic and lacking in metropolitan toughness. It is one of the aspects that looks forward to the ideas of the Independent Group and Pop artists, but it is also in complete opposition to the formalist aesthetic that Fry and Bell had only recently developed. In "An Essay in Aesthetics" (1909) Fry emphasized the differences and separateness of art and life: "Art, then, is an expression and a stimulus of this imaginative life, which is separated from actual life by the absence of responsive action."[42] Bell, in his highly influential book *Art* (1914), is even more emphatic and outspoken in stressing the break between art and life:

...if a representative form has value, it is as form, not as representation. The representative element in a work of art may or may not be harmful, always it is irrelevant. For, to appreciate a work of art we need bring with us nothing from life, no knowledge of its ideas and affairs, no familiarity with its emotions. Art transports us from the world of man's activity to a world of aesthetic exaltation. For a moment we are shut off from human interest; our anticipations and memories are arrested; we are lifted above the stream of life.[43]

Such extreme formalism—summed up succinctly in Bell's memorable, if curiously empty phrase "significant form"[44]—allowed the possibility of abstraction, and was to prove influential on that generation of abstract or semi-abstract artists who came to

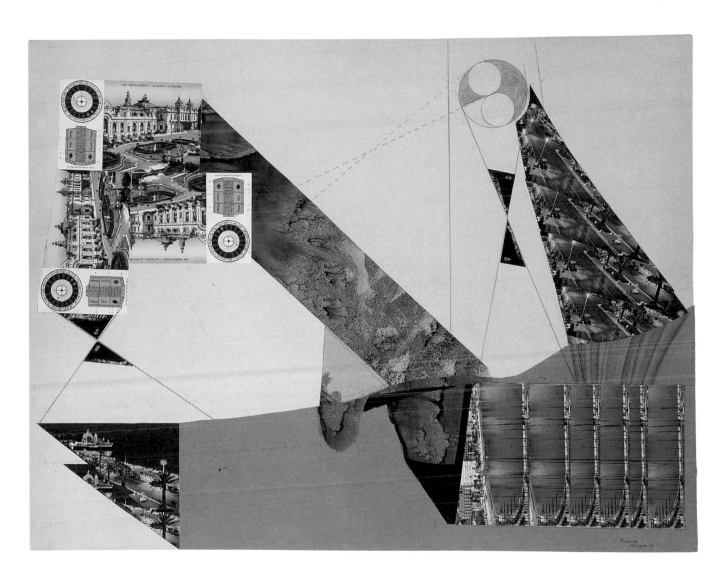

Plate 1
Roland Penrose
*Collage,*1937
(cat. no. 13)

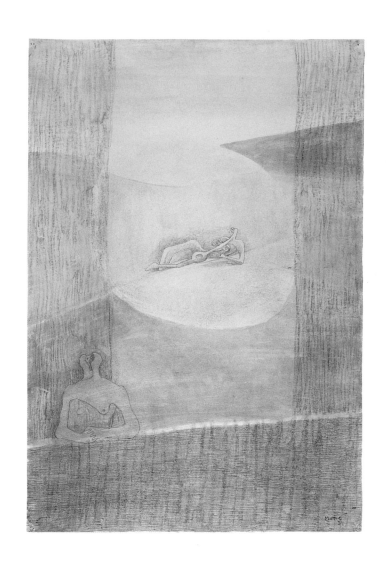

Plate 2
Henry Moore
Two Figures, 1939
(cat. no. 11)

Plate 3
Henry Moore
*Ideas For Sculpture:
Internal/External Forms,*
1950
(cat. no. 37)

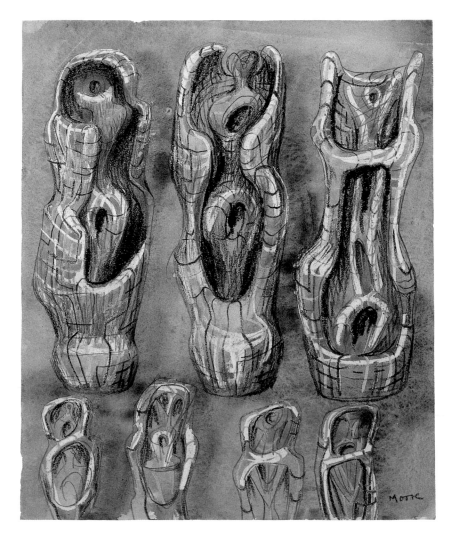

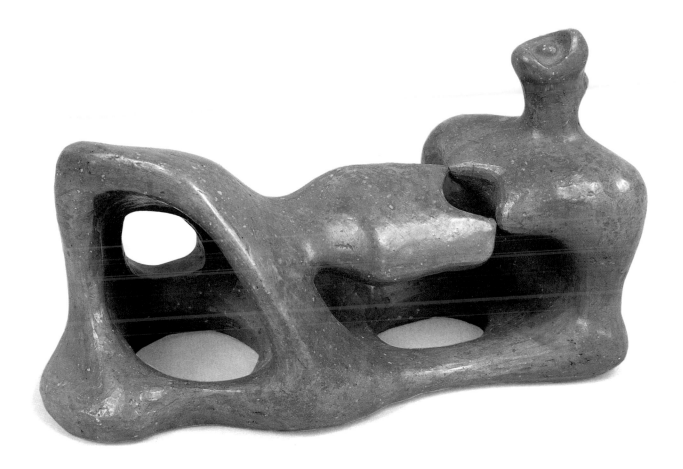

Plate 4
Henry Moore
*Sketch Model for
Reclining Figure,* 1945
(cat. no. 12)

Plate 5
Barbara Hepworth
Landscape Figure, 1959
(cat. no. 51)

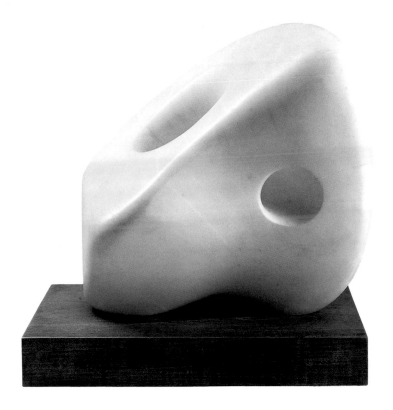

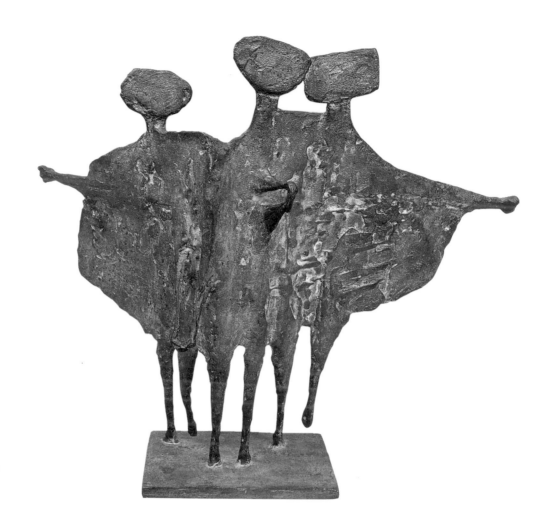

Plate 6
Kenneth Armitage
Children by the Sea, 1953
(cat. no. 55)

Plate 7
Eduardo Paolozzi
Man in a Motor Car, 1956
(cat. no. 83)

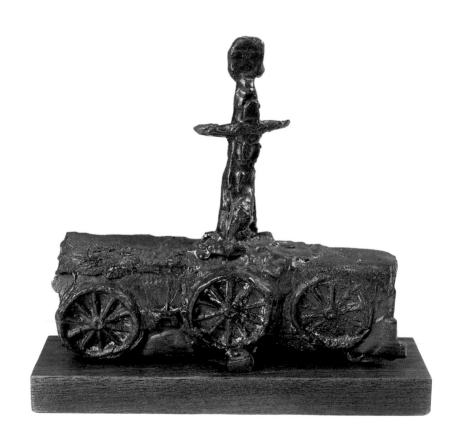

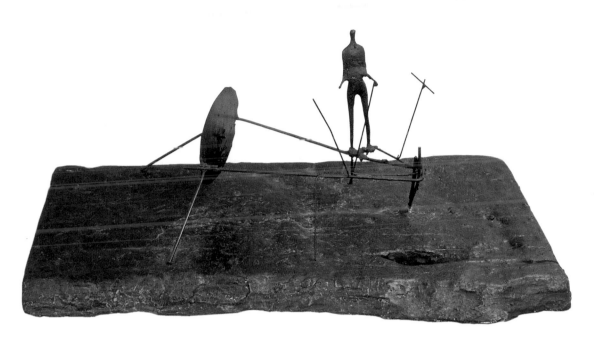

Plate 8
Reg Butler
The Machine, 1953
(cat. no. 58)

Plate 9
William Turnbull
Game, 1949
(cat. no. 64)

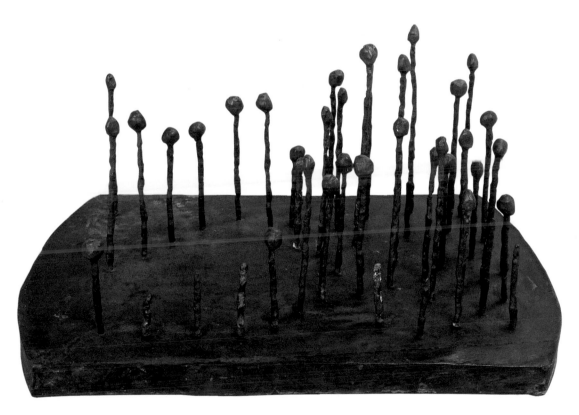

Plate 10
William Turnbull
Untitled, 1954
(cat. no. 72)

Plate 11
John Bratby
Kitchen Table, 1954
(cat. no. 24)

Plate 12
Peter Blake
Wall, 1959
(cat. no. 88)

Plate 13
Robyn Denny
Untitled, 1959
(cat. no. 99)

creative maturity in the late 1920s and 1930s—notably Hepworth, Moore, and Nicholson. Moore has gone on record in saying how much he owed to Fry's *Vision and Design*—"Once you'd read Roger Fry the whole thing was there"[45]—especially to his championing of tribal African sculpture and the formal qualities that could be found in these works. Moore also stated: "Fry in his essay on Negro sculpture stressed the 'three-dimensional realisation' that characterised African art and its 'truth to material'. More, Fry opened the way to other books and to the realisation of the British Museum. That was really the beginning."[46] However, it is probably also true that Moore owed a great debt to Herbert Read, who wrote some of the earliest and certainly the most appreciative criticism of Moore's work.[47] Read was a crucial figure, between the wars and after, as a disseminator of ideas about modern art to artists and public alike.[48] What is interesting about him is how he opened up the debate about formal values in art, partly under the influence of the French philosopher Henri Bergson but more importantly after having been introduced to Worringer's ideas through Hulme's writings.[49]

Read came to reject the Bloomsbury Group view that there was a distinct aesthetic emotion, that the Classical art of the Mediterranean countries was superior to the Romantic art of the North, and that associative qualities were totally extraneous to the aesthetic value of a work of art. In *The Meaning of Art* Read wrote:

We may conclude, therefore, that besides purely formal values, such as we find in a pot, there may by psychological values—the values arising out of our common human sympathies and interests, and even those arising out of our subconscious life; and beyond these, philosophical values which arise out of the range and depth of the artist's genius.[50]

Through his contacts in Germany,[51] Read came to appreciate German Expressionism's vital contribution (alongside that of Cubism) to the development of modern art, and at home he praised the unique synthesis between the geometrical and the organic, between Constructivism and Surrealism, that he saw embodied in the work of Moore.[52]

Moore, echoing Read, likewise stressed the need for a synthesis rather than an either/or in considering art. In his contribution to the *Unit One* publication (1934), Moore wrote: "Abstract qualities of design are essential to the value of a work, but to me of equal importance is the psychological, human element. If both abstract and human elements are welded together in a work, it must have a fuller, deeper meaning."[53] He is even more explicit in an article that he wrote for *The Listener* in 1937: "The violent quarrel between the abstractionists and the surrealists seems to me quite unnecessary. All good art has contained both abstract and surrealist elements, just as it has contained both classical and romantic elements—order and surprise, intellect and imagination, conscious and unconscious."[54]

After the war Moore and Read were to represent the art establishment in Britain. Moore's timeless themes; his traditional materials and techniques; Read's interpretation of the history of art as a set of "ultimate values . . . [that] transcend the individual and his time and circumstance . . . [that] express an ideal proportion or harmony which the artist can grasp only in virtue of his intuitive powers"[55] all seemed out of date and romantic to the members of the Independent Group in view of the way that their perception of the world had been changed through the new mass media. Art for them was no longer a separate, higher culture cut off from everyday life. It had to reflect the contingencies of the modern world, the world of high technology, film, television, and advertising. Modernism, if it was to have any meaning, had to reflect life as it was lived, rather than being a formalist paradigm, where subject matter counted for very little. Even though Read had gone beyond the formalism of Bell and Fry by insisting on psychological and associative, i.e. humanist values, he still stood for an art that transcended its own period. The Independent Group questioned this

If any one THING could be said to be the unifying principle of the Independent Group, it was a REJECTION of the very institutionalisation of modernism it most admired in New York.

stance and in so doing looked back to one of the *loci classici* of modernism, to Charles Baudelaire's essay on "The Painter of Modern Life." Baudelaire had written in defense of Constantin Guys and of his depictions of Parisian life: "He is looking for that quality which you must allow me to call 'modernity';. . . He makes it his business to extract from fashion whatever element it may contain of poetry within history, to distil the eternal from the transitory."[56] The Independent Group also echoed the Vorticists' insistence on contemporaneity, on an art that is infused with the essence of life at a particular moment, at the still point between the past and future. In characteristically bombastic language, Wyndham Lewis had described what their art aspired to:

Our Vortex insists on water-tight compartments. There is no Present—there is Past and Future, and there is Art. Any moment not weakly relaxed and slipped back, or, on the other hand, dreaming optimistically, is Art.

"Just Life" or *soi-disant* "Reality" is a fourth quantity, made up of the Past, the Future and Art. This impure Present our Vortex despises, and ignores.[57]

The Independent Group went even further in their insistence on an art of the present day. For them art had to be so reflective of contemporary life that it could be expendable, that it might be forgotten one day. Toni del Renzio explained the essence of what they were trying to achieve in their discussions:

If any one thing could be said to be the unifying principle of the Independent Group, it was a rejection of the very institutionalisation of modernism it most admired in New York.... Herbert Read, for example, was seen as compromising and compromised.... Our objections were primarily concerned with a certain academicising "purism" which somehow separated art from life and spoke about "harmony"....[58]

The Independent Group rejected the formalist interpretation of modernism and recognized a fellow spirit in the American critic Harold Rosenberg, who propounded a more existential interpretation of painting. Del Renzio quoted a passage from Rosenberg's classic essay "The American Action Painters" as representing something similar to their own views:

The painting in itself is a "moment" in the adulterated mixture of his [the artist's] life—whether "moment" means the actual minutes taken up with spotting the canvas or the entire duration of a lucid drama conducted in sign language. The act-painting is of the same metaphysical substance as the artist's existence. The new painting has broken down every distinction between art and life.[59]

The Independent Group and Pop artists who followed them wholeheartedly embraced this breakdown of barriers between art and life, and thus rejected a hierarchy of values between High and Low art. As Lawrence Alloway put it: "The idea was of a fine art–Pop Art continuum, in which the enduring and the expendable, the timeless and the timely, co-existed. . . ."[60] Like the Vorticists before them, the artists of the Independent Group and Pop movement created something of lasting and international significance by being wholly of the present day and by welcoming stimuli from abroad.

CATALOGUE OF THE EXHIBITION

In the catalogue, dimensions are in inches followed by centimeters in parentheses; unless otherwise noted, height precedes width precedes depth. For works on paper, the dimension is for the sheet, unless otherwise noted.

1915

EARLY MODERNISM: ABSTRACTION, PRIMITIVISM, AND SURREALISM

The year 1915 is a watershed for early modernism in England. The quickening pace of new art movements stalled and group activity dissipated as the nation became locked in the protracted struggle of World War I. In the five years preceding the war, a small vanguard of the art world of London had abandoned the legacies of Victorian and Edwardian painting to embrace recent formal developments from the Continent. Stimulated by a series of landmark exhibitions mounted in London between 1910 and 1913, Vanessa Bell, Duncan Grant, and other painters associated with the Bloomsbury Group began painting in modified Fauvist and Cubist idioms, and in 1913 opened the Omega Workshops dedicated to the promotion of modern design. Another group, the Vorticists, centered around Wyndham Lewis at the Rebel Art Centre, developed a more extreme form of nonrepresentational abstraction; the dynamic rhythms of their geometric abstractions and unrestrained celebration of modern urban life embodied in their paintings, sculptures, and writings were profoundly indebted to Italian Futurism. In 1915, however, the Vorticist

group began to lose cohesiveness, and staged its last group exhibition in England in June; by the end of the war the movement had disbanded.

After the war, a younger generation of sculptors was inspired by other, mostly non-Western traditions: the diverse art of ancient and tribal cultures, from dynastic Egyptian and pre-Columbian stone carvings to the tribal sculpture of Africa and Oceania. Among these sculptors were Leon Underwood and several students from the Royal College of Arts in London, Barbara Hepworth and Henry Moore foremost among them. They were carvers of stone and wood, not modelers of clay and plaster, and during the 1920s asserted that their primitivist carvings of abstracted figures embodied, for them, the principles of "significant form" and "truth to materials", formal concepts they identified with the so-called primitive arts they admired.

Hepworth and Moore shifted to new sources of inspiration in the early 1930s. Recent Surrealist and abstract art in Paris by Hans Arp, Joan Miró, and Pablo Picasso was especially important to them in the first half of the decade. The activities of the small group of English Surrealists that developed in the early thirties culminated in the organization of a major international exhibition of Surrealist art presented in London in 1936. Roland Penrose, who had lived in Paris for a decade and was personally associated with many of the leading French Surrealists, was an important catalyst for Surrealism in London after 1935. The outbreak of World War II quickly brought this international modernist activity to an end, dispersed its artists, and enforced a cultural isolationism until the end of the war. For Moore and Hepworth, the war years were periods of transition to new styles built on their experiences of the previous decade.

1945

Helen Saunders
1885–1963
Island of Laputa, 1915
Pen and ink and paper
collage on wove paper,
10 x 8 1/2 (25.4 x 21.6)
The Joel Starrels, Jr.
Memorial Collection,
1974.275

After attending the Slade School of Fine Arts and the Central School in London, Helen Saunders rejected many of the principles fostered by the conservative academies of Edwardian England. In eschewing recognizable subject matter rendered in approved naturalistic styles, Saunders joined a small coterie of young English artists enthusiastic about the French avant-garde. The 1910 London exhibition organized by Roger Fry, *Manet and Post-Impressionism*, which featured the paintings of Edouard Manet, Vincent van Gogh, Paul Gauguin, Henri Matisse, and Pablo Picasso, inspired united attacks against the conservative London art world. Pilloried in the press, scorned by academicians, and ridiculed by the public, this and similar exhibitions in London in 1912 and 1913 spawned such artist associations as the Camden Town Group and the Bloomsbury Group, aligned with the Neo-Impressionism of Georges Seurat and the color harmonies and simplified forms of Matisse and the Fauves, respectively.

In 1914, Saunders enlisted in the most controversial and experimental new English art and literary union. Led by the writer and painter Wyndham Lewis, and naming their movement Vorticism, the half-dozen members established their own London salon and showroom, the Rebel Art Centre. Saunders signed the Vorticist manifesto and contributed poems and illustrations to the group's aggressively polemical journal, *Blast*. Influenced by French Cubism, Italian Futurism, and, to a lesser extent, German Expressionism, Vorticism

1

represented the most extreme English response to avant-garde developments in continental Europe, advocating a style that often appeared wholly nonrepresentational. Although the movement lasted barely two years, its members mounted a strident campaign of exhibitions, lectures, and publications designed to shock or "blast" London society out of the complacent legacy of the Victorian empire. The Vorticists sought to forge an up-to-date view of England as a major industrial nation governed by the unsentimental dynamics of the modern machine age.

Most Vorticist compositions are based on references to the physical world, but individual elements are so reduced to fundamental forms that the final image appears abstract. Mature Vorticist works, such as Saunders's drawing-collage *Island of Laputa*, are characterized by precise geometric shapes, unmodulated color, and bold diagonal structures. The lines, rectangles, arcs, and triangles that establish this image are splintered fragments isolated from each other by stark, unshaded white ground or by severe, thick outlines circumscribing the separate parts. Individual units are, nonetheless, locked together by a linear grid overlaying the surface, and pressed firmly against each other by dense, impacted juxtaposition. The combination of lancing oblique composition, asymmetrical balance, and immobile, interlocking forms contributes to a characteristic Vorticist tension between movement and stasis. Avoiding illustration, Saunders evokes the levers and forces of an engine by means of mechanistic shapes and dynamic compositional devices.

Customarily appended only after the fact, Vorticist titles are not descriptive of subject matter; *Island of Laputa*, nevertheless, brilliantly asserts Vorticist theory. Laputa is the kingdom in Jonathan Swift's satiric eighteenth-century novel, *Gulliver's Travels*, where geometry, mathematics, and music inflexibly govern life.[1] The diagrammatic logic of Saunders's drawing, akin to the irrevocability of the draftsman's blueprint, establishes a pictorial parallel to Swift's mythical island, brutally and methodically ruled by the absolute principles of science.

Island of Laputa was reproduced as a black xylograph in the second (and last) issue of *Blast* in 1915. Saunders is usually identified as a close follower of Lewis, her style heavily indebted to his dominating presence. She was, however, an original and outstanding colorist. The restricted, black-and-gray palette of this collage-drawing is uncharacteristic and suggests that the image may have been conceived from the start as a monochromatic study for a wood engraving in the war issue of *Blast*.[2] Alternatively, Saunders's rare departure from her inventive chroma may have been an experiment, recommended by her mentor, and inspired by contemporary German Expressionist woodcuts. In 1914, Lewis had praised such prints as "disciplined, blunt, thick and brutal, with a black simple skeleton of organic emotion," and described their bold interplay of lights and darks as "surgery of the senses."[3]

In 1915, shortly after the outbreak of World War I, *Island of Laputa* was included in the first—and, as it turned out, only—Vorticist group exhibition in London, and subsequently, in 1917, in a Vorticist exhibition at the Penguin Club in New York. The organizer of the American show, John Quinn, a pioneer patron of avant-garde art, purchased the work for his own collection. Presumed lost for many years,[4] the drawing is a rare surviving witness to the important English contribution to the theory and language of abstract art in Europe, Russia, and even America before the dispersal of its energy in the aftermath of the fateful war years.

Vanessa Bell
1879–1969
Christmas Decorations,
circa 1915
Pencil, gouache, and
oil on wove paper,
23 1/4 x 42 5/8
(59.1 x 108.3)
Lent by Rhoda Pritzker

after their father's death in 1904, Vanessa Bell and Virginia Woolf rebelled against their Victorian upbringing and moved to London, where they took up residence in the then unfashionable district of Bloomsbury. Bell's paintings and Woolf's writings form a remarkable record of upper-middle-class artistic and literary London. The nascent Bloomsbury coterie of artists, writers, and political reformers that was to become the Bloomsbury Group expanded when Vanessa married the art critic Clive Bell in 1907, and in 1910, when the critic and artist Roger Fry entered their artistic circle. The painter Duncan Grant had joined the inner circle in 1908. It was Fry who organized two landmark exhibitions of French Post-Impressionist painting at the Grafton Galleries in 1910 and 1912, which presented a skeptical London art world with vast surveys encompassing most of the significant artistic developments in Paris since the turn of the century, from Edouard Manet and Paul Cézanne to Henri Matisse and Pablo Picasso.

The impact of vanguard French painting on Bell's style was decisive for her development as an artist. Her investigations centered around the progressive styles of Fauvism and later Cubism; the work of Matisse was especially influential to the formation of her style before World War I. *Christmas Decorations* shows this indebtedness to early French modernism in the simplification, distortion, and two-dimensional flattening of figures and settings, an emphasis on surface design, and a preference for subjects drawn from daily life. The impact of Matisse's Fauvist style is felt most keenly in Bell's expressive use of simple lines to define contours and color to embellish internal forms without complicated modeling and shading, her judicious brushing of thinly applied, limpid color washes, the importance placed on chromatic harmonies in establishing the structure of the composition, and her inclination toward patterning, especially in the details. This impressively large mixed media drawing is unusual among the works executed by Bell around 1915, and it is possible that it may, in fact, be connected to some decorative project for the Omega Workshops.[1] Conceived by Fry as a design center informed by progressive European art, the Omega Workshops had opened in London in the spring of 1913, and, as co-directors, Bell and Grant were among the artists who produced designs for fabrics, furniture, ceramics, and interior decorations until its closing six years later.

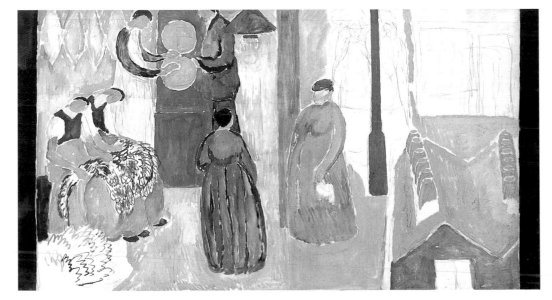

2

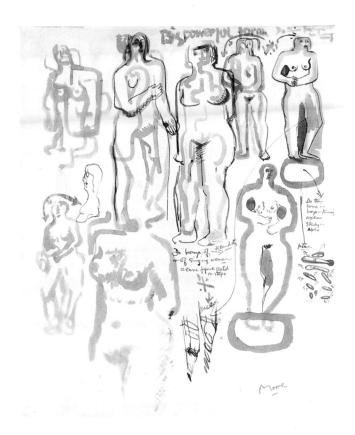

3

3
Henry Moore
1898–1986
Studies for Sculpture:
Big Powerful Forms, 1929
Pen and brush and
ink on wove paper,
16 7/8 x 13 9/16
(42.9 x 34.5)
H.M.F. 740
The Joel Starrels, Jr.
Memorial Collection,
1974.254

enry Moore was the son of a coal miner, and Moore's remembrances of childhood presage his decision in 1919 to study sculpture, first at the Leeds College of Art and later at the Royal College of Art in London: the imposing slag heaps formed by local mining companies in his native Yorkshire and, at age eleven, a story in Sunday school about the Italian Renaissance artist Michelangelo.[1] Active for nearly seven decades, Moore left an oeuvre of more than nine hundred sculptures in wood, stone, and bronze and over five thousand known drawings. In the 1930s, he championed an abstract sculptural vocabulary and established the authority of direct carving in stone and wood among the avant-garde British artists active in London. From the end of World War II, Moore focused on his preferred subject, the human figure, inventively uniting a modern formalist aesthetic with classical humanist thought.

Henry Moore's introduction to so-called primitive art undoubtedly was Roger Fry's 1920 book *Vision and Design*, which the artist read during his last year at the Leeds School of Art in 1921. This experience provided the catalyst for Moore's discovery of ancient and tribal sculpture, of many cultures for the most part of non-European origin: ancient Sumeria and dynastic Egypt, pre-Classical Greece and pre-Roman Etruria, Mexico and Peru before the Spanish conquests, sub-Saharan Africa and Oceania. Pre-Columbian stone carving in particular played a profound formative role, both formally and in Moore's choice of material, especially in his sculptures of the 1920s.

Fry's book also pointed the way to the necessary models, and, as Moore referred to it, "the realisation of the British Museum."[2] Moore shocked his teachers at the Royal College of Art in London by spending his time among the encyclopedic collections of so-called primitive art in the British Museum, where he filled pages of notebooks with sketches of sculptures in the crowded display cases; his teachers preferred that he devote his attention instead to the approved curriculum of the Academy, based on the copying of antique Greek and Roman statuary and the masters of the Italian Renaissance. In addition, Moore saw excellent examples of ancient and tribal art at the London gallery of Sidney Burney, who was the most important and influential dealer in England during the 1920s of African, Eskimo, and Oceanic art.[3] Moore was also invited at this time to see the sculptor Jacob Epstein's private collection of tribal art (see cat. no. 19).[4]

In the formative decade of 1920–30, Moore rejected the Greek ideal of beauty and the academic tradition based on the art of antiquity and the Renaissance despite a 1925 trip to Italy where he greatly admired the paintings of Giotto and Masaccio. His appreciation of so-called primitive art led him to the realization that the realism begun in fifth-century Greece was only a digression from the main world tradition of sculpture and "that the Greek and Renaissance were the enemy, and that one had to throw all that over and start again from the beginning of primitive art."[5] Moore contended that ancient and tribal art of diverse origins embodied a common world-language of form, including "three-dimensional realization" and "truth to material". He was not interested in making works of art that looked primitive. By using ancient and tribal art as a touchstone and exemplar, he sought instead to tap the same wellspring of what he understood to be "universal" shapes that held a power of expression and spiritual vitality. Significantly, the dealer Burney organized a pioneering exhibition in 1928 in which he showed African sculpture along with the work of contemporary artists.[6] This public affirmation of the affinities between tribal and modernist Western art coincides with Moore's first major sculptural commission, in which he developed an initial mature style informed by the overarching influence of ancient and tribal art (see cat. no. 25).

The simplified shapes and massive limbs, torso, and neck of the female in this set of studies for a standing figure bring to mind the earth-bound, bulky-figured style of Picasso's "classical period" paintings and drawings of the early 1920s, which Moore acknowledged as an inspiration in his own approach to form between 1925 and 1930. The gesture of the clasped hands and the foursquare head of the uppermost right-hand figures remind one as well of Sumerian sculpture of about 2100 B.C.E. in the British Museum, in particular *Gudea, Ruler of the City of Lagash*. Moore was greatly impressed with such sculpture, writing that it "contained bull like grandeur and held-in energy."[7]

The notation "fecundity" on the drawing also occurs no less than eight times in the sketchbooks kept by Moore from 1921 to 1926. Other related references are "Eve", "Venus", and "mother and child".[8] In this context, Moore may have had his thoughts on the "paleolithic Venuses", prehistoric fertility or cultic figurines, about which he wrote in 1935, and which he called "a part of life, here and now."[9]

The inscription, "carve figure seated on steps," probably refers to another sketchbook sheet (Private Collection),[10] which is among the earliest studies of a human figure seated or reclining on steps, a motif which the artist translated into sculpture only in 1957–58 (L.H. 428).

The *X* surrounded by four dots next to the upper right-hand standing woman in this drawing is a shorthand indication by the artist that he considered this study of particular interest.[11] Of the hundreds of sketches in the notebooks, only a relatively small number of ideas were destined for transformation into three dimensions. This manner of marking certain sketches provided Moore with an easy reference for later selection of a composition for a sculpture. The present study may be identified with the marble *Figure with Clasped Hands* carved in 1929 (L.H. 60).

4

Leon Underwood
1890–1975
Torso: June of Youth, 1934
(model, this cast 1958?)
Cast bronze,
h. 24 1/8 (61.3)
The Joel Starrels, Jr.
Memorial Collection,
1974.145

artist, teacher, book illustrator, and writer, Leon Underwood began collecting tribal African sculpture in 1919, and over the years he formed a substantial collection of so-called primitive art. At the beginning of the 1920s, he taught life drawing to Henry Moore and Barbara Hepworth when they were students at the Royal College of Art in London. His interests led him to visit the prehistoric caves of Altamira in 1925, and to travel to Mexico three years later to study the pre-Columbian sculpture of the Mayas and Aztecs. With Henry Moore and C.R. Nevinson he founded in 1931 the magazine *The Island*, to which Moore and the British Surrealist artist Eileen Agar contributed.[1] The next year Underwood organized an exhibition at Sidney Burney's gallery in London, in which he stressed the affinities among ancient, tribal, Asian, and modern art through the juxtaposition of works from dynastic Egypt, pre-conquest Mexico, sub-Saharan Africa, China, India, Persia, and New Zealand with sculptures by Edgar Degas, Henri Gaudier-Brzeska, Hepworth, Amedeo Modigliani, and Moore, along with two of his own pieces. In the late 1940s, he published three books on the tribal sculpture of West Africa.

During the 1920s Underwood was carving stone and wood pieces in a primitivist style indebted ultimately to the prewar style of the English Vorticist sculptor Gaudier-Brzeska, who had been killed in World War I. Underwood's interest in tribal and ancient non-Western art was also a powerful stimulus to his own sculpture. He enjoyed a measure of success for the modernity of these works, and was linked by contemporary critics with Henry Dobson, Eric Gill, Maurice Lambert, Paul Skeaping (then married to Hepworth), and other direct carvers who were characterized as the new generation of British vanguard sculptors. Underwood was also a skilled modeler, whose bronze nudes increasingly moved after the mid-1930s toward a gently idealized though still approachable naturalistic style.[2]

Torso: The June of Youth was executed during this transitional period, and while the simplified silhouette, reductive features, and curvilinear body proportions are less extreme than in earlier primitivist works, the fluid outline and schematic rendering of features, through shallow incised lines rather than modeled forms, show a continued allegiance to a modernist idiom. For example, the use of such schematic lines to activate unmodulated surfaces and define internal features is paralleled in the Surrealist-derived biomorphic carvings of Moore around 1931–35.[3] Although the female nude retained its role as a central subject of academic art in Britain at the time, the seemingly arbitrary cutting of the limbs and much of the head in *Torso* likewise is linked to a modernist sculptural tradition that begins with Auguste Rodin. Rodin had recognized the sculptural fragment as an important compositional format, one in which the partial human figure and parts of the body—such as the torso—are conceived not as fragments (*membra disjecta*) but as complete forms and independent sculptures in themselves.

The unblemished, sensuous surfaces and assured, swelling forms that emphasize the sexuality of this figure suggest the moment of transition from adolescence to adulthood. This sentiment is also expressed in the title, with its allusion to the changing of seasons, of nature moving from the first promises of spring to the early fulfillment of summer in the month of June.

4

Henry Moore
1898–1986
*Two Standing and
One Seated Figure*, 1931
Pencil, crayon, and
pen and brush and ink
on thin wove paper,
9 15/16 x 7 7/8
(25.3 x 20.1)
H.M.F. 854
The Joel Starrels, Jr.
Memorial Collection,
1974.246

t his drawing marks the abrupt change in Moore's approach to the human figure in the early 1930s. His new idiom was provoked by the Surrealist work of his contemporaries in Paris: Hans Arp, Alberto Giacometti and, above all, Picasso. The fluid curves of the bodies, the simplified treatment of the hands, and especially the double head seen simultaneously as frontal and in profile reflect the influence of the decorative rhythms of Picasso's curvilinear Cubistic mode, exemplified in such works as *Seated Woman* of 1926–27 (Art Gallery of Ontario, Toronto).[1]

The original impetus for the composition may be a loose, spontaneous pen and ink drawing from 1930 (Art Gallery of Ontario, Toronto), made without preconception in the spirit of the Surrealist automatic drawing method practiced by André Masson. The figures' poses and the composition in general also suggest certain of Picasso's "classical" paintings of the early 1920s. Although the Smart Museum drawing has been gridded for transfer to a larger size, no final project has yet been identified among the extant or destroyed sculpture from the early 1930s, but the idea presages the family groups of the mid-to-late forties (see cat. nos. 31–34). Perhaps the transfer was intended for a larger drawing, but the definitive version seems to exist only in an altered format, in another drawing from 1931 (London art market, 1964) featuring the right two figures.[2] Here the forms have solidified in the manner of Moore's primitivizing work from 1925–30, except for the heads which retain the split image of frontal/profile. It is as though the young artist were caught between two stylistic options, the primitivism of the 1920s and Picasso's recent work, both of which he would abandon for Surrealist possibilities as the decade proceeded.

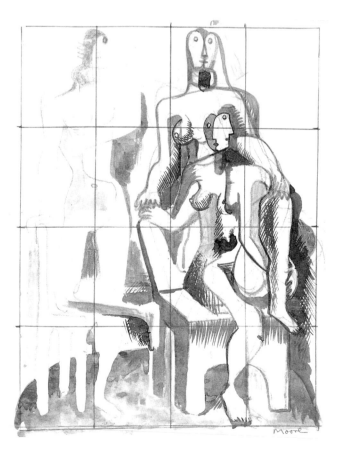

Moore 5

6

6
Henry Moore
1898–1986
*Ideas for Sculpture
(Transformation Drawing)*,
1932
Pencil on wove paper,
14 7/16 x 10 11/16
(36.7 x 27.2)
H.M.F. 978
The Joel Starrels, Jr.
Memorial Collection,
1974.243

t he earliest visual record of Moore's interest in natural forms is the inscription "remember pebbles on beach," surrounded by what is probably an outline of a pebble, which was written on the inside cover of his *No. 6 Notebook* from 1926 (Henry Moore Foundation, Much Hadham, England). On his frequent visits to the Natural History Museum in London, Moore often took along a sketchbook and made studies of bone and shell specimens. In addition to straightforward drawings from the motif, he also made far more complex studies in which the original shape of a bone, pebble, shell, or flint has been altered.[1] In these drawings, as exemplified in this pencil sketch from 1932, Moore first drew a likeness of the natural object and then transformed it into human shape. The process is well illustrated at the upper right of the drawing, where Moore converts an animal bone into a mother and child subject or again into a reclining figure with child—turned 90 degrees to the vertical orientation of the sheet—through the overlaying of human features suggested to the artist by the original bone morphology. In this way he extends the initial driving force behind the naturally occurring shapes and blends them into his current biomorphic formal vocabulary, adjusting the subject matter to address the format to two of his major sculptural themes, Mother and Child and Reclining Figure.

Most of the transformation drawings date from 1932, the year of this study.

7

Henry Moore
1898–1986
Seated Figure, 1934
Terracotta, h. 5 1/2 (14)
Lund Humphries 129?[1]
Lent by Rhoda Pritzker

the distinctive style of this seated female nude identifies the origins of the small maquette in the many sketches for sculpture and the transformation drawings of 1932 (see cat. no. 6). These show Moore exploring curvilinear, biomorphic shapes, partly derived from recent Surrealist art from Paris and partly grounded in the sculptor's own use of bone, small stones, and other natural *objets trouvés* as possible sources of sculptural ideas. In addition, the shallow, abstract incisions—freed from any obvious pictorial realism—used to define features of the head and breasts in *Seated Figure* are characteristic of Moore's sculpture of the period.

Seated figures are infrequent among Moore's sculpture of the 1930s, and they assume an importance in his work only in the mid-1940s, in the guise of the Mother and Child and Family Group sculptures (see cat. nos. 31–34). Moore's reluctance here was based on formal problems which he felt compromised the motif as a self-sufficient pose:

There are three fundamental poses of the human figure.... But of the three poses, the reclining figure gives the most freedom, compositionally and spatially. The seated figure has to have something to sit on. You can't free it from its pedestal.[2]

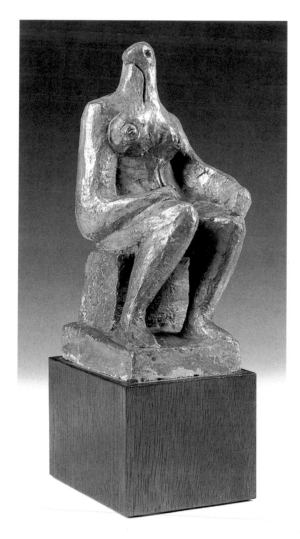

7

8
Henry Moore
1898–1986
Head and Shoulders, 1935
Cast bronze, ed. 5/6,
h. 5 (12.7)
Lund Humphries 159a
The Joel Starrels, Jr.
Memorial Collection,
1974.202

this intimate bronze of a mother cradling her child belongs to a series of small abstract sculptures, each no larger than five inches in height or length, which Moore modeled in clay or carved in hardened plaster in 1935 and subsequently had cast in bronze only in the 1960s.[1] The overall conception brings to mind the bonelike forms or human figures emerging from animal bone or stony matrixes in the transformation drawings of 1932 (see cat. no. 6).

The allusive character of this bronze follows aesthetic principles set down in Moore's "The Nature of Sculpture" essay of 1937:

I am very much aware that associational, psychological factors play a large part in sculpture. The meaning and significance of form itself probably depends on the countless associations of man's history. For example, rounded forms convey an idea of fruitfulness, maturity, probably because the earth, women's breasts, and most fruits are rounded, and these shapes are important because they have this background in our habits of perception.[2]

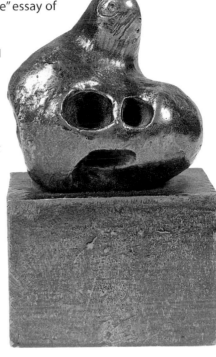

8

9
Henry Moore
1898–1986
Four-Piece Composition,
1934
Cast bronze, ed. 9/9,
h. 7 5/8 (19.4),
l. 16 3/4 (42.5)
Lund Humphries 140
The Joel Starrels, Jr.
Memorial Collection,
1974.163

this bronze belongs to the inventive decade 1930–40, when Surrealism held profound significance for Moore. Despite its noncommittal title and its non-objective appearance, this sculpture is essentially an image of a reclining figure, and specifically a supine woman, or rather the dismembered elements of the female anatomy. The reclining figure is set forth here as an ensemble of separate forms, with the individual parts splayed out along a single axis and united by the surface of the irregular angular base. The artist commented about this work: "Although this sculpture looks abstract, it has organic elements. There are two separate forms—a head and a torso. . . ."[1] Thus, even when engaged in his most abstract work of the 1930s, Moore remained steadfast in his commitment to the expressive possibilities of the human figure, as he maintained: "For me sculpture is based on and remains close to the human figure."[2] Although disjointed, the body in this bronze is curiously invoked through the emphasis on its component parts, and ultimately the figurative theme is reinforced, albeit in a highly schematic fashion. The ball/umbilicus is set apart emphatically, suggestive of Moore's assertion that "the umbilical area is absolutely central to me—the cord that attaches you to your mother, after all."[3]

The compositional idea of the dislocated elements spread across a unifying surface seems indebted to the earlier multiple-piece tableau sculpture of Hans Arp and Alberto Giacometti, both of whom Moore had met in Paris in 1931–32.[4] The direct thematic antecedent for such an extreme presentation of the female figure possibly is Giacometti's

ferocious 1932 bronze *Woman with Her Throat Cut*, without, however, the attendant aggressive content. Some of the elements in *Four-Piece Composition* also recall the amoeboid, organic, and biomorphic shapes of Arp and Joan Miró of around 1930 and the bonelike forms encountered in Picasso's paintings and drawings from the late twenties.[5]

Aside from the liberating effect of Surrealism in the creation of more elusive, organic forms, this sculpture demonstrates Moore's concern with the formal possibilities of abstraction and the creation of what he called "significant form". It is a turning away from the previous decade's idea of a sculpture as a solid, unitary block. The implications of the hole penetrating and thereby uniting both sides of the block—seen here in the largest of the four units—are carried forward into an experiment with the dislocation of forms in such a way that immaterial space functions as a tangible, active compositional device in the overall conception and realization of the work's final configuration.

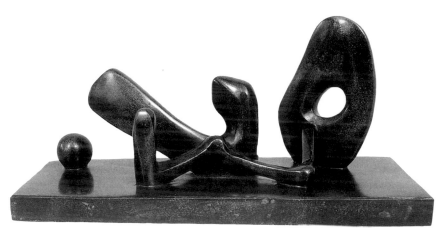

9

10
Henry Moore
1898–1986
Ideas for Sculpture, 1936
Pencil, charcoal, and pen
and brush and ink on wove
paper, 14 7/16 x 21 7/8
(36.7 x 55.6)
H.M.F. 1262
The Joel Starrels, Jr.
Memorial Collection,
1974.267

although his work of the thirties is linked to Surrealism, Moore should not be considered exclusively an English Surrealist artist. Between 1930 and 1940 Moore maintained his studio in Hampstead in London literally around the corner from a community of artists sharing similar concerns. Constituting the vanguard of the Constructivist movement in England, which emphasized geometrically-derived abstraction, this group included Barbara Hepworth, Paul Nash, and Ben Nicholson among the British artists, and later the important émigrés Marcel Breuer, Walter Gropius (in 1934), Piet Mondrian (1938), and most importantly, Naum Gabo (1936) and László Moholy-Nagy (1936).[1] Moore exhibited with the Constructivist group in the first purely abstract show in England, *Abstraction and Concrete*, at the Zwemmer Gallery, London, in 1935; and in 1937, the year after his participation in the landmark international Surrealist group exhibition in London, he contributed to the Constructivist manifesto and journal *Circle*. In the 1930s, Moore regularly exhibited with both the Surrealists and the abstractionists in London, Paris, and New York, and although accepted by both groups, he never felt entirely absorbed into either. As he wrote in 1937:

The violent quarrel between the abstractionists and the surrealists seems to me quite unnecessary. All good art has contained both abstract and surrealist elements, just as it has contained both classical and romantic elements—order and surprise, intellect and imagination, conscious and unconscious. Both sides of the artist play their part.[2]

The year of this drawing, 1936, marks the artist's participation in the *International Surrealist Exhibition* held in June at the New Burlington Galleries in London. This was the first comprehensive group exhibition of Surrealism in England; it included 390 works by sixty-eight

exhibitors from fourteen countries.[3] The four black-and-white shapes of the Smart Museum study for sculpture are closely related to the biomorphic Surrealist forms of Hans Arp or Joan Miró. The freely drawn doodles and linear marks at the top of the composition may originate in the Surrealist concepts of tapping the unconscious and automatic drawing. They appear as a visualization of a working method practiced by Moore, in which, as Moore wrote, he would begin drawing on a piece of paper "with no preconceived problem to solve, with only the desire to use pencil on paper, and make lines, tones and shapes with no conscious aim; but as my mind takes in what is so produced, a point arrives where some idea becomes conscious and crystallizes, and then a control and ordering begins to take place."[4]

This study corresponds in date to some of Moore's most abstract sculptures and drawings, where the underlying human body—central to his repertoire of motifs and themes even in his most abstract works—has been pressed into a rigid, blocklike, geometric frame, acquiring thereby the appearance of an architectural monument

This large sheet was included in the sculptor's first American retrospective at the Museum of Modern Art in New York in 1946.[5]

11
Henry Moore
1898–1986
Two Figures, 1939
Pencil, charcoal, pen and
ink, and pastel on wove
paper, 22 x 14 15/16
(55.9 x 38)
H.M.F. 1442
The Joel Starrels, Jr.
Memorial Collection,
1974.255

In the late 1930s, Moore began to use blocks of color to enliven his drawings and to provide an atmospheric sense of space and setting, thereby enhancing the three-dimensionality of the forms depicted. Sketches in which sculptural ideas appear in imaginary settings are an extension of his working method of making drawings as ideas for sculpture; as the artist explained: "I have thought of a piece of sculpture in a particular setting—a landscape, a stage, in rooms or caves—that is of placing sculpture in some defined or suggested space."[1] In 1953, he wrote:

There is a general idea that sculptors' drawings should be diagrammatic studies, without any sense of background behind the object or of any atmosphere around it. That is, the object is stuck on the flat surface of the paper with no attempt to set it in space—and often not even to connect it with the ground, with gravity. And yet the sculptor is as much concerned with space as the painter.[2]

The reclining figure in the center of its imaginary landscape in this large, richly worked and colored drawing is the final version of the small bronze of 1939 titled *Reclining Figure: Snake* (L.H. 208a), itself a maquette that was never enlarged for a full-scale sculpture.

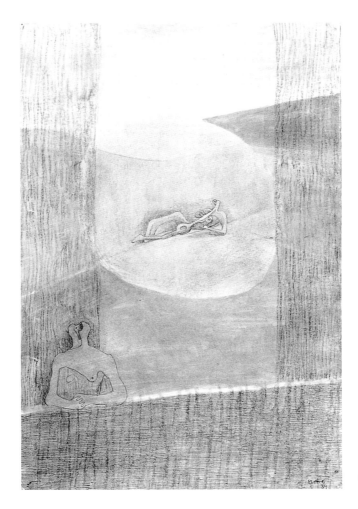

11

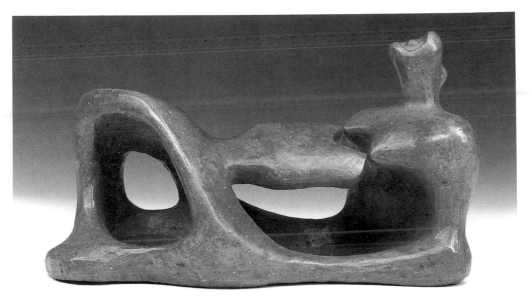

12
Henry Moore
1898–1986
Sketch Model for Reclining Figure, 1945
Unglazed modeled terracotta, h. 3 3/4 (9.5), l. 6 1/2 (16.5)
Lund Humphries 245
The Joel Starrels, Jr. Memorial Collection, 1974.138

nearly all of Moore's sculptures from 1921 to the early 1950s are ultimately based on preparatory drawings. By the late thirties, however, he established an additional, intermediary stage in the working process, which he called a sketch-model, before the execution of the final piece. The Smart Museum's reclining figure is an early example of one of these small hand-held maquettes, usually modeled in clay or carved in hardened plaster. Unlike his two-dimensional studies, the sketch-models did not limit the sculptural conception to a few key points of view (front, back, ends). With the maquettes, Moore believed he was able to exploit the full potential of multiple views afforded by freestanding sculpture.

Wartime restrictions and the Blitz over London prevented Moore from making sculpture from 1940 to 1943. In 1945, he began carving his first postwar large-scale reclining figure, in elm wood. At the same time, he fashioned a half dozen small clay models for wooden sculpture, including the Smart Museum maquette.[1] The present terracotta was conceived several years earlier, in the richly colored 1942 drawing *Reclining Figure and Red Rocks* (British Museum, London).[2]

Formally, the Smart Museum figurine belongs with Moore's Surrealist-derived biomorphic sculpture of the mid- and late thirties, distinguished by smooth, highly reduced, curvilinear shapes that suggest the organic flow of elusive microscopic or cosmic life forces. In the terracotta, the extensive excavation of the torso and thinning of limbs—so that the space between parts and penetrations of the core are nearly equal in volume to the remaining mass—are consistent with Moore's rejection at the time of his own previous exploration of sculpture as a solid, unitary block. The hollowed body and attenuated limbs can also be understood in terms of the terracotta's function as a study for a sculpture in *wood*: "I have always known," the artist later explained, "how much easier it is to open out wood forms than stone forms, so it was quite natural that the spatial opening-out idea of the reclining figure ... first appeared in wood [in 1936]"[3]

Two-thirds of Moore's major sculptures explore the theme of the reclining woman. In 1961, assessing four decades of his career, the artist noted that "the reclining figure is an absolute obsession with me."[4] Despite the overarching significance for Moore of ancient non-Western and tribal sculpture during the 1920s, the reclining figure motif was probably first suggested to him by the classical Mediterranean tradition of the recumbent river-god, the personification of nature's flowing energy. In addition to examples of the type in antique and Renaissance statuary, there are also Michelangelo's carvings of *Dawn* and *Night*, complex allegories in the guise of awakening or slumbering reclining nudes (Medici

Chapel, San Lorenzo, Florence). The reclining figure gained further impetus after Moore discovered the pre-Columbian stone carvings of the Toltec-Maya rain-god, Chacmool, from Chichén Itzá.[5]

One of Moore's greatest contributions to twentieth century sculpture was the use of the human figure as a metaphor for landscape, in which the recumbent female body assumes the contours and rhythms of a mountain range. Moore wrote in 1930 that the sculpture that moved him most in was "strong and vital, giving out something of the energy and power of great mountains."[6] In the British Museum drawing, he places the reclining figure in an imaginary setting in front of an eccentrically shaped rock. Unequivocally establishing the interplay between the jutting rock and the corresponding limbs and head of the "wooden" female, he identifies the human body with elemental nature. Forms of the natural world—ridges, swellings, holes, depressions, and protrusions—find equivalents to the human form in works such as this terracotta.

13

Roland Penrose

1900–1984

Collage, 1937

Pencil, decalcomania, and paper collage on paperboard,

19 5/8 x 25 5/8 (49.8 x 65.1)

Gift of Sylvia Sleigh in memory of Lawrence Alloway, 1991.304

After demobilization from the army in World War I, Roland Penrose began his studies at Cambridge, where he met the influential critic Roger Fry. It was Fry who had promoted vanguard continental art in England before the war in a series of landmark, and frequently controversial, exhibitions in London between 1910 and 1913. At Cambridge Duncan Grant, one of the leading artists in the Bloomsbury Group, encouraged Penrose to go to Paris to pursue a career as an artist. Penrose arrived in Paris in 1922, where he met Georges Braque and studied with André Lhote. A fundamental shift from these experiences—which must have confirmed an aesthetic promulgated in the prewar French modernism of Post-Impressionism, Fauvism, and Cubism—occurred three years later when he met the German-born artist Max Ernst, a proponent of Dada and Surrealism, who became a lifelong friend.

During his decade-long sojourn in France, Penrose was introduced by Ernst to Surrealist ideas and techniques. By the early 1930s Penrose had become friends with leading members of the Surrealist group, including Man Ray and Salvador Dalí. After his return to London in 1935, Penrose championed the cause of Surrealism, playing a central role in the organization of the 1936 *International Surrealist Exhibition*. The next year, he and E.L.T. Mesens became co-owners of the London Gallery, which they dedicated to the promotion of Surrealist art, through exhibitions and the publication of *London Bulletin*, a journal devoted to Surrealist activities in England, continental Europe, and the Americas.

In his pictorial autobiography *Roland Penrose Scrap Book 1900–1981*, the artist records that in the summer of 1937 he traveled to the south of France, to the seaside resort of Mougins, and there enjoyed the company of Paul and Nusch Eluard, Dora Maar and Picasso, Man Ray, and other friends and acquaintances associated with French Surrealist art, poetry, and writing. It was during this memorable trip or shortly thereafter that this collage-drawing was fabricated, as the artist recounts in *Scrap Book*:

Attracted by the vivid colour of the picture postcards on sale everywhere, I began to experiment with them in collages. Sometimes I found that repetitive clusters could take the effect of a spread of feathers or a single image cut out and set at a peculiar angle could transform completely its original meaning.[1]

Inscribed and dated at the bottom of the composition, "Mougins 1937", the Smart Museum collage must count among the earliest of such works made by Penrose over the next several years.

13

Here, Penrose deployed several sets of whole or cut pieces of color postcards, laid down either in sequences of three or more related sections from the same image, or of the same section from two identical cards in paired opposition; in one instance, three such pieces are mounted in a pinwheel rotation.[2] Also included are an irregularly-shaped piece of red construction paper and a strip of paper imprinted in mottled gray through an offset technique, akin to the monoprint. Called decalcomania, this process later became integral to the Surrealist art of Ernst and other Surrealist artists.

Penrose exhibited six of these collages at a one-person exhibition at the Mayor Gallery in London in 1939.[3] His innovation attracted the attention of René Magritte and Paul Nougé, who discussed them in an article in *London Bulletin*. They described the innovation in works like the one in the Smart Museum as "an important contribution to surrealist inquiry"[4] and wrote:

Roland Penrose ... has thought of formulating the problem [of color] in entirely new terms: up till now, he says, colour has been used for no other purpose than the creation of the images of the objects. *But what if we tried to use the image of the objects to create colours?*[5]

The authors argued that the new structure imposed on cut pieces of postcards altered the original pictorial illusionism of the scenes depicted, and that the simplicity of triangles, wedges, and other geometric shapes that Penrose used to reorder our reading of these naturalistic views transforms them into chromatic zones, stripped of their original pictorial necessity.

In these collages there is a tension between the fragments of pictorial illusionism of the altered postcards and the flat, diagrammatic sensibility to the composition overall. This is also in part the function of the positioning of the collage elements. Occasionally they are placed on top of one another, but for the most part they are contiguous, abutting each other. These two-dimensional elements are supplemented by straight and segmented lines, a schematic disk, and other marks in pencil. The schema of machine imagery and non-illusionistic configuration of Penrose's "landscape" recall Ernst's own collage-drawings of 1919–20, in which bits and pieces of ready-made printed images are similarly reconfigured into ambiguous, irrational situations that vaguely conjure up urban and pastoral settings. For Penrose and his collages, "the transmutation process ... is that by means of which the apparently banal and commonplace material provided by picture postcards is transformed into the magic element of an enchanting new visual experience."[6]

Stanley William Hayter
1901–1988
Amazon, 1945
Engraving, soft-ground
etching, and scorper,
ed. 38/50,
plate: 24 1/4 x 15 3/4
(61.6 x 40)
Black and Moorehead 165
VI/VI
Gift of Mr. and Mrs. Eugene
Davidson, 1978.21

15
Stanley William Hayter
Cérès, 1947–48
Engraving, soft-ground
etching, scorper, roulette,
burnisher, and color
screenprint, ed. 24/50,
plate: 23 1/2 x 14 3/4
(59.7 x 37.5)
Black and Moorehead 185
V/V
Gift of Mr. and Mrs. Eugene
Davidson, 1978.22

Stanley Hayter is considered the most innovative and influential of all twentieth-century British printmakers. He restored modern engraving as a fine art form rather than simply a printmaking technique used primarily for the reproduction of works of art in other media. Trained as a chemist and geologist, he saw his art as a process of discovery in which cooperation was essential among the artist, technical assistants, and professional printers in the making of a print. First in Paris and later during World War II in New York, his experimental printmaking workshop Atelier 17 was the meeting place of many of the major figures of the international avant-garde of the period. Although he made paintings and occasionally sculptures, Hayter is known primarily as a printmaker, principally an engraver and etcher, in the European tradition of the artist-printmaker or *peintre-gravure*. In his prints, he sought to push standard techniques, revive old processes, and achieve new effects through experimentation. The richness and subtlety of his prints were achieved by the use of textures, the effect of varying biting times, the use of different levels of the plate, and the differing viscosity of inks employed. In 1934, he made his first plate in which he used his newly discovered technique of engraving a line so deeply into the metal plate with a gouging tool (scorper) that the incision no longer held any ink but printed as an embossed line. It is generally held that his greatest and most influential prints were the large, technically ambitious New York plates and color prints made after the war. These show a bewildering mixture of techniques in a single plate, often achieved through new processes of his own invention, evident in these two prints.

In 1926, abandoning his science career, Hayter moved to Paris to devote himself to art, and by 1929 he had begun to be influenced by Surrealism. For a number of years he was "officially" recognized as a Surrealist artist by André Breton, but Hayter resigned after

14

15

Breton's expulsion of Paul Eluard from the group in 1938. Eight etchings, two paintings, and a sculpture by Hayter were included in the historic *International Surrealist Exhibition* staged in London in 1936.

In the 1930s and 1940s, Hayter's style was poised halfway between Surrealist or fantastic imagery and abstraction, and he adapted an automatic drawing technique derived from Surrealism in the creation of his imagery. These characteristics are exemplified in *Amazon* and *Cérès*, which also demonstrate the complex counterpoint of line and space formed in his prints of the mid- to late 1940s. Each of the images contains a personage developed out of an intricate skein of lines whose organic contours recall the biomorphism of Jean Arp, Joan Miró, and Yves Tanguy—artists who had frequented Atelier 17 in the 1930s. Before the war Picasso occasionally sought technical advice from Hayter, and it may not be coincidental that the head in *Amazon* is reminiscent of Picasso's portraits of Dora Maar. As in Greek mythology, the Amazon has only one breast,[1] and Hayter's introduction of a yellow screen in *Cérès* may be an oblique reference to this Roman goddess of grain and the harvest.

The titles Hayter assigned to these works are suggestive of the artist's position in the American art world of the 1940s. In New York, Hayter's atelier was a link between émigré Surrealist artists from Europe like André Masson and the emerging generation of expressionist artists, including William Baziotes, Mark Rothko, and Jackson Pollock, who were then involved with abstract imagery drawn from classical mythology, which they altered into symbols of the existentialist existence of modern life.

1920
ACADEMIC TRADITIONS: REALISM AND FIGURATION

Although often eclipsed by the formal innovations of vanguard art movements in Britain before World War II and the rise of a new internationalism in the 1950s, academic traditions were nonetheless a vital part of the varied fabric of British modern art during the period. For some artists, such as Jacob Epstein and Christopher R.W. Nevinson, who had executed some of the most innovative abstract sculptures and paintings in England before World War I, their later realist styles were personal rejections of their own early modernism and the avant-garde fascination with the impersonal dynamics of machinery and fast-paced urban life. This was perhaps related to the carnage and destruction they had witnessed during the war, which had savagely revealed the darker side of modern industrial society.

Others in the 1920s worked in conservative naturalist styles or adopted a limited modernism derived from French Post-Impressionism, continuing a long-standing preference for academic style and subject matter. This was the case especially among printmakers like John C. Copley and Laura Knight, who were part of the etching and lithography movements in England. Their activity as printmakers linked them not only to venerable print traditions, whose origins lay in the mid-nineteenth and early twentieth centuries in Britain, but also to

an established patronage, which was limited for more avant-garde modernist artists in Britain between the wars. This conservative trans-Atlantic print industry was driven by an upper middle-class clientele that favored realist compositions, suitable for bourgeois interior decoration.

Neo-Romantic painters active in the late 1930s and 1940s such as John Minton chose figuration to convey a belief in the continued vitality of humanist values in modern society. Although interested in early modernist styles—from Picasso's neo-classical paintings of the 1920s to the Italian Scuola Metafisica paintings of Giorgio de Chirico, which had also reintroduced such humanist values into the modernist tradition—artists like Minton and Michael Ayrton often turned to the indigenous Romantic tradition of early nineteenth-century England for inspiration. For this reason, during World War II this movement was occasionally linked to nationalist sentiments.

In the aftermath of World War II and during the tense early years of the Cold War, with its almost palpable threat of nuclear annihilation, John Bratby and other so-called Kitchen Sink painters in London favored a type of existentialist realism. Part of the postwar generation of painters and writers collectively called "Angry Young Men", they presented a nihilist vision of the battered urban spectacle of postwar London—the alienation and despair which for them it embodied—in gritty depictions of prosaic subjects, rather than the metaphoric symbols of more abstract styles.

1955

16
John C. Copley
1875–1950
Two Gentlemen Laughing,
1920
Lithograph, image:
9 3/4 x 9 1/4 (24.7 x 23.5)
Wright 180 II/II
Gift of Mrs. C. Phillip Miller,
1978.10

t rained as a painter, John C. Copley was primarily a printmaker, and active in the London-based Senefelder Club, dedicated to the promotion of lithography in Britain. The first quarter of the century saw the final fluorescence of the British etching revival, initiated by William Haden and other printmakers in the 1860s, but Copley worked almost exclusively as a lithographer during this period, and his etchings came later. Copley was an observer of society, frequently with a slightly sardonic humor. His imagery was almost exclusively connected with urban life, and he shared with the Camden Town painter Walter Sickert a fascination with middle-class suburban life, and with the music hall and the world of the theater.[1]

Copley's lithographic style betrays the unmistakable impact of French Post-Impressionism—in particular the print revolution in color lithography at the end of the century associated with the master printmaker Henri de Toulouse-Lautrec. *Two Gentlemen Laughing,* for example, exhibits the characteristicly expressive use of the lithographic crayon line, the close cropping of the sides of the scene, and jumps in scale between objects in the foreground and forms behind. The figures in *Two Gentlemen Laughing* are faintly puppetlike, and one senses a moment plucked from time in the isolation of the two men, who are claustrophobically wedged behind a chair and table and the rear wall pressing them from behind.

Copley's lithographs, which were widely collected at the time, were for him an important means of making a living. His subjects and diluted modernist style appealed to the prosperous middle-class collector who helped fuel the print industry in England, with its clubs and societies, dealers and publishers, and its secondary market in the auction house, which came to an end with the stock market crash of 1929.[2]

16

17
Laura Knight
1877–1970
A Cornish Harbor, 1927
Drypoint, proof ed. of 40,
plate: 9 7/8 x 13 13/16
(25.1 x 35.1)
University Transfer from
the Max Epstein Archive,
Carrie B. Neely Bequest,
1967.116.547

the painter Laura Knight was a dedicated exponent of the intaglio print, both in mixed methods and as pure etching and drypoint. Many of her prints were executed in a relatively brief period of time, between 1923, when her earliest etchings were published, and 1925. The context for these works is the etching revival, begun by Seymour Haden and James McNeill Whistler in the 1860s, that after World War I had eclipsed in popularity the rival lithograph movement led by Joseph Pennell. This market was trans-Atlantic: an important part was played by American dealers and collectors. Knight's intaglios show the high degree of technical proficiency common to the etching revival, but her style is less conservative in its realism, and her etched line is not as insistently tied to a literal pictorialism.

Knight preferred subjects from the bohemian world of the circus, the ballet, and gypsy life. She made occasional landscapes, such as *A Cornish Harbor*, which shows great originality in its use of bird's-eye perspective. The specific site in this print is probably the fishing town of St. Ives. Since the late nineteenth century, St. Ives's rugged beauty had attracted painters, and Knight and her husband were among the many artists who visited. The pace quickened after World War I, as St. Ives became the locus of a progression of artist's colonies: Bernard Leach and a generation of English studio potters in the 1920s, Barbara Hepworth and Ben Nicholson with Naum Gabo after 1939, and after the Second World War the St. Ives School, including Terry Frost, Roger Hilton, Peter Lanyon, and Bryan Wynter.

17

18
**Christopher R. W.
Nevinson**
1889–1946
Quartier Latin, 1927
Drypoint, plate:
13 7/8 x 9 13/16
(35.3 x 24.9)
University Transfer from
the Max Epstein Archive,
Carrie B. Neely Bequest,
1967.116.547

before World War I, Nevinson participated in the most extreme activities of London's avant-garde. Although not officially a member of the Vorticist group centered around Wyndham Lewis and the Rebel Art Centre, he was sympathetic to their cause and exhibited with them, but his activities as the leading British Futurist set him apart. His association with Futurism culminated in the Italian artist Filippo Marinetti's visit to England for a series of lectures and Futurist manifestations, and the publication of their joint manifesto, "Vital English Art", in June 1914. His own paintings in the mid-teens embody a Cubo-Futurist vision of modern urban life. After the war, he visited New York, first in 1919 and again in 1922. There he met the lithographer Joseph Pennell and was introduced to George Bellows, whose lithographs Nevinson admired. These experiences acquainted him with the realist urban images being produced in America, and he was deeply impressed by New York's architecture and vitality. His own lithographs of New York vary in mood, but overall he embraced its modernity. By the late 1920s, his view of the modern city had changed, and the metropolis was now the locus of disintegration and alienation, conjured up in T. S. Eliot's doom-laden vision of postwar urban living in *The Waste Land* (1922).[1]

Nevinson employed a variety of printmaking techniques during his career, including drypoint, etching, lithography, mezzotint, and woodcut. In the 1920s he produced a large number of prints, mostly drypoints, but his style grew increasingly conventional. In 1919, he had stated, "I wish to be thoroughly disassociated from every 'new' or 'advanced' movement,"[2] and asserted in his autobiography that 1922 marked "the beginning of a search for a way out of the aesthetic cul-de-sac which modern art had led me into."[3]

After World War I, Nevinson's subject matter was often French, as in this drypoint of Paris's venerable Latin Quarter. Here the style, subject, and melancholic mood—expressed by the isolation of a few solitary figures and darkened, blank windows—are consistent with the artist's retreat from his prewar vanguard style and celebration of modern living. But the simplification of forms and repetitive patterning of the rooftop garrets are faint recollections of the bold simultaneity of repeated geometric shapes in his Cubo-Futurist style from around 1915.

In 1920, the American-born Jacob Epstein was the leading modernist sculptor in Britain, even though he had turned away from the "primitivism" of his direct carvings in stone and the vanguard abstraction and startling formal innovations of his Vorticist works, and had turned to modeling and the medium of bronze, in the tradition of Auguste Rodin. A legacy of his modernist works is the unromantic, even brutal intensity of expression that infuses his portraits. However, because of the public and official furor that surrounded his memorial monuments before the war and in the mid-1920s, Epstein received only a few commissions for architectural reliefs between the wars, and in 1924, he failed to secure a teaching position, partly because of his controversial bohemian life (he maintained two households). Both are factors in his turning increasingly to portraiture for a living. Epstein's sculpture included both studies of sitters chosen by the artist and commissioned works, as his reputation as an outstanding portraitist grew in the 1930s and 1940s.

In August 1921, Epstein met Kathleen Garman, an art student. It was a momentous encounter, and Epstein was to do seven portraits of her between then and 1948.[1] Her distinctive features and presence embodied Epstein's ideal of beauty. This 1932 bronze shows his ability to "distil personality and underlying spirit through penetrating observation and empathy, backed by superlative modelling technique."[2] The informal naturalism of this portrait was a dominant trait in other of his female studies. It is also a characteristic example of Epstein's revival of a Renaissance portrait bust type seen in the work of Donatello, for example, where the bust is cut in a straight line across the chest.

After 1915, the smooth surfaces of his portraits gave way to a rougher treatment, which fragments reflections, enhancing the animation of the head as in this 1932 portrait of Kathleen. The bust from 1944, a commission, shows a small but significant change in technical procedure, in which the finish is sometimes smoother depending on the physique and character of the sitter. Princess Nadejda was a member of the royal line of Portugal, which became a republic in 1910. Epstein has infused her portrait bust with a calm, aristocratic demeanor by a combination of formal devices: the static frontal pose, symmetrical balance, and even, fluid surfaces.

19

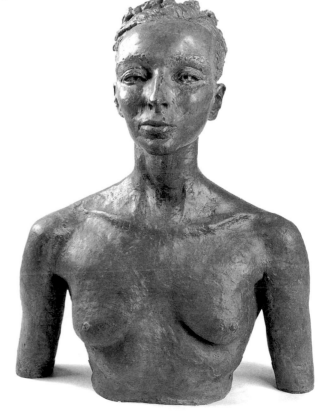

20

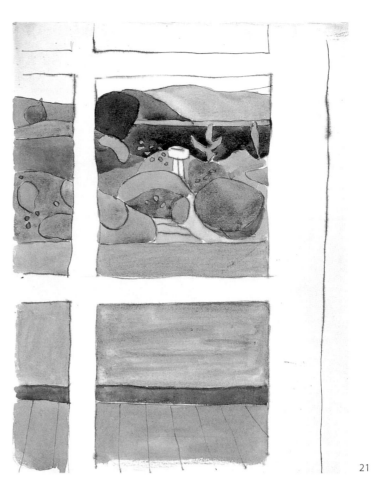

21

21
Richard Hamilton
Born 1922
Untitled, 1941
Pen and ink and watercolor
on wove paper, 13 1/2 x 10
(34.4 x 25.4)
Gift of Sylvia Sleigh,
1995.69

richard Hamilton's reputation as the father of British Pop art is based on his work of the mid-1950s. This watercolor is a rare surviving example of his juvenilia. Three years before its execution in 1941, Hamilton enrolled at the Royal Academy Schools in London. He was only sixteen, younger than usual for an art student of his generation. The few paintings that survive from 1940 exemplify his preoccupation at the time with the accurate rendering of tonal ranges in the motif, achieved with precise edges that define each block of color.[1] Hamilton achieved a similar clarity and precision in this watercolor, made the following year after he had left school: flat hues are circumscribed by ink outlines in the construction of the imagery.

The painter Sylvia Sleigh recalls that in the summer of 1941 she rented a house in Betts, Sussex, where Hamilton visited. Sleigh had painted a small portrait of a friend living in Betts, the rector Roland Clifford Wood, and placed it over the fireplace. Hamilton commented that this was not a fitting subject for its location, and painted this watercolor, a view of the garden attached to the house, as seen through a divided window, as a replacement.[2] Although the landscape was painted from the motif, the style is close to the semi-abstraction associated with the Bloomsbury Group, and Hamilton's student work also shows an awareness of early British modernism, notably the work of Vorticist Wyndham Lewis. Hamilton's Pop art paintings and prints center on a sophisticated examination of the icons of popular culture (see cat. nos. 90–92), and his choice of subject here hints at this future direction in his work: the enduring English preoccupation with gardens and gardening.

22

John Minton

1917–1957

Portrait of a Young Man,
1950

Oil on canvas,
36 1/4 x 28 3/8 (92 x 72)

Lent by Rhoda Pritzker

althought somewhat of an artistic and social outsider, John Minton is customarily associated with the neo-Romantic movement in Britain. This direction in British painting was first identified as a coherent movement during World War II, and in hindsight may be seen as a response to the closed atmosphere of a country at war and the desire to celebrate aspects of the British tradition. Its members, including Michael Ayrton, Robert Colquhoun, and Graham Sutherland, focused on images of nocturnal landscapes, ruined monuments, portraits, and other subjects common to early nineteenth-century British romantic painting. Minton himself professed enthusiasm for the works of Thomas Bewick, William Blake, John Constable, and William Turner.

This portrait of a young man exhibits many of the formal characteristics associated with neo-Romantic painting: an essentially linear mode of expression, a predilection for realism, and an intricate decorative presentation. However, other influences were also important to Minton's style. He had lived for eight months in France in 1938 and 1939, and there he met a number of Parisian artists, in particular the Russian émigrés Eugene Berman and Pavel Tchelitchew, who were developing a French school of neo-Romanticism (sometimes called neo-Humanism). This experience confirmed the direction that his art was to take for the rest of his life.

A gifted draftsman, Minton is remembered today primarily for his line drawing illustrations for travel and cook books from the 1940s. He was also a skilled and sensitive portrait painter, and the years 1944–50 are widely considered the best for this phase of his oeuvre. Minton was a friend of Lucian Freud, whose early career is often linked to the neo-Romantic movement, but his own portraits lack the ruthless penetration of Freud's studies. As in this painting, there is usually a sense of loneliness about his subjects. Although such melancholy is linked with neo-Romantic painting in general, there may also be a projection of Minton's own sense of isolation from mainstream British society, because of his open homosexuality. In addition, around 1950, the date of this work, the artist increasingly felt himself at odds with the new existentialist sensibility of much postwar British paint-

ing. For example, in 1955 he attacked mid-decade paintings by John Bratby and other "Kitchen Sink" artists (see cat. no. 24), for their lack of humanist optimism: "Doom being in and Hope being out . . . the existentialist railway station to which there is no more arrival."[1] Likewise, the following year he gained notoriety for his vitriolic attack on the rising influence of American and French action painting among a younger generation of art school students in London (see cat. nos. 96–98). Increasingly depressed, he committed suicide in 1957.

This painting of an unidentified young man displays a pose favored by Minton: a three-quarter length format with the sitter in a slightly hunched position. The semi-abstract, linear design of angular tree branches in the background is a familiar motif from his contemporary landscapes and still lifes.

22

23
Sylvia Sleigh
Born 1917
The Wrestler, 1952
Oil on canvas,
46 1/4 x 34 1/4 (117.5 x 87)
Anonymous Promised
Bequest

Sylvia Sleigh studied at the Brighton School of Art. She fondly recalls the many Victorian paintings that formed her earliest awareness of fine art, and retains a particular feeling for the Pre-Raphaelites, with their penchant for allegorical or moralist subjects cloaked in consciously modern guises, their detailed realism, and jewellike brilliance of color. The particularly British interest in portraiture, as exemplified in the work of such twentieth-century artists as Augustus John and Vanessa Bell, also had its effect on Sleigh. During World War II, her study of old master paintings in the National Gallery, London inspired her to reach beyond portrait and model studies to larger historical or allegorical themes, but always in a distinctly contemporary idiom.[1] In 1954, she married Lawrence Alloway, then a lecturer at the National Gallery. Alloway's appointment in July 1955 to the assistant directorship of the Institute of Contemporary Arts placed her in close proximity to the activities of the Independent Group, who formed London's vanguard throughout much of the decade. Despite her indirect ties to this informal group of young artists, critics, designers, and architects—including Richard Hamilton, Eduardo Paolozzi, and William Turnbull—Sleigh remained committed to figurative art, and her realist work from this period stands apart from the mainstream of British modernism. It is her view that the objectively observed world continues to offer endless sources of subject matter for her art, and this viewpoint precluded any excursions into abstract styles.

23

This painting is one of her first efforts to combine the nude or semi-nude with the portrait. Although she had painted portrait heads in the 1940s, the artist recalls that she had not done many males nudes before. A year or two earlier than the date of this study, she had designed an altarpiece of the resurrection incorporating a full nude of the risen Christ. Her first husband, Michael Greenhouse, was the Christ, flanked by Alloway and a close friend, the rector Roland Clifford Wood, as the watchful Roman soldiers. In 1952, Wood sat for the present painting, and its title, *The Wrestler*, refers to his love of the sport, as a spectator.[2] This painting is the harbinger of the fully mature work that followed, after Sleigh moved to United States in 1961: the empathy expressed between painter and model (in the choice of close friends as models), the integration of a full nude within a complex setting, the use of a light-filled palette of high-keyed color, and restrained, painterly brushwork. Sleigh has said of her nudes:

I am primarily a portrait painter. In the past portraiture and the nude were usually separate *genres*, with few exceptions that have been inspiring to me. . . . Each work combines the statement of body and personal identity.[3]

The work also hints at the fullest expression of her approach to painting, seen in canvases from the 1970s that integrate fully the portrait concept with that of a monumental figure painting in direct imitation of an earlier prototype, and the reversal of gender in her odalisques of *male* nudes, an innovation that propelled her into the forefront of the feminist debate in the New York art world at the time.

24
John Bratby
Born 1928
Kitchen Table, 1954
Oil on masonite,
48 x 28 (121.9 x 71.1)
The Mary and Earle Ludgin
Collection, 1982.69

24

ondon-born John Bratby studied at the Kingston School of Art and the Royal College of Art between 1951 and 1954. His first one-person exhibition was at Helen Lessore's Beaux-Arts Gallery in London in 1954, where he showed a number of kitchen still lifes, possibly including *Kitchen Table*. This exhibition led the critic David Sylvester to dub Bratby and a group of like-minded painters, among them Edward Middleditch and Jack Smith, the "Kitchen Sink" school. Their realist images of domestic trivia had their equivalents in literature, such as John Osborne's play *Look Back in Anger* for instance.[1] The designation of these painters and writers as "Angry Young Men" occurred later, in J.B. Priestly's review of Colin Wilson's 1956 analysis of literature and alienation in *The Outsider* and Osborne's play. This became the catch-phrase for the gritty, nihilistic outlook of this new artistic generation, four of whom—Bratby, Derrick Greaves, Middleback, and Smith—exhibited together that year at the Venice Biennale.[2] Their egalitarian vision of contemporary life emphasized individual experience, and was quite distinct from the politically-committed social realism of the British artists who supported the Artists International Association in the 1930s or the realism of the Euston Road School, established in 1937.

As seen in this painting, Bratby treated prosaic, everyday objects in a brutal, somewhat mannered naturalism. Both realistic and expressionistic, the drawing is forceful, and allied to an emotive impasto in which the influence of Vincent van Gogh is paramount.[3] The expressive nature of his paintings is also realized in the high-keyed colors employed, which are not always tied to the accurate depiction of the motif. Bratby favored high viewpoints in his compositions, and this perspective is used to great effect in *Kitchen Table*, in which the precipitously pitched table top displays a jumble of consumer products, including boxes of Vim cleansing powder, Tide laundry soap, and corn flakes from America. This assemblage is reminiscent of the iconography of later Pop art in Britain, but Bratby's use of vernacular objects is different. Neither a celebration nor analysis of popular consumerism, as in the works of Peter Blake, Richard Hamilton, and Allen Jones (see cat. nos. 88–92), Blake's work is an empathetic, if tough-minded recording of the artist's bohemian surroundings, possibly with ironic overtones, since the wartime rationing of basic consumer products continued in Britain into the 1950s.[4]

1930

INTERNATIONAL MODERNIST SCULPTURE: HENRY MOORE, BARBARA HEPWORTH, AND ROBERT ADAMS

In the 1930s, the sculptors Barbara Hepworth and Henry Moore, with the painter Ben Nicholson, were part of a small coterie of British Surrealist and abstract artists working in London. As the decade advanced, Moore's and Hepworth's Surrealist-derived curvilinear, allusive shapes of the early thirties became austere, spare geometric forms that sometimes appear totally nonrepresentational, although references to the world of nature persist in their abstract wood and stone carvings.

In a series of thematic exhibitions in London and in their polemical publications, which first appeared in 1934, this group of sculptors and painters proclaimed two new modernist directions in British sculpture and painting: geometric abstraction and Constructivism. In 1934, for example, they published a volume called *Unit One* that announced in its subtitle "the modern movement in English architecture, painting, and sculpture." That same year a group of artists including Hepworth, Moore, Paul Nash, Nicholson, and Edward Wadsworth exhibited together in a show of the same title at the

Mayor Gallery in London. Hepworth, Moore, and Nicholson were also among the artists who exhibited with the group Seven and Five, which held the first purely abstract exhibition in England at the Zwemmer Gallery in 1935. The following year, the New Burlington Galleries organized the exhibition *Abstract and Concrete*, in collaboration with the journal *Axis*, founded in 1935 as a quarterly review of abstract art, according to its subtitle. All these activities gained further impetus between 1935 and 1938 with the arrival in England of important émigré artists such as the Dutch Neo-Plastic painter Piet Mondrian, the Hungarian Constructivist László Moholy-Nagy, and the Russian Constructivist sculptor Naum Gabo. For instance, in 1937, *Circle: International Survey of Constructive Art*, a volume edited by Gabo and Nicholson, was published to promote international abstract art, architecture, and design.

The declaration of war in September 1939 scattered the critic Herbert Read's "nest of gentle artists". During the war Hepworth and Moore worked apart, and the shared international style of their prewar sculpture was replaced by more distinctly individualistic work. By the end of World War II, both had begun to receive widespread public attention at home, and their international reputations were made when Moore was selected to represent Britain in a one-person show at the 1948 Venice Biennale; Hepworth followed in 1950.

At the following biennial, in 1952, a new generation of sculptors caught in the uncertainties of the Cold War challenged the continued value of prewar modernist sculpture in a display entitled *New Aspects of British Sculpture*. Nonetheless, a standing figural sculpture by Moore was sited outside the entrance, partly to throw into relief the changes that had occurred in contemporary British sculpture, and partly to suggest continuity with the formal vitality of prewar modernist sculpture in Britain.

25

Henry Moore

1898–1986

Two Reclining Figures, 1928

Crayon and wash on wove paper, 8 3/4 x 9 3/16 (22.3 x 23.3)

H.M.F. 686

The Joel Starrels, Jr. Memorial Collection, 1974.247

his study of two reclining female nudes belongs to the period of the sculptor's first important public commission, *West Wind*, a monumental relief carving set into the central tower of the new headquarters of the Underground Railway (now London Transport) at St. James's Park Station.[1] Reluctant at first to accept the commission, Moore began a series of preparatory drawings that eventually filled an entire notebook (Henry Moore Foundation, Much Hadham, England), and also produced at least five independent unbound sheets. These studies "mark the beginning of Moore's total obsession with this motif," according to Alan Wilkinson, who has made an intensive study of the artist's drawings.[2]

In all, Moore produced more than one hundred sketches for the *West Wind* relief. If not actually one of these, the Smart Museum sheet is certainly in the style and of the period of the *West Wind* studies. The lower figure is characterized by the same quick jottings and numerous reworkings found in page after page of the notebook as Moore relentlessly sought the definitive form of the relief sculpture. In style and subject matter, this reclining figure is in the European tradition of the nude-bather theme, as seen in the work of Paul Cézanne and Auguste Renoir, both of whom Moore greatly admired. In contrast, the upper figure is an unabashed "modern" exploration of abstract, diagrammatic masses formed by groups of blocklike shapes. Alan Wilkinson points out that Moore's use of these angular forms is reminiscent of the 1912 remark by the early modernist sculptor Henri Gaudier-Brzeska, a member of the Vorticist movement in England immediately before the First World War: "I drew square boxes altering the size, one for each plane, and then suddenly by drawing a few lines between the boxes they can see the statue appear."[3]

The pose and organizational structure of the nude figure at the top of the sheet is close to several of the prone female figures found on the recto and verso of a large, single sheet, *Ideas for West Wind Relief* of 1928, in the Art Gallery of Ontario, Toronto (gift of Henry Moore).

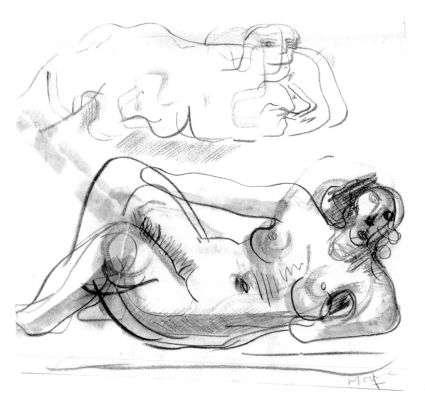

25

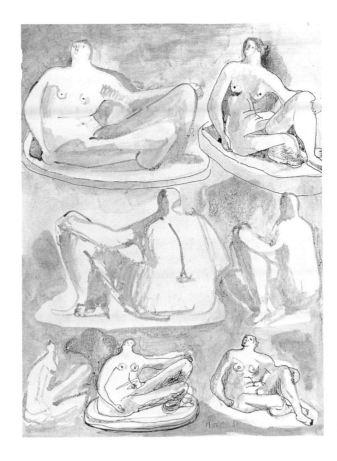

26

26
Henry Moore
1898–1986
Ideas for Sculpture: Seven Seated Figures, 1931
Pencil and pen and brush and ink on wove paper,
14 7/16 x 10 11/16
(36.7 x 27.2)
H.M.F. 865
The Joel Starrels, Jr. Memorial Collection, 1974.276

henry Moore produced drawings throughout his career, and he left nearly five thousand sheets at his death. These drawings cover a wide spectrum of subjects and types: life drawing from the model, ideas for sculptures, the form study of individual motifs, copies after the art of the Old Masters, and independent pictorial compositions. Some of the drawings are single sheets of paper; others were originally in bound notebooks, some of which have since been dispersed.[1] Moore's drawings have a special quality that distinguishes them from the drawings of painters and other graphic artists: the dominant distinguishing characteristic is the focus on the object in space.

The well-defined plinth on which the woman reclines clearly identifies this sheet as a study for a sculpture, although this drawing also has many of the qualities of Moore's highly accomplished life drawings of the nude model posed in the studio. 1931, the date of this work, was a pivotal year for the artist. 1929 and 1930 witnessed the completion of two stone reclining figures (L.H. 59 and 84) which culminated the dominant influence of pre-Columbian Mexican sculpture as the wellspring of his first mature style. In 1931, Moore carved the enigmatic blue Horton stone *Composition* (L.H. 99), with which the impact of Jean Arp, Alberto Giacometti, and Picasso, and Surrealism in general, is evident. The simple massive forms and bather-nude pose of the reclining woman in the Smart Museum drawing, however, have associations with Moore's stylistic and formal concerns of the previous decade.

The powerful, broad, expansive back of the figure, seen from behind, is an image that resurfaces years later in the sculptor's 1957 bronze *Seated Woman* (L.H. 435). Of this work, it has been written:

One of Moore's earliest and most important tactile sensations was, as a boy, rubbing his mother's back with liniment, to ease the pain of her rheumatism. Years later, Moore said that while working on the large original plaster for *Seated Woman* …"I found that I was unconsciously giving to its back the long-forgotten shape of the one I had so often rubbed as a boy."[2]

the Mother and Child theme is, with the reclining figure, a predominant subject for Henry Moore. His first exhibition in London in 1926 included a figure entitled *Maternity* and another work called *Mother and Child*. Earlier, on page 103 from the 1922–24 *No. 3 Notebook* (The Henry Moore Foundation, Much Hadham, England), Moore had made a drawing at the upper right of a mother and child in all likelihood copied after a Nootka wood carving from Vancouver Island, British Columbia, which he saw during a visit to the British Museum in London.[1] In 1981, the artist wrote of this carving and related Northwest Coast Native American works that the Mother and Child theme posed for the sculptor:

...the relationship of a large form to a small one, and the dependency of the small form on the larger. Its appeal lies particularly in its expression of two basic human experiences: to be a child and to be a parent. These mother-and-child figures are remarkable. There is a great feeling of maternal protectiveness but they are not at all sentimental.[2]

It may not be entirely coincidental that Moore's interest in the theme finds its first expression in the decade of his strongest receptiveness to ancient and tribal art. The Great Mother, the goddess of human fertility, is a recurring motif in the art of many of the ancient and non-Western cultures he was most interested in at the time.[3]

The compositional format of this 1933 drawing, with a large seated mother and child study filling most of the sheet and much smaller sketches of the same subject running down the left and right sides of the central motif, is closely related to other drawings by Moore from the same year. Such figure drawings exemplify one of Moore's methods for generating ideas for his sculpture, as described later by the artist:

Early in the morning I used to find one would start off with a definite idea, that, for instance, it was a seated figure I wanted to do. That in itself would lead to a lot of variations of the seated figure; you would give yourself a theme and then let the variations come, and choose those which seemed best.[4]

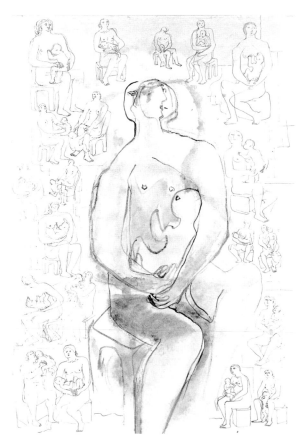

27

28

Henry Moore
1898–1986
*Reclining Figures: Ideas for
Sculpture*, 1939 (misdated
later by the artist 1942[1])
Pencil and pen and
ink on wove paper,
10 11/16 x 7 1/8 (27.1 x 18)
H.M.F. 1469
The Joel Starrels, Jr.
Memorial Collection,
1974.261

he drawings of 1939–40 are among the most richly inventive of all Moore's studies for sculpture. Although none of the sketches on this sheet can be related to existing sculptural projects of the late 1930s, the drawing is, nonetheless, an instructive example of the way in which Moore filled a page with a flood of ideas, frequently working new images on top of earlier pencil studies or reworking to a higher degree of finish in ink an underlying pencil sketch. Moore commented on drawings such as this one:

When my sculpture was mainly carving I would be having many more ideas than I was able to carry out, and I would get rid of ideas by drawing to prevent them from blocking each other up. Often I would make pages of drawings of ideas. On one sheet of paper there could be as many as thirty projects … all produced in a few hours.[2]

Despite the reworkings and crowding of images, a certain order prevails in the horizontal stacking of the reclining figures. At times, this is underscored by the suggestion of a groundline or setting that establishes a context for the individual figures, providing both a surface on which they rest and implying a spatial environment that enhances the fictive three-dimensional plasticity in these drawings of individual sculptural configurations.

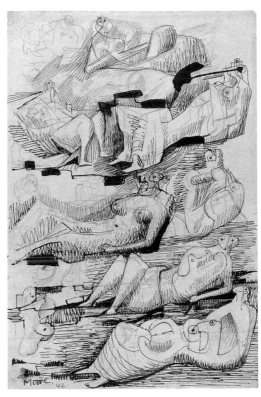

28

29

Henry Moore
1898–1986
*Ideas for Sculpture: Four
Studies of Reclining Figures,
One Half Figure*, 1949
Pencil, pen and ink, and
wash on wove paper,
15 7/16 x 10 3/4
(39.2 x 27.2)
H.M.F. 2542
The Joel Starrels, Jr.
Memorial Collection,
1974.248

his beautifully colored, highly worked drawing presents ideas for five reclining figures displaying varying degrees of abstraction. The motif at the left in the second tier from the top recalls the clay sketch-models of 1945–46 (see cat. no. 12). A reprise of the Surrealist-derived biomorphism of the mid- to late thirties, the organic conception is in marked contrast to the mechanistic, geometric forms of the other studies on the sheet, although these too have a precedent in the square form studies of 1935–36.

The insistence of the principal view shown in each of the motifs depicted on this sheet was one of the factors that led Moore away from drawn studies of sculptural ideas and to the fashioning of small clay or plaster models. By working in the round at the genesis of a piece, Moore felt he was better able to exploit the full potential of multiple views afforded by freestanding sculpture.

55

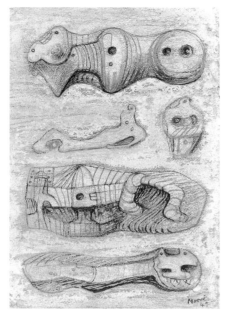

29

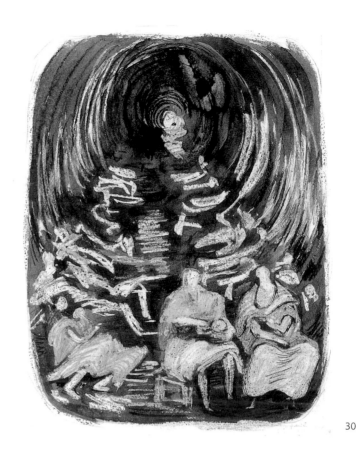

30

30

Henry Moore

1898–1986

Shelter Drawing, 1941

Pencil, crayon, charcoal,
and wash on wove paper,
14 13/16 x 10 7/8
(37.1 x 27.5)

H.M.F. 1776

The Joel Starrels, Jr.
Memorial Collection,
1974.249

between August 1940 and 1943, Moore was unable to make sculpture because of the uncertainty of daily life in wartime England and a shortage of suitable materials. He turned to drawing in the months following the declaration of war in 1939, and first encountered the subject of his Underground shelter drawings when he sought safety in a subway tube station in London during a bombing raid. He saw, as he said, "hundreds of Henry Moore Reclining Figures stretched out along the platforms" seeking there shelter from the air raid.[1] Moved by the scene, he began to fill a notebook with drawings of shelter life, not on the spot, but from memory when he returned home. Impressed by the resultant drawings, Kenneth Clark, Chairman of the War Artists' Committee, persuaded its members to commission ten of them. Moore in fact made forty or fifty, from which the Committee made a selection. Absorbed in the work for a whole year, the artist eventually produced about a hundred large independent sheets and filled two bound notebooks. Some were exhibited in the National Gallery in London in the early 1940s and became the first of Moore's works to be exposed to a much larger public than he had reached before. This exhibition also led to a certain degree of financial security, and Moore was able to give up teaching for a living.[2]

London Underground stations are quite similar, and Moore seldom differentiated among them in his shelter drawings. However, several shelters differed from the rest and particularly attracted his attention. For Moore, the most visually exciting of all was the unfinished tunnel of the Liverpool Street Extension, which he described: "no lines [of track had yet been laid], just a hole, no platform, and the tremendous perspective."[3] The Smart Museum shelter page is from a notebook and records two rows of figures sleeping on the tunnel floor against the deeply receding curved wall of the tunnel, motifs common to the Liverpool Street Extension *Tube Shelter Perspective* drawings of 1940–41. In addition, Moore has populated the foreground with three large and more precisely defined draped figures: a reclining/sleeping figure and two seated women. The central figure, who holds a swaddled child in her lap, hints at the artist's preoccupation with the Mother and Child theme in 1943–44, and in general the entire grouping prefigures the family group sculptures and drawings of the late 1940s and early 1950s (see cat. nos. 31–34).

31
Henry Moore
1898–1986
Two Studies for Family Groups, 1944
Pencil, crayon, and wash on laid paper, 7 1/16 x 8 15/16 (18 x 22.7)
H.M.F. 2211
The Joel Starrels, Jr. Memorial Collection, 1974.241

32
Henry Moore
Four Studies: Family Groups, 1944
Pencil, crayon, wash, and gouache on laid paper, 7 1/8 x 8 15/16 (17.9 x 22.7)
H.M.F. 2212
The Joel Starrels, Jr. Memorial Collection, 1974.242

detached from the same notebook, these two studies of family groups are related in subject matter to various sculptural projects undertaken by Moore towards the end of the war. All are the direct descendants of the many scenes of daily life encountered by the artist during the wartime Blitz over London and depicted in the shelter drawings of 1940–41 (see cat. no. 30), although the first of the wartime sculptures, the 1943–44 *Madonna and Child* (L.H. 226) in Horton stone made for the church of St. Matthew, Northampton, elevates the domestic image of a mother holding her child to a religious icon. Moore then turned to another subject suggested by the groups of two or three figures of his shelter sketches, in a series of fourteen terracotta models, all dating from 1944 and 1945, for a composition entitled *The Family*. One of these eventually served as the sketch-model for the large bronze *Family Group* (L.H. 226) of 1948–49, for the Barclay School.

The notebook sketches of family groups, maquettes, and full-scale sculptures of this period reintroduced into Moore's work a new humanist spirit suppressed in the abstract and Surrealist-derived work of the late thirties. In 1946, Moore commented on the significance of this new direction in his work:

I didn't think that either my shelter or coal-mine drawings would have a direct or obvious influence on my sculpture when I got back to it As a matter of fact the *Madonna and Child* for the Northampton and the later *Family Groups* actually have embodied these features. Still I sometimes wonder if both these and the wartime drawings were not perhaps a temporary resolution of that

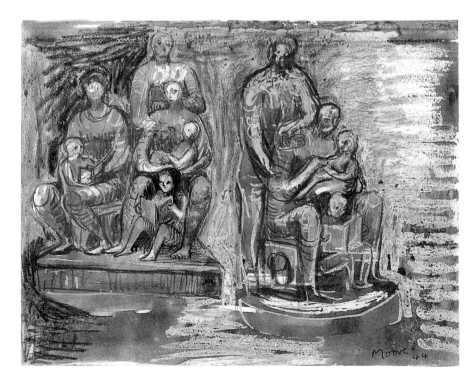

31

conflict which caused me those miserable first six months after I had left Masaccio behind in Florence and had once again come within the attraction of the archaic and primitive sculptures of the British Museum [in 1925].[1]

The two family group drawings, like the wartime *Shelter Drawing* (cat. no. 30), are realized in a drawing technique, combining wax crayons and a watercolor wash, discovered by the artist in the late 1930s, as he later related:

I hit upon this technique by accident, sometime before the war when doing a drawing to amuse a young niece of mine. I used some cheap wax crayons (which she had bought from Woolworth's) in combination with a wash of water-colour, and found, of course, that the water-colour did not "take" on the wax, but only on the background. I found also that if you use a light-coloured or even white wax crayon, then a dark depth of background can easily be produced by painting with dark water-colour over the whole sheet of paper. Afterwards you can draw with ink to give more definition to the forms. If the waxed surface is too greasy for the India ink to register it can be scraped down with a knife.[2]

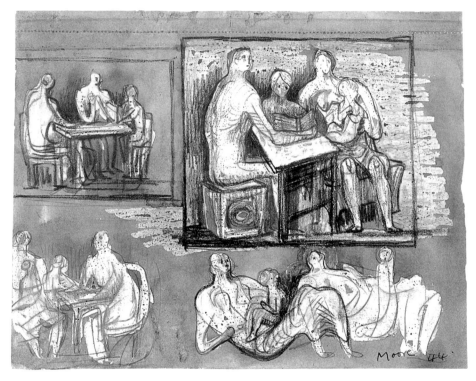

32

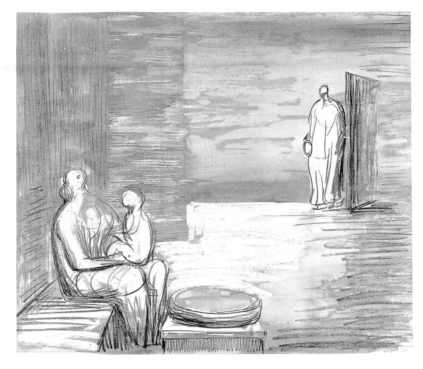

33

33

Henry Moore
1898–1986
*Mother and Child with
Figure in a Room*, 1948
Pencil, crayon, and wash
on wove paper,
19 1/2 x 22 9/16
(49.5 x 57.3)
H.M.F. 2483
The Joel Starrels, Jr.
Memorial Collection,
1974.256

the earliest drawings by Moore of the Mother and Child theme are six sheets dated between 1920 and 1924. Moore then virtually abandoned the motif for five years, until 1929 when he produced another set. Both of these sets of sketches coincide with events in the artist's life: two of his older sisters gave birth, one in 1924 and the other in 1929. In 1946, a daughter was born to Irina and Henry Moore. This event gave rise to another series of mother and child studies, which the artist explained "were chiefly made to try to understand more about the mother and child relationship, which has always been one of my favorite themes."[1] His drawings over the next four or five years were for the most part of a domestic nature, including, as in the Smart Museum drawing, women bathing a child.

This illusionistic scene exemplifies Moore's own definition of his pictorial compositions as "an imaginative drawing in which the whole drawing came together as an idea and which cannot be translated into sculpture."[2] The austere, cell-like room in which the figures move is used in a series of drawings done between 1948 and 1950, although this setting had first appeared in 1936 and in a number of drawings of sculptures in a room from 1937–39.[3] The pictorial set-up in the drawings of the late 1940s provides a stage upon which the individuals act, and serves as a spatial counterpart to the solid masses of the separate figures, but also establishes in the wax-resist washes a mysterious, enigmatic, even vaguely threatening atmosphere. One is reminded of the eerie and timeless plazas in the paintings of the Italian artist of the Scuola Metafisica, Giorgio de Chirico. Moore acknowledged his enthusiasm for de Chirico, whose metaphysical paintings had been exhibited in London in one-person shows in 1928 and 1931. Works by Moore were displayed next to de Chirico's in the 1936 *International Surrealist Exhibition* in London.

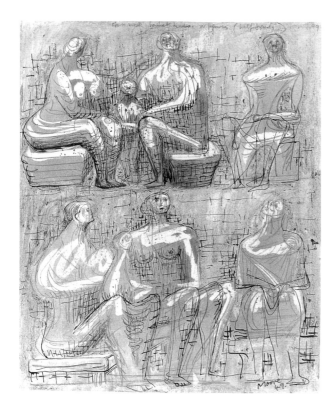

Henry Moore

1898–1986

*Studies for Family Groups
and Two Seated Figures,*

1949

Pencil, pen and ink, crayon,
and wash on wove paper,
11 3/8 x 9 5/16 (29 x 23.7)
H.M.F. 2471A
The Joel Starrels, Jr.
Memorial Collection,
1974.268

this drawing is not only exemplary of Moore's protracted engagement with the Mother and Child and Family Group themes in the second half of the 1940s, but also especially interesting because of the manner by which the figures are depicted. Although enlivened with washes of color, features have not been rendered in the traditional chiaroscuro method of tones and highlights to suggest the fall of light over three-dimensional forms. Instead, the surfaces of figures are given definition by a network of horizontal and vertical ink lines to suggest the swelling and recession of limbs, torso, and facial features. Moore first used this "sectional-line drawing" style (as he called it) in 1928:

Around the late 1920s, I found a personal way of describing three-dimensional form, using line, without light and shade. I let my pencil follow an image's horizontal section of the form I was drawing and then change direction, at right angles, to follow the vertical section. These "sectional lines" are a shorthand method of describing three-dimensional form.[1]

The reverse of the sheet contains Moore's notes on the function of space and mass in direct carving. These read in part:

Solid sculpture—carving—cutting down—starts with the surface but can eventually invade the block and make space The distance between forms, the spaces between forms must be as much a concern as the forms themselves, so that the forms and space become inseparable.

International Modernist Sculpture, 1930–1965

35
Henry Moore
1898–1986
Heads, 1939
Crayon, pen and ink, and
pastel wash on wove paper,
17 x 10 1/16 (43.2 x 25.6)
H.M.F. 1436
The Joel Starrels, Jr.
Memorial Collection,
1974.251

this study of heads is an important document relating to the first of the internal-and-external sculptures in 1939–40. The earliest hint of the "Internal and External" theme—where one form is enclosed within a hollow shell with an opening or openings through which the internal form is visible—in the work of Henry Moore is a two-piece wooden composition from 1934, *Two Forms* (L.H. 153).[1] Numerous influences and specific proto-types have been identified that reveal the wide-ranging interests of Moore and his ability to distill significant ideas from both the banal and the exotic: the "unique spatial sense, a bird-in-cage form" of New Ireland Oceanic ritual statues proposed by the artist;[2] myste-rious prehistoric Greek objects of unknown function;[3] the stringed-figure drawings of Naum Gabo;[4] and the stringed mathematical models seen by the artist in 1938 at the Science Museum in South Kensington, of which Moore remarked that the ability "to see through [the strings], see inside, see one form within another," was a formal possibility that excited him.[5]

As the designs move down the sheet from top to bottom, it is evident that the heads become more formally and spatially complex, eventually culminating in the "helmet head" motif at the lower left. The extreme left-hand head in the second row from the top brings to mind the series of eleven masks that Moore sculpted between 1927 and 1930 and the attendant related drawings.[6] Many of these sculptures reflect Moore's interest in pre-Columbian Mexican stone masks which the artist saw on frequent visits to the British Museum, and some of his own masks may have been inspired as well by a book he acquired in 1928, *L'Art Précolumbian* by Adolph Basler and Ernest Brummer.[7] The features of the mask in the Smart Museum drawing correspond to Moore's description of Mexican-influenced stone masks of the late 1920s: "In other masks, I used the asymmetrical princi-ple in which one eye is quite different from the other, and the mouth is at an angle bringing back the balance."[8]

The emphatic touches of color with which Moore highlights the helmet head of the Smart Museum drawing under-score the special interest the design elicited from the artist.[9] The helmet head idea may well have been suggested to the artist by two bronze prehistoric Greek implements or utensils in the National Museum in Athens, which Moore recorded in his *Page from Sketchbook*, a drawing from around 1937 (Private Collection) that copied plates 4 and 5 in Christian Zervos's *L'Art en Grece des temps préhistoriques au debout du XVIII siècle* (*Cahiers d'Art*, 1934).[10]

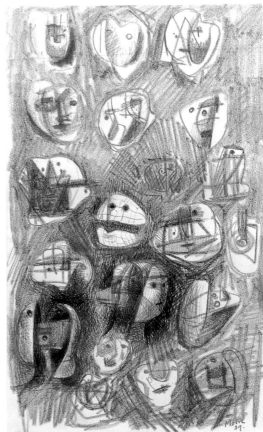

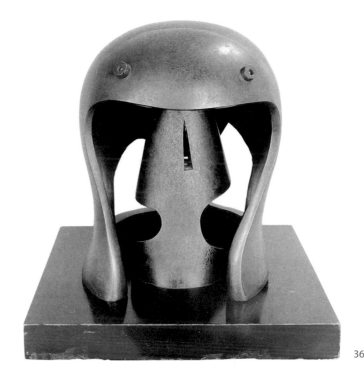

36

36
Henry Moore
1898–1986
Helmet Head No. 1, 1950
(lead original, bronze
edition 1960)
Cast bronze, ed. 8/9,
h. 12 1/2 (31.8)
Lund Humphries 279
The Joel Starrels, Jr.
Memorial Collection,
1974.190

moore first explored the "Internal and External" theme in sculpture with *The Helmet* of 1939–40 (L.H. 212) and returned to the idea in a sculptural series initiated a decade later with the original lead version of the Smart Museum bronze. In talking about these works, the artist referred to their conception as "one form being protected by another … the helmet is really a figure and the outside casing of it is like the armour by which it might be protected in battle."[1] The references to protection and military accouterment is reiterated in a reminiscence by the sculptor of the impression left on him by a visit to the Wallace Collection in London, where he saw suits of medieval European armor and realized how the hard carapace of the armor protected the vulnerable body of the man within. The original derivation of the helmet motif may have been from two enigmatic prehistoric Greek utensils in bronze of unknown function, but suggestive of a warrior's headgear (see cat. no. 35); they have the same two holes at the back as are encountered in the Smart Museum bronze helmet head.[2]

Despite the origins of the helmet head motif in military iconography, Moore transformed the formal device into a highly personal, associative idea, which he later likened, somewhat surprisingly, to other of his principal sculptural themes: "I suppose in my mind was also the mother and child idea, and the idea of birth and the child in the embryo. All these things are connected in this interior and exterior idea."[3]

Ultimately, *Helmet Head No. 1* and the other pieces in the series are behind the dome-like skull shape of the monumental outdoor sculpture *Nuclear Energy* (L.H. 526), the unique twelve-foot high cast bronze from 1964–65 commissioned by the University of Chicago, that marks the location of the first sustained nuclear chain reaction.

37
Henry Moore
1898–1986
Ideas for Sculpture:
Internal/External Forms,
1950
Pencil, crayon, wash, and
pastel wash on wove paper,
11 7/16 x 9 7/16 (29 x 23.9)
H.M.F. 2604
The Joel Starrels, Jr.
Memorial Collection,
1974.245

Oceanic art was the dominant tribal influence on Moore's sculpture and drawings of the 1930s. The earliest manifestation occurred in 1931 when the sculptor borrowed forms found in New Ireland sculpture in the British Museum, which, of all Oceanic tribal styles, had the greatest formal impact on his work in the thirties. For example, Moore's "Internal-External" theme originated in his fascination with wooden Malanggan cult statues of female figures enclosed in open-work cages.[1] The motif appeared first in several drawings made between 1935 and 1940, and reappears later in a group of four drawings executed in 1948–50, culminating in this sheet from 1950. In size, chroma, and facture, this work is very close to another internal-and-external study from that year, *Study for Sculpture: Internal/External Forms* (Private Collection); both depict three full-length internal-and-external studies above three or four similar forms that have been cut off at the bottom of the paper. Although the Smart Museum drawing did not lead to a final sculptural composition, other works from the series, including the 1948 *Ideas for Sculpture: Internal and External Forms* (1948, Smith College Museum of Art, Northampton, Massachusetts), anticipate the definitive bronze study of the first full-length figurative internal-and-external sculpture, the 1951 bronze *Working Model for Upright Internal and External Forms* (L.H. 295), based on a maquette of the same year (L.H. 294).[2] Other closely related sculptures of the period are the maquette and larger working model, *Upright Internal/External Form: Flower* (L.H. 293b) and *Working Model for Reclining Figure (Internal and External Forms)* (L.H. 298, cat. no. 38), both from 1951.

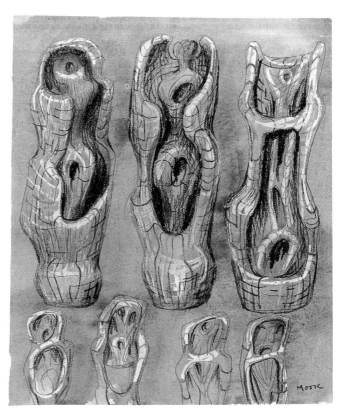

37

38

Henry Moore
1898 1986
Working Model for Reclining Figure (Internal and External Forms), 1951
Cast bronze, ed. of 9,
h. 13 3/4 (34.9), l. 21 (53.4)
Lund Humphries 298
The Mary and Earle Ludgin Collection, 1985.101

in the mid-1940s, Moore firmly established a working method in the creation of a sculpture that continued until his death. In addition to, and increasingly in place of, a preparatory drawing, he fashioned a small working three-dimensional model, which he termed a "sketch-model" before the final full-scale carving or cast bronze. Beginning in the 1950s, when the sculptor decided to enlarge the concept of a hand-held maquette to monumental size, he might first produce an intermediate or working sculpted model. In most cases this is three to five times the maquette size, but usually it is not more than forty-eight inches in length (for a reclining figure sculpture). The working model allowed Moore to make adjustments in the original design to accommodate the increased scale. The process culminated in the full-scale finished piece, which is most often about four times the size of the working model.[1] The Smart Museum reclining figure is an early example of one of the working models, a quarter in length of the final bronze version.

In the four years after *Helmet Head No. 1* (cat. no. 36), Moore made versions in different sizes of a standing figure and a reclining figure based on the "Internal and External" theme. This 1951 working model was eventually cast as a full-sized, monumental bronze in 1952–54 (L.H. 299). In the final version the internal element was eliminated, leaving an empty shell. Moore subsequently made several minor works with internal-and-external forms and one major piece, the *Reclining Mother and Child* of 1960–61 (L.H. 480).

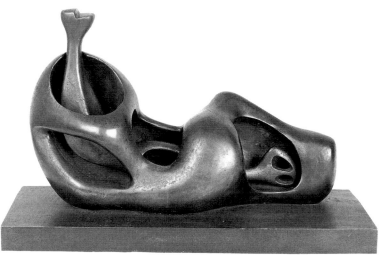

38

39

Henry Moore
1898–1986
Two Figures in a Landscape, 1950
Pencil, pen and ink, crayon, and wash on wove paper,
9 5/8 x 9 (24.4 x 22.8)
H.M.F. 2647
The Joel Starrels, Jr. Memorial Collection, 1974.252

drawings that serve as studies for sculpture or as an aid in generating ideas for sculptures appear less frequently in Moore's oeuvre in the 1950s. At this time his working method changed. Now he might start with the actual physical arrangement of real objects from nature: bones, pebbles, and pieces of driftwood, for example, which he collected and stored in his studio. He also modeled small sketches in clay or carved hand-sized pieces of dried plaster. This drawing is not, then, a study of the type that had dominated the artist's graphic production since the late twenties. Although one can see a placement of recognizable forms—a standing figure to the left and a reclining figure to the right—within an imaginary landscape, the sheet functions mainly as a liberating force, an exercise in draftsmanship that Moore practiced with no declared functional application or sculptural purpose in mind. As he stated: "I sometimes draw just for its own enjoyment."[1]

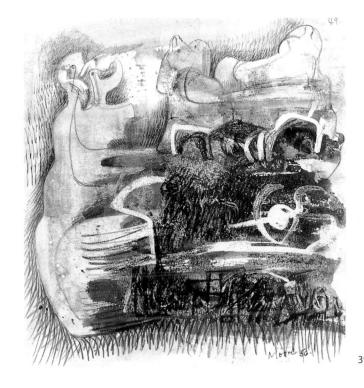

39

Henry Moore
1898–1986
Seated Figure, 1951
Pencil, crayon, gouache,
and wash on wove paper,
11 3/8 x 9 1/4 (28.9 x 23.5)
H.M.F. 2672
The Joel Starrels, Jr.
Memorial Collection,
1974.244

40

among the family studies and scenes of domestic life in his drawings from around 1948, Moore occasionally simplified the setting to an indeterminate wash ground and reduced the composition to a single seated man or woman. In writing on the principles of carving the human form, Moore listed three fundamental positions: standing, sitting, and reclining. Of the three, he felt that the reclining figure offered the most freedom, compositionally and spatially, and expressed reservations about the seated figure because of the need for a pedestal on which to set the body. This drawing was made at a time when the sculptor was preoccupied with the family group sculptures and drawings, and it may show Moore working out a certain pose or attitude unencumbered by the other elements of a more ambitious, multi-figured composition. The richness of the application of wash and wax-resist, on the other hand, argues against such an interpretation as a study rather than an independent drawing.

Beginning with the drawings of 1936–37, Moore used color as an independent expressive element within his sculptural studies and complex pictorial compositions. This sheet bears testimony to his accomplished and sensitive use of color.

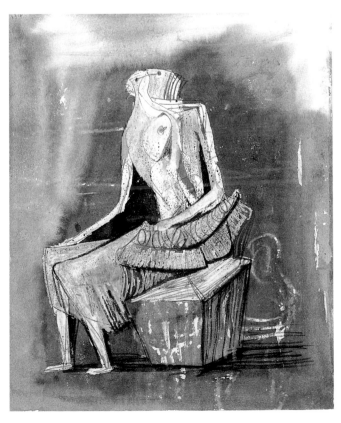

40

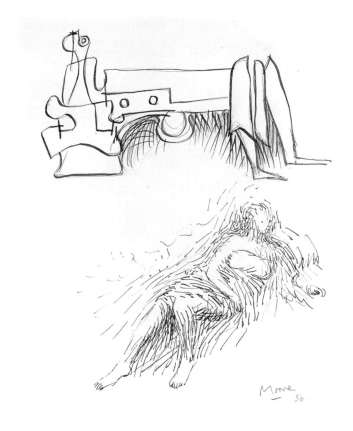

41

41

Henry Moore

1898–1986

Studies for Two Reclining Figures, 1956

Pencil and pen and ink on wove paper, 10 3/8 x 8 3/4 (26.4 x 22.3)

H.M.F. 2909

The Joel Starrels, Jr. Memorial Collection, 1974.253

In manner and mood this drawing is comparable to a series of female nudes that Moore drew from life in 1954. As far as is known, he had executed no life drawings since 1935, but in 1954, Moore hired a female model and made a series of life studies at Swan Court, Hampstead, in the apartment of Peter Gregory where he was studying. Of the thirteen known drawings, only one was of a reclining figure. Moore later remarked on the extremely pretty model who posed for these works: "I couldn't ignore this prettiness—I couldn't make these drawings detached."[1]

The lower of the two reclining figures in the Smart Museum sheet belongs stylistically to what may be called Moore's neo-classical period of the 1950s. The return to naturalism and the diaphanous quality of the drapery appear in a number of sculptures from 1953 to 1958, following the artist's first visit to Greece in 1951 on the occasion of the British Council's touring exhibition of his work. This drawing is particularly related to the large bronze *Draped Reclining Woman* of 1957–58 (L.H. 431), with which this series ends.[2] Moore commented on the use of drapery:

Drapery played a very important part in the shelter drawings I made in 1940 and 1941 [see cat. no. 30] and what I began to learn then about its function as form gave me the intention, sometime or other, to use drapery in sculpture in a more realistic way.... And my first visit to Greece in 1951 perhaps helped to strengthen this intention.[3]

The Smart Museum drawing demonstrates how Moore was able to work in different styles concurrently, a phenomenon encountered in other modern masters, such as his contemporary, the sculptor Jacob Epstein, and most well-known in the work of Pablo Picasso.

42
Henry Moore
1898–1986
Draped Seated Figure:
Headless, 1961
Cast bronze, ed. 5/9,
h. 7 3/4 (19.7)
Lund Humphries 485
The Joel Starrels, Jr.
Memorial Collection,
1974.204

I n 1946, Moore spoke of the conflict he felt after his 1925 trip to Italy, where he was able to study firsthand the monuments of the classical past and the Renaissance, and his discovery of the rich traditions of non-Western art of ancient and tribal cultures in the British Museum on his return to London. He remarked as well on the resolution of this conflict in his wartime shelter and coal-mine drawings.

His first visit to Greece in 1951 ushered in a return to a new naturalism, manifested first in the wartime drawings. He achieved this in part by the exploration of the function of classical drapery in Greek art of the fifth century B.C.E. Stimulated by the trip to Greece, Moore once again found sources of inspiration in the collections of British Museum. In 1960, the year of the plaster model for this bronze, the artist stated: "It is only perhaps in the last ten or fifteen years that I began to know how wonderful the Elgin marbles are."[1] This little sculpture is somewhat reminiscent of the fragmentary seated figures originally located on the east and west pediments of the Parthenon and since the early nineteenth century on view in the British Museum.[2] Reminiscent of a fragment of a draped torso from antiquity, this bronze also belongs unequivocally to the modernist tradition established by Auguste Rodin, who considered fragmented torsos and isolated arms, hands, and feet as finished, complete works of art, capable of conveying in the part the emotion and meaning of the whole.

The original plaster is in the Art Gallery of Ontario, Toronto (gift of Henry Moore). In the bronze version, the seated headless figure was mounted on a high bronze base, an allusion possibly to ancient Greek and Roman cult statues and votive figures that were similarly mounted.

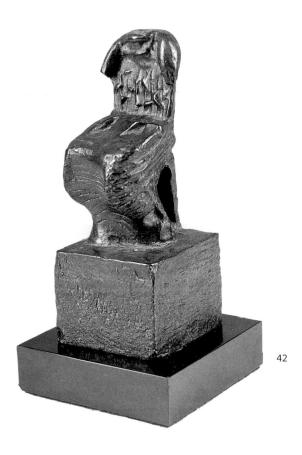

42

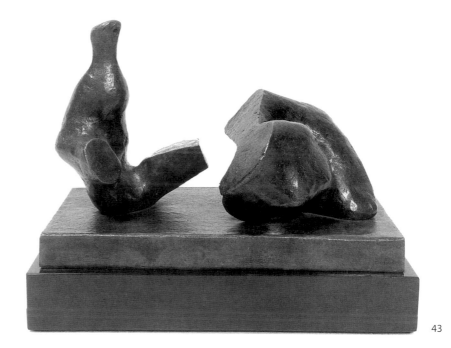

43
Henry Moore
1898–1986
Two-Piece Reclining Figure:
Maquette No. 3, 1961
Cast bronze, ed. 5/9,
h. 5 5/8 (14.3), l. 7 3/4 (19.7)
Lund Humphries 475
The Joel Starrels, Jr.
Memorial Collection,
1974.205

f*our-Piece Composition* (cat. no. 9), together with other two-, three-, and four-part sculptures in wood, stone, and bronze of the 1930s, had far reaching implications for later developments in Moore's art. The divided figure motif reappears twenty-five years later in 1959, when Moore made the first of what, over the next decade, became a series of divided reclining figures. The group explored the role of forms in opposition (in two-piece works like this one) and of forms in series (in the later pieces which added a third element). The asymmetry and contrappostal interplay of the parts of the body are the direct descendants of his experiments and discoveries of the 1930s.

The multi-piece sculptures of the 1950s and 1960s set a new direction in the artist's exploration of the theme of the reclining figure as a metaphor of natural, earth-bound forces. Where previously the reclining figure was viewed as a landscape, the sculptor now established the idea of the landscape as figure. In the 1930s, the individual elements were smooth, highly reductive, and generally curvilinear. In later works such as this bronze the separate pieces have the appearance of rocks and stony outcroppings, in accordance with Moore's conception of the two-piece sculptures around 1960:

I realized what an advantage a separated two-piece composition could have in relating figures to landscapes. Knees and breasts are mountains. Once these two parts become separated you don't expect it to be a naturalistic figure; therefore, you can justifiably make it like a landscape or a rock.[1]

The sources of inspiration for the individual elements found in this significant series reveal much about Moore's method of assimilating diverse visual cues. These include: a specific rock outcropping seen by Moore at about age ten; the remembrance of a coastal rock depicted in a painting by Georges Seurat formerly in the collection of Moore's friend, Lord Kenneth Clark (Tate Gallery, London); the recollection of Claude Monet's canvas *Cliff at Etretât;*[2] and flints and animal bones collected by the artist to form a handy repository of the organic shapes of the natural world.

44
Henry Moore
1898–1986
Slow Form: Tortoise, 1962
Cast bronze, ed. 2/9,
h. 4 1/4 (10.8), l. 7 1/2 (19.1)
Lund Humphries 502
The Joel Starrels, Jr.
Memorial Collection,
1974.203

this is the maquette for the intermediate-size working model entitled *Large Slow Form: Tortoise* of 1962–68 (L.H. 502a). Moore explained how the interlocking forms fit together: "It is one right-angled form, repeated five times, and arranged together to make an organic composition. This repeated slow right-angle reminded me of the action of a tortoise."[1] The compositional structure of the bronze is based on a lifetime of inquiry into the rhythmic forces of the world of nature, including the structure of bones and shells.

Moore's imagery is founded primarily in the human figure, and whenever he departed from this starting point, as in a few animal motifs such as this, he explored affinities or analogies with the human figure. The counterbalance, measured sweep, horizontality, and sense of "head" and "foot" of this bronze recall contemporaneous reclining figures, which the artist identified with the repose and stasis of a mountainous landscape.

The plaster model for this piece is in the collection of the Art Gallery of Ontario, Toronto (gift of Henry Moore).

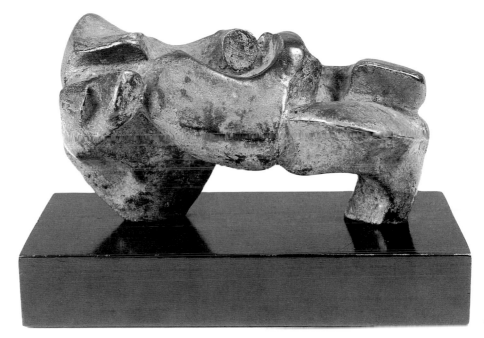

44

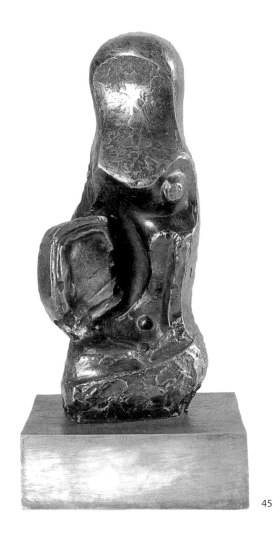

45

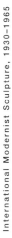
45

Henry Moore

1898–1986

Mother and Child: Round Head, 1963

Cast bronze, ed. 1/6,
h. 11 (27.9)

Lund Humphries 512

The Joel Starrels, Jr.
Memorial Collection,
1974.186

the abstracted vision of maternity of this bronze continues the Mother and Child theme that first entered into Moore's preferred thematic repertoire in the 1920s. The original plaster was based on organic forms, in a cast of one of the *objets trouvés* Moore collected. As was the case with other sculptures in the early 1960s, he would select one of his bones, flints, or shells and take a plaster cast from it. Then he would alter the plaster cast, adding to the work with more plaster or carving it when dry until the shape became integrated into the sculpture.[1]

The excavation of the central region of the torso of the upright mother, the hollowing out of the entire body of the child held in the mother's lap, and the placement of the child in the torso/cavity of the woman identify a second tradition within the artist's oeuvre, that of the "Internal and External" theme. Specifically, the sculpture reprises formal issues raised in the full-figure internal-external sculptures of the early to middle 1950s, as exemplified in the 1951 bronze *Working Model for Reclining Figure (Internal and External Forms)* (cat. no. 38). As the *Reclining Figure* sculpture demonstrates, Moore used the "Internal and External" theme as both a formal invention and as an associative device that he successfully appropriated to other subjects.

The original plaster is in The Henry Moore Foundation, Much Hadham, England (gift of the artist).

46
Henry Moore
1898–1986
*Upright Motive: Maquette
No. 4,* 1955
Cast bronze, ed. of 9,
h. 11 3/8 (28.9)
Lund Humphries 381
The Joel Starrels, Jr.
Memorial Collection,
1974.200

47
Henry Moore
*Upright Motive: Maquette
No. 5,* 1955
Cast bronze, ed. of 9,
h. 11 (27.9)
Lund Humphries 382
The Joel Starrels, Jr.
Memorial Collection,
1974.199

48
Henry Moore
*Upright Motive: Maquette
No. 8,* 1955
Cast bronze, ed. of 9,
h. 11 3/4 (29.8)
Lund Humphries 387
The Joel Starrels, Jr.
Memorial Collection,
1974.201

n 1954, Moore was asked to do a sculpture for the courtyard of the new Olivetti office building in Milan.[1] The architect and the sculptor agreed on a vertical sculpture, which would provide a contrasting "upright rhythm" to the horizontal structure. The decision rested in part on Moore's response to a particular feature of the site, a lone Lombardy poplar tree growing behind the building. As an aid in finalizing the commission, the artist fashioned thirteen small models in 1955, each between nine and twelve inches in height of which these are three. Engrossed in the project, Moore independently executed a number of them at full size, between eight and twelve feet high. *Upright Motive: Maquette No. 5* and *No. 8* were scaled to monumental size and cast in bronze. *No. 4* was never enlarged beyond the maquette.

If the original inspiration for the vertical format was Moore's response to the specific site of the commission, the project was also influenced by Moore's interest in so-called primitive art, with at least one direct borrowing from an Eskimo carved ivory drum handle in the British Museum, London.[2] In connection with those works, Moore also mentioned Northwest Coast Native American totem poles, with their balancing of different motifs one above the other in the construction of a unified history of the particular clan honored by the commemorative carving.[3] The reference is formal only, for Moore intended neither the narrative implications nor the cultic associations of this art form. It is also a possibility that Moore was also thinking of Leon Underwood's *Totem to the Artist,* 1925–30 (Tate Gallery, London), a wooden carving by Moore's teacher and fellow vanguard sculptor in the 1920s and early 1930s.[4]

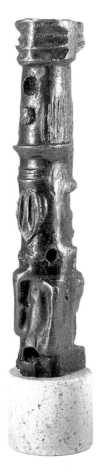

46

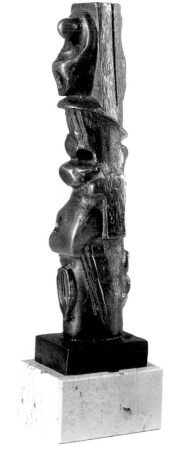

47

In the end, the vertical stacking of elements in these works is perhaps more the product of the artist's method of working after World War II. Increasingly, he gave up drawings of proposed sculptures in favor of the actual fashioning of small, three-dimensional models in clay or plaster, so that he could experience through the process the entire structure of the piece and not simply the front, back, or side views afforded in a drawing. Unlike the Native American totem pole, where the many individual animal and human shapes are distinctive and orderly, stacked one on top of the other, the upright motive sculptures are more compositionally unified. In the words of the sculptor, they "gained more unity . . . became more organic,"[5] as forms were piled one on top of another and inextricably linked to yield a composition made up of the seminal forms of nature: ridges, swellings, holes, depressions, and protrusions.

The original plasters for the three Smart Museum bronzes are in the Art Gallery of Ontario, Toronto (gift of Henry Moore). Two plaster versions of *Maquette No. 5* exist: the one from which the Smart Museum maquette was cast in bronze is the definitive study for the monumental *Upright Motive No. 5*; the other plaster is a variant which was never cast.[6]

48

49

Barbara Hepworth

1903–1975

Curved Form (Wave II), 1959
Painted cast bronze with
steel rods, ed. 6/7,
h. 15 3/4 (40), l. 18 (45.7)
Hodin 264
The Joel Starrels, Jr.
Memorial Collection,
1974.195

n the 1930s, Barbara Hepworth and Henry Moore were the leading abstract sculptors in England. Both were committed to direct carving and the tenets of "truth to material" and "significant form", concepts that had been much discussed and then fervently embraced by the new generation of British sculptors who had emerged from art school in the previous decade. The style of Hepworth's wood and stone carvings decisively shifted around 1930, from a primitivism inspired by tribal and ancient art to a curvilinear biomorphism indebted to contemporary French Surrealism. After the middle of the decade her work became increasingly austere and geometric. Despite their close friendship and shared goals during this period, the art of Moore and Hepworth diverged in expression. Whereas Moore based his sculpture on the human figure, Hepworth's spare forms refer to nature more obliquely. The shapes of Hepworth's sculptures were, she felt, the embodiments of a sensory experience of nature, her intuitive, expressive response to the experience of moving through the landscape.

In 1943, Hepworth carved *Wave* (Tate Gallery, London), an abstract wood piece incorporating painted color and strings in its concave interior, that made direct references to the landscape and sea of Cornwall, where she and her family had relocated at the beginning of the war. Hepworth commented on the kinesthetic experience this and related sculptures had for her:

"I used colour and strings in many carvings of this time. The colour in the concavities plunged me into the depth of water, caves, or shadows deeper than the carved concavities themselves. The strings were the tensions I felt between myself and the sea, the wind or the hills.[1]

Stimulated by three-dimensional mathematical models, Moore had begun to thread strings across the pockets of space in his abstract sculptures in 1937, around a year before Hepworth's first stringed carvings. However, Hepworth's appropriation of the technique may have been independent of Moore's example because of her own previous interest in these scientific sculptures. This concern was reinforced by the arrival of Naum Gabo in London in 1936, whose constructions at the time were also explorations of the sculptural potential of these scientific models. The two had first met the previous year, when Gabo briefly visited London.[2] Her *Wave*, for example, is reminiscent of the mathematical model of a "Cubic with an A3 double point" in the elliptical pocket of space defined by a swollen curving plane. In Hepworth's stringed sculptures, the cavities are larger and more spatially complex than the simple holes in her carvings of the 1930s, and the strings set up a linear tension in this region of the sculpture so that the voids become equal in importance to the encompassing, increasingly complex solid masses. The surfaces of the mathematical models she admired were left the color of the plaster, and Hepworth's painting of the interiors of her own pieces was a formal device inspired by the paintings and painted reliefs of her husband and leading British Constructivist, Ben Nicholson.[3] This coloration played inside forms against outside contours, and the selective use of color helped make the shapes of the hollows more perceivable.

Beginning in 1956 Hepworth worked in metal: first cut sections of sheet-metal and then bronze, whose models had been directly carved in hardened dental plaster, rather than modeled in clay, wax, or soft plaster. Executed three years later, *Curved Form (Wave II)*, as its title indicates, is a refashioning of her earlier carving in wood. While the overall configuration is retained, forms are a bit thicker, noticeably in the lower arc of the curve, the interior surface of the concavity is now lightly textured rather than smooth, and the many thin strings in the wooden version have been replaced by fewer metal rods. She retained the critical element of the colored interior, but the hue is now a mottled white and green rather than the original pale blue, perhaps a coloristic adjustment to the dark green patina of the outer surfaces. Although some critics have seen such bronze "reproductions" of earlier carvings in stone or wood as problematic for a sculptor who espoused the principle of "truth to materials" since the 1930s, the subtle changes in shape and color in the Smart Museum bronze are understandable as artistic shifts to accommodate the specific properties of the new material.[4]

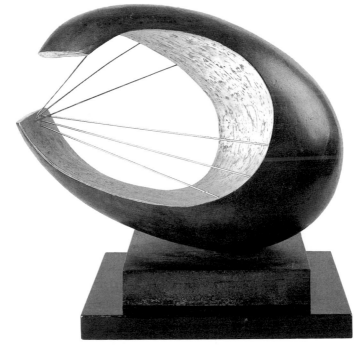

49

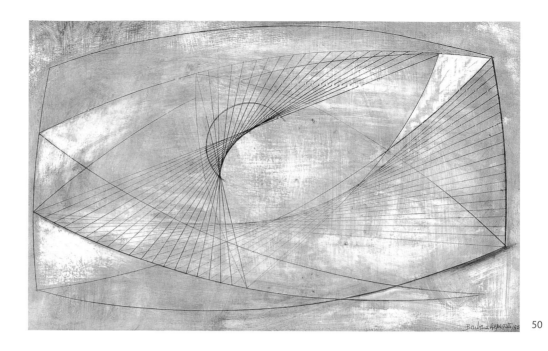

50

Barbara Hepworth

1903–1975

Pierced Forms, 1959

Pencil and enamel on
masonite board,
13 1/2 x 21 1/2 (34.4 x 54.6)
The Joel Starrels, Jr.
Memorial Collection,
1974.277

the drawings Hepworth produced in the 1920s and 1930s are the byproduct of her work as a sculptor, and they include life studies from the model and sketchy ideas for new sculptures. With the outbreak of war in September 1939, she and Ben Nicholson and their three children left London for the safety of Carbis Bay near St. Ives on the coast of Cornwall. Two weeks later Miriam and Naum Gabo joined them there. Hepworth was not able to carve again for several years and the only sculptures done until 1943 were small plaster maquettes. Instead, she turned to drawing:

In the late evenings, and during the night I did innumerable drawings in gouache and pencil—all of them abstract, and all of them my own way of exploring the particular tensions and relationships of form and colour which were to occupy me in sculpture during the later years of the war.[1]

These drawings of 1940–42 were accompanied by painted plaster sculptures, and their significance as a group lies in Hepworth's exploration of ideas about space and rhythm that were to be brought into the language of her sculpture in the immediately succeeding years.

Hepworth continued to draw abstractions after the war but also produced a group of figure drawings and a major series of hospital studies. The artist herself recognized the mutual influence and interrelationships of the figurative and abstract drawings. In the mid-fifties, drawing became a less important activity as the sculptor was engaged in a group of wood carvings that were her responses to a journey to Greece in 1954.

When Hepworth began to explore new sculptural techniques involving bent sheet-metal in 1956 and cast bronzes the next year, she once again turned to drawing as a liberating force for new approaches to sculptural forms and spatial relationships. The unprecedented freedom of the 1957 drawings, in which Hepworth searched for forms natural to the metal media, was quickly absorbed into a general drawing style that was now altogether more painterly. This is evident in the scumbled oil paint surfaces of *Pierced Forms* that make rich and variegated textures on which accents of stronger colors and thicker paint are applied. At the same time, the tightness and precision of the pencil line evoke sculptural forms first released in the 1940–42 drawings. Hepworth's description of the sig-

nificance of her abstract drawings of the late 1940s to her work in general is revealing as well of her attitude toward those made a decade later.

Abstract drawing has always been for me a particularly exciting adventure. First there is one's mood; then the surface takes one's mood in colour and texture; then a line or curve which, made with a pencil on the hard surface of many coats of oil or gouaches, has a particular kind of "bite" rather like on slate; then one is lost in a new world of a thousand possibilities because the next line in association with the first will have a compulsion about it which will carry one forward into completely unknown territory. . . . Suddenly before one's eyes is a new form which, from the sculptor's point of view, free as it is from the problems of solid material, can be deepened or extended, twisted or flattened, tightened and hardened according to one's will, as one imbues it with its own special life.[2]

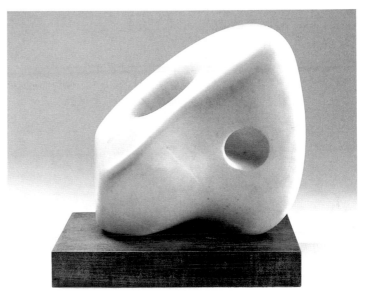

51

51
Barbara Hepworth
1903–1975
Landscape Figure, 1959
Carved alabaster,
h. 10 3/4 (27.3),
l. 9 1/2 (24.1)
Hodin 255
The Joel Starrels, Jr.
Memorial Collection,
1974.143

there is a retrospective feeling to some of Hepworth's carvings in stone made in the period immediately after the technical and formal innovations of the open, linear metal sculptures of 1956–58. In this alabaster and the marble *Holed Stone* (Art Gallery of Ontario, Toronto), both from 1959, one is reminded of the compact solidity of the pierced stone carvings of the second half of the 1930s. But the forms are more curvilinear and organic than the geometrical cones, hemispheres, and polyhedrons of the mid- to late thirties, and are closer in style to the biomorphic carvings begun after the war.

In August 1954, Hepworth made a trip to Greece, the Aegean, and the Cycladic Islands, and on her return to St. Ives she produced a remarkable group of wood sculptures with Greek titles that reflected the profound impact of the landscape and architecture of Greece. The Greek experience resurfaces periodically about a decade later in several carvings, including *Landscape Figure*, which is formally similar to *Curved Form (Patmos)* (Art Gallery of Ontario, Toronto) from 1960, even in the piercing of the stone matrix with two different sized holes. The title of the Smart Museum carving underscores the allusive references in both works to the sculptor's kinesthetic experience of the Greek landscape.[1] It also is a reaffirmation of a central theme in Hepworth's work, of the Figure in a Landscape, in which the artist can be the spectator or the object. As she said: "I was the figure in the landscape and every sculpture contained to a greater or lesser degree the ever-changing forms and contours embodying my own response to a given position in that landscape."[2]

Barbara Hepworth
1903–1975
Serene Head (Thea), 1959
Polished cast bronze,
ed. of 7, h. 13 1/4 (33.7)
Hodin 269
The Joel Starrels, Jr.
Memorial Collection,
1974.142

t he human head had been the subject of several Hepworth sculptures of the 1940s, such as *Two Heads (Janus)* (Hirshhorn Museum and Sculpture Garden, Smithsonian Institution, Washington, D.C.) and *The Crosdon Head* (Birmingham Museums and Art Galleries, England). In each of these, the eye appears, as in this head from a decade later, as a shallow circular depression. The head of another abstract bronze from 1959 called *Reclining Form (Trewyn)* (B.H. 262) is defined by the same motif with the addition of three bladelike incisions that are like the single mark to the left of the eye on the Smart Museum bronze. In this work Hepworth invests the image of a reclining figure with features of the landscape (as the title suggests). *Serene Head (Thea)* also appears to link human features with references to nature. The contours of the head, when viewed from the front, are remarkably like those (in reverse) in a bronze from 1961 titled *Single Form (Chûn Quoit)* (B.H. 311). The eye motif is also retained, but is now an incised circle. The flat, curved shape of *Single Form* has been related to the monolithic stones (quoits) of a neolithic tomb in Chûn Quoit located in west Cornwall.[1]

Hepworth had used Greek names and classical references in some sculptures of the 1940s, and again in the carvings made after her memorable trip to Greece and the Aegean islands in 1954, and occasionally in the 1960s (see cat. no. 51). The title of this piece refers to Thea, the chaste companion of the hunter Artemis. After being raped and bearing a daughter, Thea was protected from the wrath of her father by the sea god Poseidon, who transformed her into the constellation of the Horse.

The genesis of *Serene Head (Thea)*, then, is complex, and the references in its shape to the prehistory of Cornwall and in its title to Greek mythology imbue this sculpture with archetypal meaning.

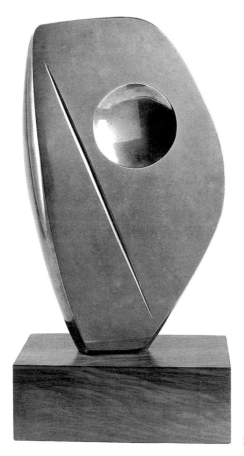

52

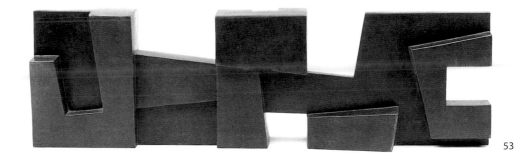

53
Robert Adams
Born 1917
Maquette for Architectural
Screen, 1956
Cast bronze, ed. of 6,
h. 9 (22.9), l. 29 (73.7)
Grieve 184
The Joel Starrels, Jr.
Memorial Collection,
1974.164

obert Adams was one of eight sculptors included in the landmark exhibition in the British Pavilion of the 1952 Venice Biennale, *New Aspects of British Sculpture*, that heralded, according to one of the co-organizers, Herbert Read, a new British sculpture collectively expressive of the mood of anxiety and despair of the postwar period in Europe and the uncertainty of the Cold War. Adams's work, however, was much closer in aesthetic expression to that of Barbara Hepworth than any of the younger generation of sculptors represented in the exhibition.

This bronze was produced during a relatively brief period in Adams's career, in 1953–56, in which he created a number of architectonic pieces that form his *Rectangular Forms* series. It is constructed along a central plane, with roughly rectangular and V-shaped blocks built out on either side, and cut away in places with quadrilateral openings. Non-systematic in its design, *Maquette for Architectural Screen* was fashioned by the intuitive placement of these angular shapes which bear clear signs of their shaping by hand (in the original model from which the piece was cast). The harmony Adams strove for in such works is dynamic, and asymmetry and irregularity are of fundamental importance. The clarity and discipline of the piece results from an order based on the artist's observation of formal relationships in nature. Although the world of nature is the stimulus, the sculpture is not tied to any figurative or representational allusions.

Adams was given the chance to realize the Smart Museum maquette on a monumental scale the next year when he received the commission for a mural relief in reinforced concrete for the façade of the Municipal Theatre at Gelsenkirchen in Germany (Grieve 220). The proportions of the building meant that the relief needed to be nearly twice as long as the maquette, and Adams translated his screen into a wall in relief by splaying both its sides over the entire length.[1]

Already in 1956, Adams's interest in the architectonic potential of his sculptural work was apparent at the collaborative project by Group Ten—consisting of Adams, the structural engineer Frank Newby, and the architects Peter Carter and Colin St. John Wilson—in the historic *This Is Tomorrow* exhibition, organized by the Institute of Contemporary Arts and presented at the Whitechapel Art Gallery, London. The idea for Group Ten's display came from Colin St. John Wilson, who envisioned a walk-through environment, and Adams devised the initial form of the whole exhibit as a maquette. The result was a sculptural architecture of curved walls articulated by rectilinear blocks, cylinders, and a circular void, and at the end of the passage formed by the walls was a freestanding object made by Adams out of concave aluminum sheets that was neither strictly sculpture nor architecture.[2]

1950

POSTWAR BRITISH SCULPTURE AND THE 1952 VENICE BIENNALE: THE "ICONOGRAPHY OF FEAR"

In 1952, a new generation of young British sculptors, all of whom had matured after World War II, represented the vanguard of sculpture in Great Britain at the Venice Biennale. As a group, their work was very different from that of Barbara Hepworth, Henry Moore, and other abstract sculptors active in Britain in the interwar period. This show, entitled *New Aspects of British Sculpture*, became synonymous with British sculpture of the period. The eight artists included were Robert Adams, Kenneth Armitage, Reg Butler, Lynn Chadwick, Geoffrey Clarke, Bernard Meadows, Eduardo Paolozzi, and William Turnbull. The selection had been made by Herbert Read, respected critic and director of the Institute of Contemporary Arts in London. Although Read's intention was not to present these artists as a united movement, he perceived a collective existentialist anxiety, which mirrored the physical suffering and mental stress of the postwar period and the Cold War in Europe.

In the introduction to the catalogue, Read characterized the unifying factors he saw in the artists

in the show: "They are individuals participating in a general revival of the art of sculpture, and they are related to each other only by some obscure instinct which has touched them all to life." Although he admitted their debt to an older generation of sculptors, such as Alexander Calder and Alberto Giacometti, he described this debt "only in the sense that these artists . . . have put at their disposal certain technical inventions which they have proceeded to exploit according to their own temperament and vision." He concluded by characterizing their collective imagery as "[belonging] to the iconography of despair, or of defiance," with "images of flight, of ragged claws 'scuttling across the floors of silent seas,' of excoriated flesh, frustrated sex, the geometry of fear."[1]

Much of the work shown did share a preoccupation with "the predicament of man," as expressed in the contemporary existentialist writings of Jean-Paul Sartre and Albert Camus: of implied cacophony and the sense of suffering. But other works embody more mundane moments: for example, the sculptures of Armitage record the small dramas of life on the street, such as people walking against a blustering wind.

Although their aims and methods were more divergent and wide-ranging than Read's "geometry of fear" implied, there is a formal relationship between many of the sculptures in the 1952 Biennale, in the use of contorted forms and battered surfaces that imbue much of the work with a time-worn appearance.

54
Kenneth Armitage
Born 1916
Two Figures Walking, 1952
Cast bronze,
h. 11 1/2 (29.2)
The Joel Starrels, Jr.
Memorial Collection,
1974.207

Kenneth Armitage studied at the Leeds College of Art (1934–37) and then for two years at the Slade School of Art in London. Like many of the sculptors of his generation who attended art academies in the 1920s and 1930s, he was influenced by the revival of direct carving in wood and stone. After 1948, however, Armitage worked almost exclusively in plaster. The change from carver to modeler of forms originated in his newfound interest in contemporary architecture and the engineering of suspension bridges. From then on his principal sculptural investigations lay in the structure of the object of inquiry— in Armitage's case, always the human form. He pursued this agenda in the successive building up of layers of plaster on armatures of metal rods, a practice that imbued the human image with the structural clarity and strength possessed by inanimate objects like buildings and bridges. In building up these forms, he was able to manipulate the material in various ways: the plaster could be poured and allowed to harden in drips, it could be modeled while still pliant, and once hardened the plaster could be carved and sanded.

One of eight sculptors who emerged in the aftermath of World War II, Armitage was characterized by Herbert Read as representative of the new direction in British sculpture at the British Pavilion in the 1952 Venice Biennale. As has often been noted since this much-acclaimed exhibition, Armitage's figurative sculptures did not easily square with Read's often-quoted phrase, "the geometry of fear." Clearly his work does not evince the mood of anxiety and apprehension seen in the sculptures and drawings of Lynn Chadwick and Bernard Meadows, which Read detected as a common factor in the work of the artists

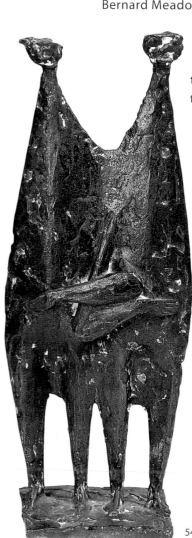

shown in Venice. Instead, Armitage's works, such as *Two Figures Walking*, are always involved in casual, everyday activities, and the attitude is one of pleasure and playfulness. Such a positive and sympathetic approach to the human figure makes it difficult to link the Smart Museum bronze to the pervasive existentialism identified by Read; perhaps it was the formal aspects of Armitage's sculptures that led Read to this conclusion. Part of the modernity of Armitage's sculpture around 1952–53 lies in the simplification and distortion of the contours of the figure. Of equal significance, and something which linked his work formally to many of the sculptors shown in the British Pavilion, were the surfaces of his bronzes, their coarse and rough membranelike textures, that he achieved through the plaster medium of their original models and careful tooling after casting.

54

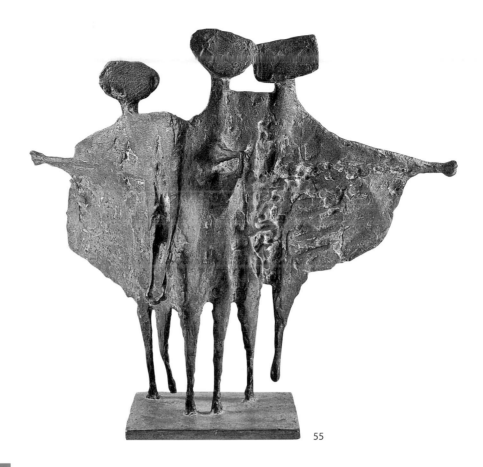

55

55
Kenneth Armitage
Born 1916
Children by the Sea, 1953
Cast bronze, h. 17 (43.2)
The Mary and Earle Ludgin
Collection, 1985.100

n his introduction to the catalogue of the retrospective exhibition of Armitage's sculp-
ture and drawings held at Whitechapel Art Gallery, London in 1959, Alan Bowness proposed
that the simple folding screen had been of fundamental significance in the artist's work in
the previous decade. Bowness recalled that among the plethora of objects in the sculp-
tor's London studio was a three-panel folding screen with projecting noblike struts at the
corners.[1] For Armitage, the folding screen acted as a visual metaphor of the human figure.
The abstract shape of the screen provided the sculptor with a ready-made structure,
whether oblong and flat for a single figure, or suggesting the linking of a group of figures
in an in-and-out movement, as in this bronze of three children racing along a coastline,
arms locked together before them, clothing fluttering behind.

The extreme flatness of Armitage's figures of this period (when viewed from the sides)
has an important connection with the screen form, but another influence was probably
the frontality of ancient Egyptian sculpture, which Armitage had admired during his stu-
dent days before the war. The insistence on front and back views in works like *Children by
the Sea* and *Two Figures Walking* (cat. no. 54), modeled the previous year, seems equally
indebted to such non-Western sculptural traditions. In particular, the hieratic pose of the
latter group—the rigid stance with one foot slightly behind the other in each figure, arms
locked together between them, and the slight differences in size—echoes the pairs of
standing men and women in Egyptian sculpture.

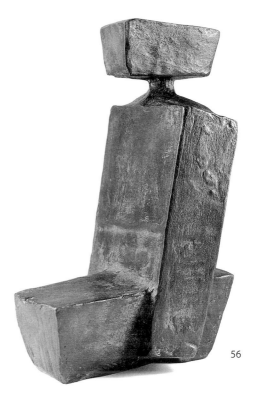

56

56
Kenneth Armitage
Born 1916
Little Box Figure, 1961
Cast bronze, ed. 1/9,
h. 11 7/8 (30.1)
The Joel Starrels, Jr.
Memorial Collection,
1974.208

t he extreme flatness of Armitage's figures in the first half of the 1950s is one the sculptor's most original sculptural achievements. By the end of the decade he began working the human image entirely in the round. Although Armitage has retained his customary division of head, torso, and limbs in a work like *Little Box Figure*, all these features have now thickened into boxlike, volumetric shapes, as the title of the bronze announces. These, however, are not rigidly geometric, and Armitage has retained his earlier intuitive and tactile process of modeling in successive layers of plaster until the proper form and surface are achieved. Thus, in spite of the reductive shapes, he manages to retain a degree of sensuality that proclaims the humanity of his abstracted figures.

57
Reg (Reginald Cotterell)
Butler
Born 1913
Cassandra, 1953
Shell bronze,
h. 28 1/2 (72.4)
The Joel Starrels, Jr.
Memorial Collection,
1974.158

r eg Butler had received international recognition for the linear cut and wrought iron figures of men and women he showed at the British Pavilion in the 1952 Venice Biennale. The next year, his reputation was assured when he received the Grand Prize for his winning design in the International Competition for a Monument to *The Unknown Political Prisoner*. The competition was sponsored by the Institute of Contemporary Arts in London, as announced by its president, Herbert Read, "to pay tribute to those individuals who, in many countries and diverse political situations, had dared to offer their liberty or lives for the cause of human freedom." For many artists who submitted designs to the selection committee, it was in fact a monument to the victims of fascism in World War II, and for a few its relevance lay in the worsening situation of the Cold War.[1] Butler's proposal consisted of an elevated skeletal wrought metal tower and cage perched on a rock with three standing figures below, looking up. These "watchers", as he called them, had been conceived as solid sculptures made of bronze. While working on the *Prisoner* monument in 1951–52, he drew several studies of heads looking up, a motif eventually incorporated in the "watchers".

The idea for this tense, alert pose may have derived from Butler's habit of staring at the sky to watch test flights of new jets.[2]

During the 1950s, Butler moved away from the reductive imagery of his iron figures toward more volumetric forms. This new plastic direction in his work seems to have been reinforced by Butler's visit to the Institute of Contemporary Arts exhibition *Wonder and Horror of the Human Head* in the spring of 1953. There he saw a plaster cast of the paleolithic ivory *Venus of Lespugue*, and he came increasingly to identify with the tradition of solid, robust human figures, which he felt this small, prehistoric idol symbolized.[3] There is a technical change during this period that supported this new idea: from the direct-metal process of forged iron—Butler had been a blacksmith during World War II—to modeling in wax, sometimes combining it with plaster but generally avoiding clay, and then casting his models in bronze. Butler at this time also invented what he called "shell bronze", a painstaking technique which enabled him to produce a very thin bronze wall in the cast; the sculptor favored the use of shell bronze because its visual and tactile effects suggested a skin enveloping a hollow body. His use of shell bronze helps account for the lithe, sensual quality of the surface of *Cassandra*, in which Butler's newfound figural solidity is less mass than volume. In 1953, he started to lift his figures off the ground on low metal perches or wiry grids, perhaps vestiges of his earlier linear style, and this device also served to counteract the weight of his figures with a visual sense of buoyancy.

Some contemporary observers detected an unconscious religious significance to the three female figures of the *Prisoner* monument, as latter-day Three Maries, and there was precedent for this conviction in the archetypal symbolism of three grouped figures in Francis Bacon's 1944 triptych *Three Studies for Figures at the Base of a Crucifixion* (Tate Gallery, London).[4] The title of the Smart Museum bronze is especially revealing in this context. In Greek mythology, Cassandra was a seer, endowed in some accounts with the power of divination and in others with the art of prophecy; but in one version of the legend Apollo had cursed her so that no one would believe her prophecies, although she could correctly foretell the future. Her name became synonymous for those prophets of doom whose warnings go unheeded until too late. In addition, the year before Butler modeled his *Cassandra*, he had completed a work with prophetic overtones called *Oracle* (Hatfield Technical College, Hertfordshire, England), in which the sculptor had conflated head, face, and neck into a single thrusting organism like a raised fist. This configuration is strikingly similar to the flattened head motif in the Smart Museum bronze.

57

Reg (Reginald Cotterell) Butler
Born 1913
The Machine, 1953
Shell bronze, unique?,
h. 13 (33), l. 30 (76.2)
The Joel Starrels, Jr.
Memorial Collection,
1974.154

already in 1946 or 1947, Butler had become interested in mechanical engineering forms and had photographed radar and radio towers along the Suffolk coast, excited, as he said, by "the tensions between the primordial vitality" of the English coastline "and the rather sinister machines."[1] His fascination with machine imagery is especially discernible in a number of sculptures made between 1948 and 1952, and in his preparatory studies and maquettes for the *Unknown Political Prisoner* monument (see cat. no. 57). It also resurfaces sporadically as a motif in his sculptures for the next two years. Like this bronze, most of these are essentially figurative pieces in which a man or woman is held in check by machinery or holds a small machine of some kind. The culmination of this group is the life-size bronze, *Manipulator* of 1954 (Hirshhorn Museum and Sculpture Garden, Smithsonian Institution, Washington, D.C.), a male figure operating a small mechanical box. As noted by Richard Calvocoressi in the catalogue of the Butler retrospective at the Tate Gallery in 1983–84, there are echoes in Butler's *Manipulator* of Germaine Richier's large bronze from 1950, *Le Diabolo*.[2] Her work centers on an insect-headed figure playing diabolo, a child's game of balance involving poles, strings, and a bobbin-shaped toy (also called a diabolo). An appreciation of Richier's *Diabolo* may also be detected in works like *Machine*, both formally and in their general existentialist mood of alienation and despair. Butler knew Richier's work firsthand, for he and Richier had been included in *London-Paris*, a group exhibition of painting and sculpture by contemporary British and French artists held at the Institute of Contemporary Arts in London in March 1950.

Although the title of the Smart Museum bronze emphasizes its machinelike apparatus, the activity is centered on the small elevated figure at the center of the skeletal construction. There is an ambiguity in this composition, in which it is impossible to determine whether the man or woman is operating the machinery or entrapped by it. The composition of *The Machine* is similar to another bronze from that year called *Study for Figure Falling*, an image of St. Catherine straining against her wheel of martyrdom: in each a broad, coarsely modeled base supports a small figure caught in a web of poles, hoops, and beams.[3] In both there is a fundamental contrast between linear and solid elements that stresses the isolation of the figure in its precarious situation. The figure suspended in space—caught between dreams of flight and the pull of gravity—was an essential aspect of Butler's iconography between 1953 and 1959. The vocabulary of tension and struggle is dramatic, even violent, and these works have a foreboding mood.

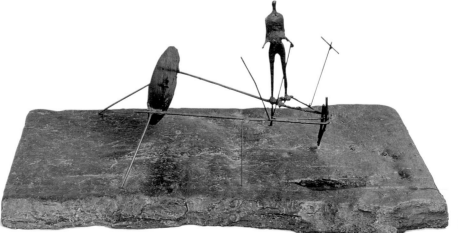

58

59
Reg (Reginald Cotterell)
Butler
Born 1913
Torso, 1954
Cast bronze, ed. 2/8,
h. 12 7/8 (32.7)
The Joel Starrels, Jr.
Memorial Collection,
1974.215

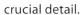

n the mid-fifties, Butler's important large figures were preceded by groups of small, related maquettes. The strong resemblance in pose between this cast bronze torso and the life-size *Girl with Vest* from 1953–54 (Tate Gallery, London) raises the possibility that it too is an intermediate study for the much larger shell bronze. In the full-scale definitive version, both arms are raised over the head of the lithe adolescent, whereas in the Smart Museum study, the angle of the shoulders indicates that only one arm is raised. However, another maquette from 1954, *Study for Girl with Vest*,[1] which is otherwise a complete small-scale version of *Girl with Vest*, also shows one arm up, the other down.

This cast retains at the end of the legs remnants of the armature of the original wax or plaster model. Although this device was a technical necessity in the modeling of the figure, it is not required in the final bronze. In the bronze version, only one of the rods has been retained and extended to link torso to base. The rod acts as an important compositional device, the equivalent of the wiry supports that Butler had introduced in his figurative sculpture in 1953. The sculptures of the 1950s explored themes related to figures in movement, and to counteract the central body mass of his bronze torsos, Butler balanced the tapering legs of his men and women precariously on metal bars attached to plinths. Similarly, there is a buoyancy and tension to the Smart Museum bronze that would have been otherwise lost without this crucial detail.

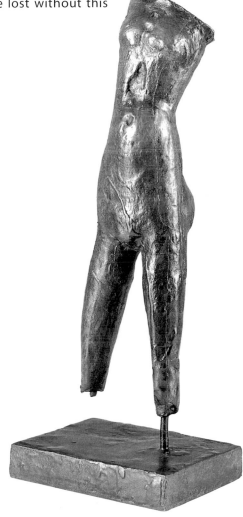

59

Reg (Reginald Cotterell) Butler

Born 1913
Bust of a Girl, Head Looking Up, 1955–56
Cast bronze, ed. 2/8,
h. 8 (20.4)
The Joel Starrels, Jr.
Memorial Collection,
1974.216

t he human head is a recurrent motif in Butler's sculpture and drawings of the 1950s. Many are studies for the *Unknown Political Prisoner* monument (see cat. no. 57), but others are independent works. Sometimes Butler concentrated on the neck and head only; occasionally he extended the composition to incorporate elements of the shoulder and arms, as in this bronze and the large 1954 bronze called *Study for Third Watcher*.[1] Especially early in the decade, there is an agonized look in many of the faces, and the eyes and tongue stick out, while the whole face thrusts vertically upwards. In the works of 1954–56, there is less distortion, though the faces are still flattened and highly expressive.

This small bronze was possibly a preparatory study for a partially clothed full-length figure (see cat. no. 59). The final model is in all probability the medium-sized bronze from 1955–56 called *Summer*, in which the bust is now tipped forward.[2] A variant of the bust and head appeared in 1956, *Head and Shoulders (arms up)*, in which the stunted arms are raised over the head.[3]

60

Bernard Meadows

Born 1915
Fish Relief, 1955
Cast bronze relief, ed. of 6,
15 1/2 x 22 5/8 (39.4 x 57.5)
Bowness BM 35
The Joel Starrels, Jr.
Memorial Collection,
1974.295

61

t he inclusion of Bernard Meadows in the group exhibition of eight emerging sculptors in the British Pavilion at the 1952 Venice Biennale propelled him to international recognition. The text of the catalogue, written by Herbert Read, who had made the selection, used the expression "the geometry of fear" to describe the new British sculpture. Entitled *New Aspects of British Sculpture*, the exhibition announced no cohesive group movement, and in reality some of the artists met for the first time at the show. Despite the lack of relevance of the term for many of the sculptors, in Meadows's case it was altogether a perceptive comment on the sculptures and drawings of cocks and crabs included in the show.

Meadows's interest in animal sculpture dates from the early 1950s, when he was commissioned to make a sculpture for a new school to be built in London Colney. The success of his over-life-size rooster in a naturalistic style led Meadows to explore in depth the formal possibilities of sculpture based on animal forms. Focusing on the cock and the crab, he used them as metaphoric substitutes for the human figure and imbued them with an emotional charge. Meadows wrote of his work in the late 1950s:

I look upon birds and crabs as human substitutes, they are vehicles, expressing my feelings about human beings. To use non-human figures is for me less inhibiting.... Lately, I have become interested in the tragedy of damaged figures, maybe one half destroyed, the bone structure crushed to pulp

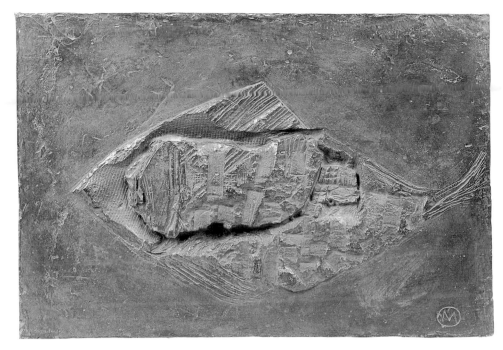

61

and the others half alive and striving to carry the damaged side.... All this has to be expressed in new ways as a complete composition.[1]

Although he was shifting from animal metaphors of the human condition to a new iconography of handicapped humanoid creatures when he wrote this, the sentiments expressed are embodied in the slightly earlier sculpture of a fish, apparently a unique foray by the artist into the subject.

At first glance, the plaque has the look of the fossilized remains of some prehistoric fish imbedded in an exposed stratum of rock. But a closer look reveals the fish's corroded surface and curiously inorganic structure, not the carefully preserved skeletal structure one normally finds in such artifacts. The violent destruction of this creature has an inevitably tragic quality, as in the surfaces of "excoriated flesh" (using Read's terminology) and shattered structures of Meadows's bird sculptures, at first defiant and ready for battle and later victims, as suggested by titles of works like *Shot Bird* of 1959–60. It is revealing that in a photograph of the artist's studio in The Malls Studios, Hampstead, taken in the 1950s, the original plaster for the fish relief has been carefully propped on a bracket in the wall in close proximity to shelves of plasters and bronzes of his bird sculptures.[2]

62
Lynn Chadwick
Born 1916
Three Watchers, 1960
Pen and ink and wash on
wove paper, 15 x 20 1/2
(38.1 x 52.1)
The Joel Starrels, Jr.
Memorial Collection,
1974.240

At the 1952 Venice Biennale, Lynn Chadwick had shown a group of welded direct-metal sculptures with moveable parts and forms suggesting spikes, teeth, claws, and watchful eyes. The mixture of animal and plant, machine and the organic in these and works from the next few years was mysterious and fraught with a sense of primal vitality. Writing about Chadwick's sculpture in 1958—six years after he had used the subsequently much-quoted phrase "geometry of fear" to define a collective impulse at work among the eight young sculptors represented in the British Pavilion exhibition—Herbert Read now preferred to speak of "a demonic force ... pent up in the unconscious ... [which] when released, can

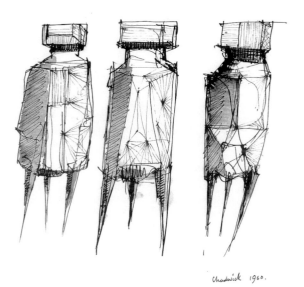

Chadwick 1960.

62

assume the significance, universal meaning, as works of art."[1] For Read, Chadwick's sculptures were "symbolic icons", which derived their power from archetypal forms.

In the mid-1950s, Chadwick had initiated a series of standing figures, often in frozen poses, and he returned to this format as a source of inspiration over the next decade. Chadwick's repertoire expanded in 1959 when he started a series of *Watchers* that are united by the brooding stillness of their stances. As the motif evolved, the heads of the *Watchers* became horizontal blocks, and arms were subsumed into thick, foursquare torsos balanced on very thin, tapering legs, frequently incorporating a third leg to form a tripod. Initially, his *Watcher* sculptures were single figures or couples, but by 1960 he had began to work with groups of three. The titles of these sculptures and their expectant, erect poses undeniably recall the series of "watcher" sculptures and drawings initiated by Reg Butler around 1951, a theme that he returned to periodically until the end of the decade (see cat. no. 57). Although these works by Butler may have acted as a stimulant, there is little formal relationship between the two series of sculptures.

The figural type and side-by-side arrangement of the personages in the Smart Museum drawing are very close to Chadwick's monumental bronze from 1960 entitled *The Watchers* (Farr-Chadwick 325), even to the slight separation of the third Watcher at the right from the other two figures. In the drawing, Chadwick has defined the surfaces of the torsos with a web of thin pen strokes that evokes the surface textures of the bronzes. The degree of finish seen in this drawing, including careful washes of gray that suggest light and shadow falling over fully three-dimensional forms, and the absence of quickly jotted notes by the sculptor indicating projected sizes both suggest that this drawing is not a preliminary study for this sculptural ensemble but possibly a drawing of record after the completed work. Formally, the drawing anticipates later lithographs by the artist, such as *Winged Figures* from 1968.[2]

88

Postwar British Sculpture, 1950–1960

63
Lynn Chadwick
Born 1916
Blue, 1960
Pen and ink and watercolor
on thin wove paper,
19 7/8 x 15 (50.5 x 38.1)
The Joel Starrels, Jr.
Memorial Collection,
1974.239

It is difficult to find a sculptural composition among Chadwick's works from around 1960 that parallels the unexpected image of a closely cropped human head in this drawing. The marked pictorialism of the design, the refined degree of finish, and the expressive coloration of the blue watercolor wash all suggest that this is an independent work that relates in a general way to the artist's subjects and themes of the period but is not a working study for any individual piece.

The accumulation of dense black lines around the wide-open eyes, thick brows, and tightly closed lips calls attention to these areas of the face, and the resulting frozen, brooding, yet watchful nature of this human head finds its analogue in the tense, alert poses of the *Watcher* sculptures of 1959–60. Chadwick has elaborated the surface of the paper with a web of thin pen and ink lines that breaks into small triangular sections. These define planes and contours of the cheeks—isolated from the ground of the composition by the areas of watercolor wash—and give structure to the shape of the head. They also enliven the surface of the sheet, and embed the isolated head into a wider matrix that seems to entrap or immobilize the face. The origins of this linear patterning are probably to be found in a technical innovation of the sculptor that first appeared in a welded iron piece from 1953. This sculpture, called *Idiomatic Beast* (Farr-Chadwick 100), was constructed from an elaborate web of welded rods which form triangular units that are joined together at various angles to express the different parts of its body. The ribbed texture of this skeletal motif appears frequently on the torsos and reedy wings of the hybrid, humanoid creatures that followed, including Chadwick's many models and large-scale sculptures of *Watchers* made around 1960.

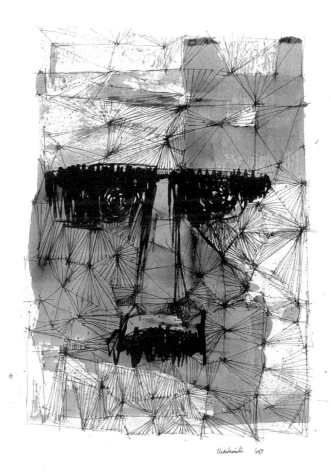

63

1945

LONDON–PARIS–NEW YORK: FROM EXISTENTIALISM AND "L'ART BRUT" TO "THE AESTHETICS OF PLENTY" AND POP ART

In the period between 1947 and 1952, some students became disenchanted with the approved curricula of British art schools and traveled to Paris, where they met well-known artists who had championed Surrealism and abstraction in the interwar period. Of great consequence for their future development were the examples of Jean Dubuffet and Alberto Giacometti, who were then defining new sensibilities in postwar French art, frequently aligned by contemporary critics with the existentialist writings of Jean-Paul Sartre and Albert Camus. Among the expatriates living in Paris were Nigel Henderson, Eduardo Paolozzi, and William Turnbull, all friends from the Slade School of Art, and the young critic David Sylvester. Sylvester, for example, referred to the 1948 Giacometti catalogue published by the Pierre Matisse Gallery—with Sartre's essay, "The Search for the Absolute," and grainy photographs by the Chilean Matta—as a "talisman" for this group. Similarly, Dubuffet's informal techniques and interest in abject material—tar, sand, found objects

—were to surface later in the mid-fifties in the work of Paolozzi and others.

In London, the founding of the Institute of Contemporary Arts In 1946 by an older generation of critics and artists, Herbert Read and Roland Penrose chief among them, had momentous implications for the loose association of young artists, designers, architects, and critics called the Independent Group, first convened in 1952. Independent Group participants led informal discussion sessions and mounted a series of thought-provoking exhibitions at the Institute of Contemporary Arts, in order to keep the parent organization in touch with developing art and ideas. Members of the Independent Group, which remained a catalyst in the London art world until the late 1950s, included the artists Richard Hamilton, Henderson, Paolozzi, and Turnbull, and the critic Lawrence Alloway. Many of its participants are now celebrated as the fathers of British Pop art, and their activities within the group were important formative influences on later developments in their art. At the time, for example, Hamilton declared that their program was "Popular (designed for a mass audience); Transient (short-term solution); Expendable (easily forgotten); Low-cost; Mass produced; Young (aimed at youth); Witty; Sexy; Gimmicky; Glamorous; Big Business."[1] Central to the cultural discourse they championed was their challenge to the humanist assumptions and entrenched hierarchy of prevailing British culture, and their dialectical strategy incorporating the concept of the "aesthetics of plenty": diversity of style and consumer affluence that broke down the traditional barriers between fine art and popular culture. Often American popular culture—in particular, the image-saturated world of mass-media advertising, Hollywood films, pulp fiction, and science fiction books and films—was analyzed because it epitomized a society of rapid consumption and obsolescence.

1960

William Turnbull
Born 1922
Game, 1949
Cast bronze, unique,
8 3/4 x 20 x 12
(22.2 x 50.8 x 30.5)
Gift of Sylvia Sleigh,
1991.4

n the autumn of 1946, William Turnbull enrolled in London's Slade School of Art. Soon transferring from the painting to the sculpture department, he abandoned the traditional approach of modeling in clay favored at the Slade and adopted a method of modeling wet plaster on a metal armature. Turnbull visited Paris in 1947, and in 1948 he moved there to live, returning to London only in the fall of 1950. During this period he met Jean Hélion, Fernand Léger, Tristan Tzara, and Alberto Giacometti, among others. Associated with the Surrealists before World War II, the Swiss sculptor Giacometti had only recently begun making a series of tall, thin standing figures and another of attenuated single, striding men, and the influence of Giacometti's new sculptures is especially strong in the sculptures Turnbull exhibited in London in early 1950. Most of these involved simple linear or stick forms, some terminating in elementary blobs, all rising from a flat plane. The rough irregularity of surfaces in Turnbull's sculptural forms is also similar to those of Giacometti's attenuated figures. In the catalogue for Turnbull's retrospective exhibition at the Tate Gallery in 1973, Richard Morphet characterized these early sculptures:

> In Turnbull's work, concern with the Surrealist object is entirely absent.... Instead of complex representational aims, Turnbull pursues a more abstract concern with form, space and function, producing forms that reflect and interact with our experiences of real life objects and situations, but are not read as revelations of a personal fantasy or very private world.[1]

Turnbull constructed his sculptures from thin, rough rods as a way of distancing the final work from any overt resemblance to natural objects. The elemental forms he employed articulated the sculptor's belief in a non-hierarchy of values in a work, where each unit is autonomous and the significance of individual elements is revealed only in the overall configuration. For Turnbull, what mattered most was the flexibility of interpretation, as he wrote about his playground sculptures from 1955: "I wanted to make sculpture that would express implication of movement (not describe it), ambiguity of content, and simplicity (lack of interesting detail separate from the whole)."[3]

An important concern for Turnbull was the expression of the sensation movement, again inspired by Giacometti's tableaux of figures walking across an open space. In addition to static pieces with titles like *Mobile Stable*, he incorporated actual movement in several hanging mobiles. In the Smart Museum bronze *Game*, the stunted rods can be plucked

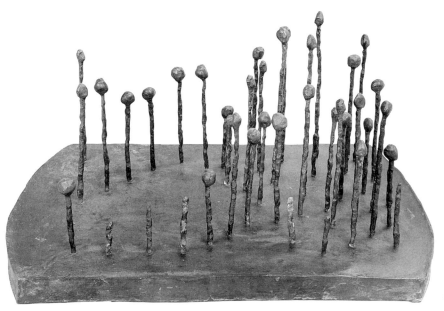

64

from their sockets in the base and placed in alternative arrangements in any variety of permutations. Here, Turnbull wanted the spectator to become a participant, so that the work is "not so much *appreciated* as *experienced*."[4] The element of play is linked with Turnbull's interest in popular culture, in particular amusement parks and sports, a theme that was investigated in other sculptures from 1949, such as *Playground (Game)*, and later in a group of playground relief sculptures from 1955. Turnbull was a billiards and pinball player at the time, and the bases of some of these works recall the channels, holes, and obstacles of such ball-games. [5]

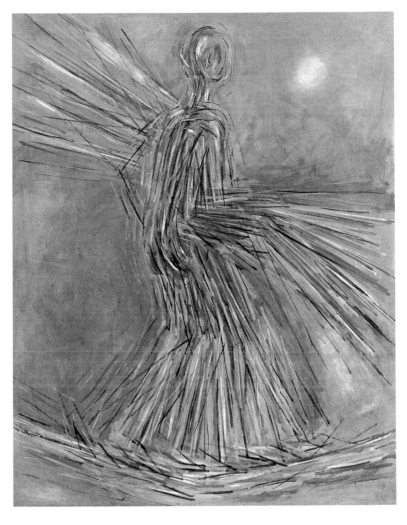

65

65
William Turnbull
Born 1922
Tightrope Walker, 1951
Oil on canvas,
49 1/4 x 39 1/4
(125.1 x 99.7)
Lent by Rhoda Pritzker

turnbull is best known as a sculptor, but throughout his career he has also made paintings. Generally, he works in one medium for a time and then in another. These are separate practices for him, but often strong parallels exist between the sculptures and paintings from a given period of activity. The abstract plasters and bronzes of the late 1940s and early 1950s dealt with concepts of motion, either implied or through moving parts. Occasionally, the etiolated rods of these works ended in headlike knobs, giving a sense of animate life to the reductive shapes (see cat. no. 64). The appearance of the human figure in this and other canvases from the period represents a new direction in Turnbull's art. Despite such overt figural references, there is thematic continuity with earlier paintings and sculptures in his focus on people in motion, in this work a circus performer balancing on a tightrope. In addition, the long, thin paint strokes defining the figure—laid down as a series of parallel colored lines—are formal analogues of the sculptural rods.

66

William Turnbull
Born 1922
Untitled, 1952
Colored pencils on wove
paper, 19 1/2 x 14 9/16
(49.5 x 37)
Gift of Sylvia Sleigh,
1991.311

turnbull's stick-figure sculptures of 1949 had been concerned with line and skeletal structure: in this untitled drawing from 1952, there is an insistence on the articulation of the lines as physical entities so that each mark is autonomous. As in the paintings from this period, this idea is underscored by the polychromy of the pencils used, which further isolates one line from its differently colored neighbor (see cat. no. 65). The surface is stressed by the avoidance of the intersection of elements that might suggest shallow spaces around the delineated forms. There is overall a balance between a system of discreet marks and the isolated figures that emerged in the drawing process.

Turnbull's acute concerns with line and movement may be based in part on his interest in the art and writings of Paul Klee, to which he was introduced in 1946, when he saw a major show of Klee's work in London.

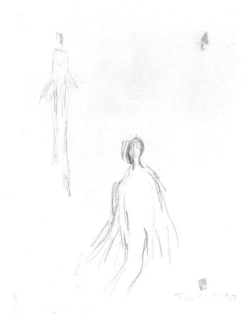

66

67

William Turnbull
Born 1922
Walking Figure, 1953
Cast bronze, unique?,
h. 19 (48.3), l. 23 1/2 (59.7)
Lent by Rhoda Pritzker

the introduction of figurative imagery into Turnbull's paintings of the early 1950s is paralleled in such contemporaneous sculptures as this bronze. The rudimental sticklike shapes of the sculptures of the late forties are now elaborated into recognizable human figures, with the introduction of limbs and head. The sensation of movement inherent in works like *Game* (cat. no. 64), in which simple individual rods were meant to be moved like pieces on a game board, is given visual form in the duplication of arms and legs of the striding figure. This suggestion of simultaneous motion is, however, denied by the earthbound feet, perhaps the legacy of Alberto Giacometti's walking figure sculptures that Turnbull admired.

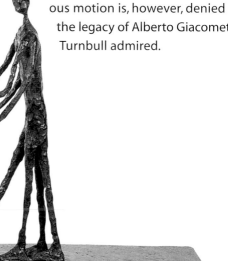

67

68

69

elements of chance and chaos are especially strong in Turnbull's paintings and drawings of striding figures from the early 1950s, much as in the hanging mobiles and the bronze *Game* of 1949 (cat. no. 64). The process may be indebted to the Dadaist ideas of emotional detachment in the creative process and distrust of self-conscious composition, and to the Surrealist practice of automatic writing as a way of arriving at less mediated images through recourse to the subconscious. But even more important was Turnbull's interest in Paul Klee, who stressed in his art and writings the idea of the artist as a natural, creative being from whom forms should arise in a naturally unfolding, non-formulaic way. Turnbull's art was also enriched by his exposure in Paris to the existentialist writings of Jean-Paul Sartre and Albert Camus.[1] Turnbull remarked years later that the printed version of Sartre's 1946 lecture, "Is Existentialism a Humanism?," was "very important" to him for decisively corroding the "conventional hierarchies of merit that structured what passed for British art."[2] This was a liberating experience for Turnbull, especially "Sartre's example of a painter freed from *a priori* rules as an allegory of existentialism."[3]

In the early 1950s, Turnbull also became interested in East Asian philosophy, and he was particularly impressed by Zen painting, the idea of the artist instantaneously projecting his idea with a flick of the brush.

Turnbull's developing concept of artistic authenticity is critical to the execution of these two unconventional drawings, whose techniques are sometimes quite informal: in one sheet, oil paint has been applied as clotted, swirling traces of unmixed pigment, and in the other Turnbull employed the unusual technique of fingerpainting. The isolated scribbles of paint and individual fingerprints remain discrete marks while also giving definition to the striding human figures they form. Although varied in technique, each graphically embodies the existentialist notion of man as nothing but the sum of his unfolding actions.

70
William Turnbull
Born 1922
Untitled, 1953
Crayon and ink (or oil)
on wove paper,
24 7/16 x 15 1/8
(62.1 x 38.4)
Gift of Sylvia Sleigh,
1991.314

in 1949, while living in Paris, Turnbull made a group of sculptures with rough, thin rods rising from flat bases. These relate to Giacometti's postwar tableaux sculptures of small stick-figures walking across a rectangular base, apparently oblivious to one another. Back in London, Turnbull continued to investigate the notion of movement in paintings and drawings of single striding figures and figures in a crowd, as in this drawing from 1953.

These polychromatic works also relate to his use of colored surfaces in sculptures exhibited in 1952. In this drawing, each figure is built up from a multitude of lines laid down in bold, blunt gestural strokes. These marks are largely confined to the figures themselves, which were envisioned as existing in a neutral space. These studies of motion are also indebted to Eadweard Muybridge and Marcel Duchamp.[1]

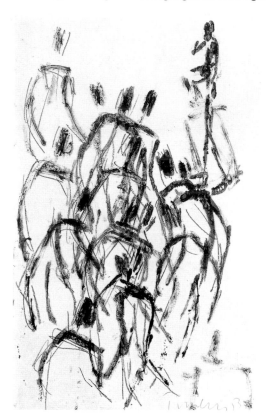

70

71
William Turnbull
Born 1922
Untitled, 1953
Pencil and pen and ink on
wove paper, 30 x 22
(76.2 x 55.9)
Gift of Sylvia Sleigh,
1991.307

72
William Turnbull
Untitled, 1954
Oil on canvas, 50 x 35 7/8
(127 x 91.1)
Purchase, Unrestricted
Funds, 1994.8

although it has been stated that Turnbull never makes preliminary drawings for his paintings and sculptures, there is a clear relationship between these two works.[1] The earlier date of the drawing strongly suggests that it is, in fact, a study for the painting. The compositions are identical, and the use of black and gray paint strokes on the canvas corresponds to the colorism of the grayish pencil lines and black ink strokes of the drawing.

Turnbull's paintings from the beginning of the 1950s employed a colored ground, executed in muted brushstrokes, that suggests a residual spatial setting (see cat. no. 65), but this painting from 1954 has a blank white ground, a kind of non-space that emphasizes the non-illusionistic, flat nature of the quickly laid down strokes of unblended oil, a formal device seen later in the calligraphic *Head* paintings of 1956–57. This treatment of the ground is identical to the artist's use of the unworked white sheet as a neutral "setting" in all the Smart Museum's figure drawings from 1953 to 1954.

71

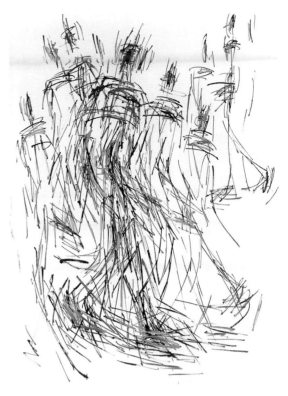

72

73
William Turnbull
Born 1922
Untitled, 1955
Cast bronze, unique?,
h. 10 1/2 (26.7)
The Joel Starrels, Jr.
Memorial Collection,
1974.153

by the mid-1950s, Turnbull abandoned the representation of movement, which had been a central concern in his earlier work, and in its place stressed stasis. Most of Turnbull's sculptures between 1954 and 1962 relate to this idea of the motionless standing human figure. Limbs no longer protrude as they did in the striding figures of the early 1950s (see cat. no. 67), and instead he presents a flattened, thick central trunk and closed legs devoid of any sense of action. Lateral symmetry is emphasized in compact front and back views. The motionless figures stand directly on the floor. Alberto Giacometti's sculpture from the immediate postwar period is again a major point of reference; like Giacometti, Turnbull was interested in establishing an arrested, frontal, upright form based on human physiognomy that avoids all suggestions of narrative and overt emotion, despite the battered, time-worn appearance of surfaces. The earliest of the figures in this series, all of which are female in gender, have a reasonably naturalistic silhouette from a frontal view, but their side views are flattened, a device that neutralizes the sense of humanity in these personages. Noses increasingly resemble ridges, as in the Smart Museum bronze, and the tapering heads resemble archaic spearheads.

These sculptures are unmistakably modernist in their rejection of Renaissance ideals of beauty and harmonious balance and in their origins in the totemic art of archaic or tribal sculpture that evokes a human or divine presence. This notion is underscored by Turnbull's titles such as *Idol, Totemic Figure,* and *Ancestral Figure*. But some of these titles may also be puns on the screen goddesses of Hollywood in a sly elision of the icons of contemporary American film culture and ancient fertility goddesses.[1] These sculptures' greatest affinity is with the hieratic carvings of ancient Egypt and Greece. In 1947, Turnbull had spent six weeks in Italy, and in the museums was drawn to archaic Greek standing male nude *kouros*

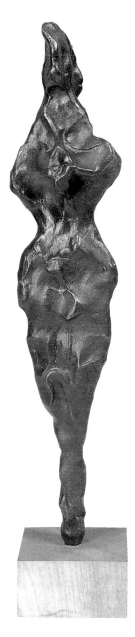

73

figures and Egyptian art. The impassivity of his own sculptures lends them a quality of silence, and this lack of action and any identifying attributes suggests that they embody no contemporary myths.

The standing figures are all large, of roughly human height, and it is not known whether the Smart Museum's unusually small piece is an independent study of the motif or a maquette for one of the upright figures.[2] There is an immediacy in the modeling of the features, and the surface retains the marks of its definition, even revealing finger prints in the original clay (or plaster?) model. This lack of finish is formally related to the coarse surfaces of the earliest of the *Idols*.

74

William Turnbull
Born 1922
Head, 1955
Gouache and colored ink
on wove paper,
30 x 22 (76.2 x 55.9)
Gift of Sylvia Sleigh,
1991.308

75

William Turnbull
Head (Calligraphic), 1955
Pen and ink on wove paper,
18 9/16 x 13 3/4
(47.1 x 34.9)
Gift of Sylvia Sleigh,
1991.312

In contrast to the paintings and drawings of walking figures in the first half of the decade, Turnbull began in 1955 a group of painted images of heads that asserted flatness and stability. In March 1953, the Institute of Contemporary Arts in London mounted the exhibition *The Wonder and Horror of the Human Head*, which juxtaposed the work of modern and contemporary artists with objects from a vast range of cultural sources. The premise of the show was that the head exemplified a universal inclination of mankind to discern human facial features within the matrix of the head shape. Against the ideas engendered in this show, "the head crudely drawn, simply modeled, or assembled from collected junk, became an important motif for Hamilton, Turnbull and Paolozzi as well as for their students. It was the question of perceiving the difference between creating a resemblance and a presence."[1] Turnbull reduced the head to its most basic form, a circle mounted on the inverted arc of a shoulder. He deployed a number of techniques deliberately designed to limit his control over the development of the final form, sometimes through expanses of atomized pigment, other times by means of calligraphic marks and splattered skeins of paint and ink. The artist asserted control in deciding when to stop and when to continue as random marks coalesced into a head shape. The conceptual and formal sources of this departure are diverse: especially important are the examples of Paul Klee's non-hierarchical, all-over design principle,[2] and the flatness, symmetry, and archaism of Dubuffet's paintings of female bodies and tables from around 1953. Turnbull was not striving here for a natural resemblance to the human head, but for an elemental presence reconstituted by the artist as an intellectual and physical act.

74

75

Overall, these works are related to a small series of primitivist mask reliefs from 1953 in which the artist rendered features by pressing his thumbs and simple pointed implements into the soft plaster head matrix. The final appearance of each mask had much to do with chance, a type of semi-automatism, for the elemental marks became legible only after the matrix had been reversed through the casting process.

The head was a persistent motif in Turnbull's work from 1950 to 1957. In notes from 1960, the artist wrote of the autonomous reality of the painting action and the resulting image:

From about 50–56 I titled a number of paintings and sculptures "HEAD". The word meant for me what I imagined the word "Landscape" had meant for some painters—a format that could carry different loadings. Almost anything could be a head—and a head almost anything—given the slightest clue to the decoding.... The sort of thing that interested me was—how little will suggest a head, how much load will the shape take and still read head, head as colony, head as landscape, head as mask, head as ideogram, head as sign, etc.[3]

76
William Turnbull
Born 1922
Head, 1956
Brush and ink on laid paper, 22 1/8 x 30 1/16 (56.2 x 76.3)
Gift of Sylvia Sleigh, 1991.309

77
William Turnbull
Head, 1957
Watercolor on wove paper, 30 1/6 x 22 1/8 (76.3 x 56.2)
Gift of Sylvia Sleigh, 1991.310

These drawings present a slightly different aspect of the *Head* series in its later phase. In the 1956 work, the thickly brushed outlines forming the head, along with the interior definition of several quickly laid down brushstrokes, look like a Chinese or Japanese ideogram.[1] Together with blotchy dabs and drips and splashes of ink, the whole recalls Japanese *habokuga*, the so-called flung ink painting tradition associated with the arts of Zen. In this context, it must be remembered that this eastern philosophy had been a liberating influence in Turnbull's paintings and drawings since the beginning of the decade. This striking drawing seems to have been of special importance to Turnbull, as it was reproduced as the cover of the catalogue for his 1957 one-person exhibition at the Institute of Contemporary Arts in London.

The 1957 watercolor shows a very different approach, in which line has been replaced by broad washes of vibrant color to define the shape and give its surface visual inflection. This change in direction is also seen in the paintings of the period, for example, in canvases in which the paint is laid on thickly in organized rows of blocks of pigment. The thinness and translucency of the watercolor medium seems instead to parallel the thinly painted abstract canvases that appear this same year.

76

77

78
William Turnbull
Born 1922
Head, 1956
Color screenprint, trial
proof impression,
30 1/8 x 22 1/16
(76.5 x 56.1)
Gift of Sylvia Sleigh,
1991.328

79
William Turnbull
Head (Calligraphic), 1956
Lithograph, ed. 19/30,
30 1/8 x 22 (76.5 x 55.9)
Gift of Sylvia Sleigh,
1991.327

n 1956, Turnbull began experimenting with screenprinting following a visit to the studio of John Coplans, who had established a non-commercial facility for artists in his studio in Hampstead in the mid-1950s.[1] Instead of employing the standard cut stencils that often resulted in heavy deposits of ink and sharply defined images, Turnbull preferred the more painterly method of drawing directly on the silk screen with lithographic crayon and tusche, then coating the surface with a water-soluble medium, and finally washing out the oil-based designs with a solvent to leave the stencil of the image. This process enabled him to print his fluid designs with relatively thin inks. In the course of these experiments in 1956, he produced a sequence of headlike shapes. These were related to his calligraphic *Head* paintings and drawings from 1955–56, but the head motif had also been an important subject in his sculpture after 1950, notably in a group of small bronze masklike reliefs from 1953.

Turnbull executed over twenty trial proofs, each one a different composition. Employing up to four separate screens, he printed them in monochrome and in several colors in different sequences on a variety of papers. He selected four of the variant images that emerged, and each was printed in an edition of twenty-five or thirty on white paper; one was inked in black and the others in combinations of colors.[2] The two-color print in the Smart Museum, a trial proof that was not editioned, has a kind of penumbra that is similar to two of the color screenprints that were later printed in multiple. The Smart Museum head printed in black ink, an apparently unrecorded contemporaneous lithograph, is related to the screenprint trial proofs that consist of a halo of concentric circles with dynamic splatter lines radiating from the center of the "head".

78

79

80
Eduardo Paolozzi
Born 1924
Head (Study for a Paolozzi Poster), 1955
Offset lithograph, artist's proof impression,
29 15/16 x 19 15/16 (76 x 50.6)
Miles-Grisebach 6
Gift of Sylvia Sleigh in memory of Lawrence Alloway, 1991.324

born in Edinburgh to immigrants of Italian ancestry, Eduardo Paolozzi studied at the Edinburgh College of Art, and after the war at the Slade School of Art in Oxford and London. Although Paolozzi has always been primarily a sculptor, in the late 1940s and early 1950s his most characteristic works were collages of popular images of urban life whose elements were drawn from predominately American comic books, magazines, and pulp fiction. His first two prints were lithographs published in 1950 and 1951. The next year he made another lithograph entitled *Man's Head* (Miles-Grisebach 4), an image that had much in common with a number of plaster heads he made in 1950. The surfaces of these works, although in very different media, are covered with the same calligraphic elements. These were followed by sculptures, collages, monotypes, and prints, which also took as their subject the human head. Paolozzi had begun using the head motif already in 1944–46, and during the 1950s many artists associated with the Independent Group, including Paolozzi's close friends Nigel Henderson and William Turnbull, turned often to this seminal shape in their work (see cat. nos. 74–79).

In 1954, the year before the Smart Museum offset lithograph, Paolozzi made a screenprint called *Automobile Head*. Instead of defining the interior of the visage with calligraphic drawing, Paolozzi photomechanically reproduced the image from a collage of photographs of different machine parts cut out of a motor catalogue. Paolozzi used this collagist principle again in this offset lithograph, and there is a clear relationship between the two prints of heads. However, in *Head* the artist drew the collage elements in a manner reminiscent of his drawings and prints from several years earlier. Locked into the schematic, all-over abstract design are vestigial traces of eyes, nose, and mouth with parted lips.

There is an implied commercial aspect to this print, for the process of offset lithography was not common to fine-art printmaking in England at the time and was linked instead to the world of commercial printing—glossy magazines, newspapers, advertising posters, reproductive prints and posters, and the like.[1] Furthermore, Paolozzi's inclusion of the title

102

of the work and the legend "Study of a Paolozzi Poster" at the bottom of some sheets recalls the identifying captions used in advertising. Only a few trial proof impressions of *Head* exist, and since the print was never editioned, it is unclear whether Paolozzi ever intended it to function as a poster in the commercial sense. Of course, posters tread the fine line between "fine" and commercial art, and Paolozzi's interest here may have been the examination of just this point, almost as a reversal of his usual practice of appropriating mass-media imagery as formal elements of his collages.

80

81

Eduardo Paolozzi

Born 1924

Figure, circa 1956

Cast bronze, unique?,

h. 11 3/8 (28.8)

The Joel Starrels, Jr.

Memorial Collection,

1974.187

82

Eduardo Paolozzi

Little Warrior, 1956

Cast bronze, ed. 3/6,

h. 8 3/4 (22.2)

Lent by Rhoda Pritzker

Paolozzi lived in Paris for two years, from 1947 to 1949. Among the avant-garde artists he met who were to have a profound influence on his work were Alberto Giacometti and Jean Dubuffet, and during this time his evolving interest in tribal, "primitive", and vernacular art was reinforced by visits to the Musée de l'Homme and the *Foyer de l'art brut*, Dubuffet's own collection of folk, naive, and outsider art. Both *Figure* and *Little Warrior* are from a series of small sculptures from 1956 that show a remarkable affinity to the assemblage sculptures of Dubuffet of 1954. Dubuffet had made these works in the spirit of his "anticultural position" that held that modern art should be engaged with the objects and images of daily life. Paolozzi knew firsthand the recent "brutalist" sculpture of Dubuffet, which had been shown in a 1955 exhibition at the Institute of Contemporary Arts in London.[1]

In both Paolozzi's and Dubuffet's sculptures, small bits of flotsam, such as coal clinkers, driftwood, and slag iron, are selected for their fortuitous resemblance to the human figure. The metamorphosis—where nature imitating life becomes art—is in the intervention of the artist, in his repositioning of these found objects to form the underlying structure and "skin" of anthropomorphic figures.[2] Unlike Dubuffet, Paolozzi seals the facture of these *objet trouvé* constructions and unifies their surfaces by casting the final forms in bronze. This also gives Paolozzi's pieces greater permanence, which was a concern for the artist who saw the loss or damage of parts of earlier sculptures fabricated from less permanent materials, like plaster and wood.

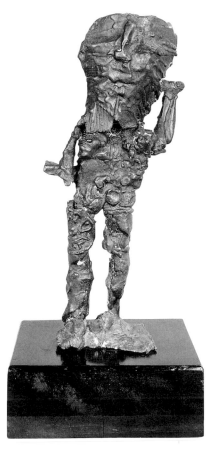

81

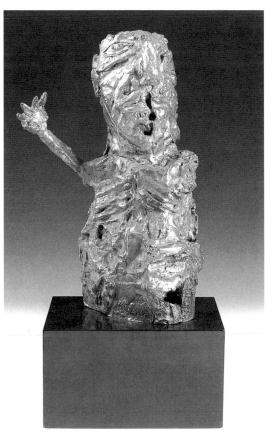

82

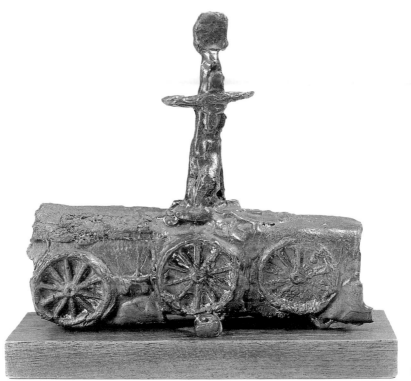

83

83
Eduardo Paolozzi
Born 1924
Man in a Motor Car, 1956
Cast bronze, unique?,
h. 11 3/8 (28.8)
Gift of Mr. and Mrs. Stanley
M. Freehling, 1985.1

as early as 1946 Paolozzi had created composite images of heads and masks that incorporated mechanical elements cut from secondhand books, such as the collage *Head of Demeter* in the scrapbook *Election*.[1] Even before the war Paolozzi had been compiling scrapbooks of ephemera, consisting of imagery cut from books and popular magazines of the day, which anticipate the iconography of Pop art with remarkable prescience. While living in Paris from 1947 to 1949, his recognition of the importance of Dadaist and Surrealist photomontage encouraged him to pursue this collage technique further. He perceived that a montage increased the layers of information and possible meanings in the picture beyond traditional representational imagery. The technique of collage forms an essential element in all his work from this period on, and his collaged drawings and notebooks plus related prints, beginning with the screenprint *Automobile Head* of 1954 (see cat. no. 80), are closely aligned to his sculpture of 1956–59, whose surfaces are built up by overlaying cast impressions of machine parts and other ready-made objects. In these works he suggests that man and machine are symbiotically interrelated in the extraordinary technological world of modern life, and his figure studies present a type of anthropomorphic machine.[2]

In addition to the example of found object assemblage in Dubuffet's sculptures from 1954 (see cat. nos. 81–82), Paolozzi was influenced here by Pablo Picasso's 1952 bronze *Baboon and Young*, which he saw in 1955 at a Picasso exhibition at Marlborough Fine Art, London. In Picasso's sculpture the baboon's head is composed of two toy automobiles and the ears from metal handlebars.[3] By 1956, Paolozzi had devised a method of creating wax sheets of impressions of miscellaneous ready-made detritus scavenged from the postwar urban environment and *objets trouvés* from the world of nature—from clock and radio parts, children's toys, and rejected industrial die castings to bits of wood and pieces of bark. He described these impressions as a handy reference: "DIRECTORY OF MASKS, sheets of an ALPHABET OF ELEMENTS awaiting assembly ... GRAMMAR OF FORMS ... DICTIONARY OF

DESIGN ELEMENTS."[4] The prepared wax sheets could be cut into pieces with a hot knife, bent, and recombined like the fragments of a three-dimensional collage on the surface of the wax, plaster, and metal maquette, as in *Man in a Motor Car*, and the final model then sent to the foundry for casting in bronze.

Whereas *Man in a Motor Car* embodies Paolozzi's personal vision of the inextricable union of modern man and machine, it also reflects an aspect of the widespread intellectual investigation of twentieth-century popular culture by various members of the Independent Group, the informal discussion group of young artists and critics affiliated with the Institute of Contemporary Arts in London. In 1955, the exhibition *Man, Machine and Motion* was held at the Institute of Contemporary Arts. Consisting of 223 photographs and photographic copies of drawings, the show was filled with images of cars, bicycles, airplanes, and other modern machines that illustrated "the mechanical conquest of time and distance [through] the structures which man has created to extend the powers of locomotion...."[5] One of the organizers, the seminal English Pop artist Richard Hamilton, had spoken four months before at a meeting of the Independent Group on American car styling, and the day before the opening, he delivered a version of this talk, called "Metal in Motion," to a general audience at the Institute of Contemporary Arts.[6]

84
Eduardo Paolozzi
Born 1924
Little Woman, 1957
Cast bronze, unique?,
h. 9 3/4 (24.8)
Lent by Rhoda Pritzker

this engaging study of a standing woman with arms raised over her head stands somewhat apart from Paolozzi's other sculptures from around 1957. Hand-fashioned, its surface shows neither the presence of found objects nor the collaged castings of bits of urban detritus (see cat. nos. 81–83). The sculpture's naive or primitivist appearance has ironic overtones, as the origin of the pose probably lies in the life-drawing classes of the Academy. Such poses, however, had also been appropriated by the vernacular world of cheap, glossy pin-up posters of Hollywood sex symbols and the sub-culture of "girlie" and "true confession" magazines, visual resources drawn from popular culture that Paolozzi had avidly collected and mined for his collages since the mid-1940s.

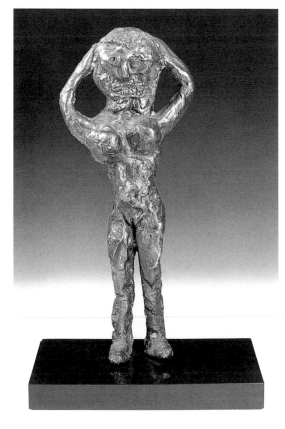

84

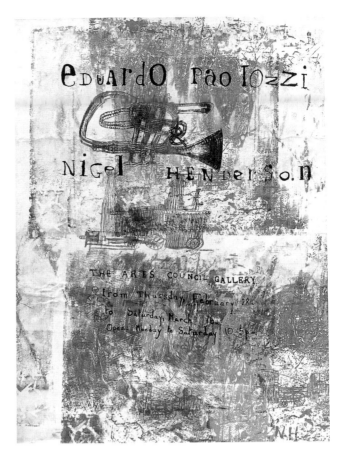

85

85

Nigel Henderson

1917–1984

Eduardo Paolozzi & Nigel Henderson, 1957

Color screenprint and lithograph, 29 15/16 x 22 (76 x 55.9)

Gift of Sylvia Sleigh, 1991.322

n the 1930s, Nigel Henderson had direct access to the upper-class bohemia of Bloosmbury and Peggy Guggenheim's gallery in London through his mother, who was a friend of Virginia Woolf's brother and manager of the gallery. By the outbreak of World War II, he was familiar with avant-garde art, including the work of Marcel Duchamp. They had met during the installation of a Duchamp exhibition at Guggenheim's gallery, where Henderson occasionally worked as a preparator. After the war, Henderson began to photograph working-class communities in the East End of London. His artistic reputation survives largely on the basis of his well-known Bethal Green photographs of 1948–52. The experimental side of his activity manifested itself throughout this period with photograms—shadowlike photographs made by placing objects between light-sensitive paper and a light source—of material from bomb sites, vegetables, and found objects. Henderson had suffered a nervous breakdown on leaving military service during the war, and this experience seems to have influenced another facet of his work, what he called the "stressed" photograph, in which he used a variety of darkroom techniques to experiment with the imagery of war destruction and the atrophy and decay of urban slums in the postwar period. This second direction in his work, with its latent existential attitude, culminated in 1956 with the large photocollage *Head of a Man* (Tate Gallery, London).[1]

Henderson and Eduardo Paolozzi had become friends during their student days at the Slade School of Art, and remained in professional contact through their activity with the Independent Group in London. In 1952, for example, the two had collaborated on an untitled photographic collage.[2] With fellow Independent Group participants Alison and Peter Smithson, they fabricated the Patio and Pavilion section—which included *Head of a Man* placed flat on the ground—of the *This Is Tomorrow* exhibition, staged by the Institute of Contemporary Arts at the Whitechapel Gallery in 1957.[3] This poster was designed that same year for their two-person exhibition at the Arts Council Gallery in Cambridge. Its popular imagery—a musical instrument and old-fashioned locomotives—is embedded in a blurred field of rubbed and mottled fragments of muted gray, blue, and red that strongly echoes the surface effects Henderson had achieved in the "stressed" *Head of a Man* photocollage from the previous year.

n 1946, Hubert Dalwood arrived at the Bath Academy of Art at Corsham to study sculpture, and an important early influence for him was the sculptor Kenneth Armitage, who was head of the Sculpture Department. Both were modelers, as opposed to carvers, and working on semi-abstracted human figures in the late 1940s and early 1950s. During 1957, Dalwood moved away from the human figure and made nonrepresentational pieces that he felt retained the organic structure of the body without any overt references to it. This change in direction was Dalwood's response to the example of abstract painters he met at Leeds University, where he held the Gregory Fellowship in Sculpture from 1955 to 1958. This period coincided with similar artist-in-residence grants at Leeds, first Terry Frost and then Alan Davie, as Fellows in Painting. Both employed imagery in their expressionist works, and Dalwood recognized that their individual brushstrokes could simultaneously define a shape and remain an abstract mark.[1]

What he came to value was the ambiguous readings offered by abstraction. *The City* is a remarkably inorganic work for Dalwood from this period and a harbinger of other sculptures to follow in 1959 and 1960, which, however abstract in appearance, retain references in shape and surface ornament to the physical world. A rising pillar with an elaborated middle section, this structure is reminiscent of the standing figure in its compact, vertical silhouette with a thinning at the top and base, but its title requires a reading of this work as either a model of something vastly bigger or as the image of a large skyscraper construction as seen from a great distance. This tension of interpretation is an underlying principle of Dalwood's pieces after 1957.

In 1958, the date of the Smart Museum sculpture, Dalwood was pioneering the use of aluminum as a sculptural medium, a material until then more often employed in industry and for consumer products. Dalwood cast his sculpture in aluminum for many years, and he learned to control the color of the sculpture's surface by means of a range of acids.

86

87

87
Hubert Dalwood
1924–1976
Open Square, 1959
Cast Aluminum, ed. of 6,
16 5/8 x 13 x 4 3/4
(42.2 x 33 x 12)
The Joel Starrels, Jr.
Memorial Collection,
1974.188

dalwood often combined geometric shapes with organic forms in his sculpture around 1960. He worked his models in clay, which allowed him to modify the surfaces of his pieces with a complex system of marks: sometimes the surface is richly modeled with the fingers and sometimes impersonal in its smoothness. In his short introduction to the catalogue for Dalwood's one-person exhibition at Gimpel Fils in London in 1960, Herbert Read suggested an affinity between the peculiarly "cryptic" style of the sculptures on view and the paintings of Alan Davie.[1] Dalwood and Davie knew one another from Leeds University, where both held fellowships in the late 1950s.

Davie's abstract paintings of the mid-1950s were both imagistic and gestural in brush-stroke; each painting usually began as an abstract sign and developed, through the painting process, allusive archaic or "primitive" imagery of unknown magical or ritualistic significance. In *Open Square*, Dalwood employed a similar wealth of freely invented forms, but also incorporated familiar shapes, such as the key and keyhole motifs. The ambiguity of meaning of such common motifs in this context transfers an aura of mystery to Dalwood's unfamiliar and inventive sculptural forms. Dalwood had, in fact, made quasi-utilitarian sculptures, "ritual objects" as he called them, in about 1949–50, but the sculptures made a decade later offer no easy reading as modern-day implements. Because of this numinous quality, *Open Square* and related works were characterized by Read and other critics at the time as archetypal or primeval objects, as exotic relics of an unknown ancient culture.[2]

88
Peter Blake
Born 1932
Wall, 1959
Collage, wood, and oil on masonite with original painted wooden frame, 18 7/8 x 11 1/4 (47.8 x 28.6)
Gift of Sylvia Sleigh in memory of Lawrence Alloway, 1991.277

One of the most celebrated British Pop artists, Peter Blake worked completely apart from the activities of the Independent Group, whose exhibitions in London he claims never to have visited. Throughout the 1950s the lectures and informal discussion meetings convened by this loosely defined group of young artists living in London, and the thematic shows they mounted under the auspices of the Institute of Contemporary Arts, examined the popular and mass-media culture of postwar Europe and America and its relation to the fine arts. Although these programs are now generally credited with having set the stage for the emergence of Pop art in Britain at the end of the decade, Blake's realist paintings from the first half of the 1950s are already filled with careful depictions of ordinary objects and consumer products such as comics. By 1957, Blake had introduced the principle of collage into his canvas with *painted* images of magazine covers, documentary photographs, souvenirs, ads, and the like. Executed two years after the seminal *On the Balcony* (Tate Gallery, London), this collage-painting is one of a series of formally inventive works made between 1959 and 1961, in which the artist actually combines a collection of mechanical reproductions drawn from popular culture with a severe, painted support. Blake here runs a row of identical, cheaply printed Edwardian advertising cards along the top of the composition. More than half of the construction below consists of clean diagonal bands of alternating primary colors (red and yellow) and a thin applied wooden strip in bright blue, all painted in ordinary house paint.

The words "wall" and "door" appear in the titles of many of these collage-paintings, and this idea is reinforced in such works by the simple, flat, and proportionally larger surface area of the lower sections in relation to the careful arrangements of the eye-catching ephemera, always limited to the top of the composition. In such works as *Wall* one is reminded most of the ubiquitous tack-boards, pin-up walls, and boards for displaying notices encountered in contemporary domestic and business life. For Blake, such works were meant to evoke the experience of the average consumer of popular culture, rather

than a sophisticated analysis of mass communication, as in the case of the contemporary British pop artist Richard Hamilton. In a 1963 interview Blake commented on this artistic position:

For me, pop art is often rooted in nostalgia: the nostalgia of old, popular things. And although I'm also continually trying to establish a new pop art, one which stems directly from our own time, I'm always looking back at the sources of the idiom and trying to find the technical forms that will best recapture the authentic feel of folk pop.[1]

The geometric fields of color employed in *Wall* may also refer to contemporary American "hard edge" painting. On the other hand, the intentionally battered appearance of the smoothly painted, bright surfaces, and the heraldic chevrons and other geometric motifs used in this series of paintings may reflect popular and folk art forms found in the fairground booth, circus prop, and gaudily painted barges and caravans of gypsies.[2] As is often the case in Blake's paintings, his imagery manages to blend the seriousness of "high art" and the banality of popular culture.

89
Allen Jones
Born 1937
Fast Car, 1962
Color lithograph,
proof impression,
22 7/8 x 31 1/16
(58.1 x 78.9)
Lloyd/Livingstone 16
Gift of Sylvia Sleigh,
1991.323

allen Jones is a prolific printmaker and skilled lithographer, who taught lithography at the Croydon College of Art after graduation from art school at Hornsey College. His earliest prints, including *Fast Car*, were printed and published by the artist himself. Jones favors color lithography for its capacity to establish a layer of rich color applied to the entire surface of the paper in a single movement through the press. Lithography is also a liberating force for him, as he commented in a 1968 interview, "because I think through my lithographs. Ideas which later crystallize into paintings, intentionally or otherwise, often appear in some form or another in my lithographs long beforehand."[1]

Best known for the eroticism in his later prints of the human figure, Jones made early forays into the world of fast moving vehicles, including automobiles, airplanes, and space flights.[2] Their appearance in his work is not so much an involvement with mass-media imagery as it is a hedonistic, ebullient response to life in the early sixties in the aftermath of the austerity of the postwar period, which in England had lasted well into the 1950s.

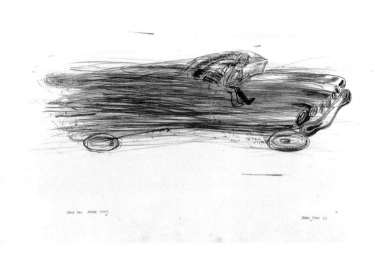

89

Jones's frenzied vision of car and driver in *Fast Car* is ultimately indebted to the Futurists' simultaneity of vision and celebration of mechanized speed. However, a closer intellectual context is the activities of the Independent Group in London in the 1950s and their exploration of aspects of postwar European and American culture in "sci-fi" space travel books and films, automobile ads and aircraft design manuals, and other expressions of the dynamic flux of science and commerce. The cover of the catalogue for the 1955 Independent Group *Man, Motion and Machine* exhibition reproduced a detail of a photograph of a race car that is strikingly close in feeling to the roaring car and driver in *Fast Car*.[3] Also, the Independent Group's wide-ranging interest in technology and mass-media advertising led them to reproduce in their publications all manner of X-ray imagery, technical manuals, and contemporary split-image glossy magazine illustrations that reveal both the interior and exterior of an object, a visual device used by Jones to great effect in this print.

There is a strong sense of spontaneity and insistence on the material identity of each mark in the blurred streak of parallel lines hastily applied to the plate of *Fast Car*. In writing on the prints of the early sixties, Marco Livingstone has proposed several influences on the development of Jones's mature style. Livingstone discussed both the ethos of American Abstract Expressionism, which Jones had encountered as an art student in the late 1950s, and the *faux naïf* figure style of Dubuffet, which was a strong influence at that time on other British artists, including Jones's fellow student at the Royal college, David Hockney. Also by 1960 Jones was beginning to experiment with Surrealist automatic drawing as a way of generating motifs, and the unmediated scribbled marks of these preparatory drawings often reappear in such prints as *Fast Car*.[4]

90
Richard Hamilton
Born 1922
A little bit of Roy Lichtenstein for …, 1964
Color screenprint, ed. of 40, 23 1/16 x 36 (58.6 x 91.5)
Waddington 53
Gift of Sylvia Sleigh, 1991.319

richard Hamilton is widely regarded as the father of British Pop art. The first public manifestation of this new direction in British art—which sought to close the gap between popular culture and "fine" art—was the enlargement of a Hamilton collage as a photo-mural that was included in the 1956 Independent Group exhibition *This is Tomorrow*. Provocatively titled *Just what is it that makes today's homes so different, so appealing?*, this collage (Kunsthalle, Tübingen), assembled from glossy and pulp magazine advertisements, shows a "modern" interior replete with a muscle-man holding a barbell imprinted with the word "pop".[1] Hamilton's sophisticated analysis of popular mass media and his use of banal imagery have remained constant elements in his work ever since.

As its title announces, the screenprint *A little bit of Roy Lichtenstein for…* takes as its subject the art of one of the leading American Pop artists of the early 1960s. It is an enlarged detail of a screenprinted announcement/poster for a 1963 exhibition of Lichtenstein's recent work at the Leo Castelli Gallery in New York. In Hamilton's print, the pear shape is a tear from the eye of a crying woman, and the four parallel strokes are shading on the nose. Hamilton wrote of this print:

My studio in the sixties always contained a Leica camera on a copying stand. It had a reflex attachment and bellows for extreme close-ups—basically a slide-making set up. I became addicted to using it as a microscope to look at details of any printed material around—playing at making compositions.… I had a Castelli poster, itself a caricature of a blow-up, for the Lichtenstein show of September '63 and I put this under the camera.… It was possible to make interesting crops on the already magnified regular field of dots.… I made several negatives of carefully contrived selections from the print and then, as carefully, selected one of the enlargements to be converted back to a screenprint.[2]

The relationship of Hamilton's print to its source is complex, involving both shifts in scale and crossovers of media. The Castelli announcement/poster, itself a blown-up detail, was a mechanical reproduction (screenprint) of a Lichtenstein canvas that combines traditional painting techniques with sections of screenprinting from stencils; the Lichtenstein painting was based on a commercial offset lithographic color comic strip, that was in turn the graphic transposition of the hand-colored drawing of the cartoon's creator. The minute dotting of the comic strip image, which created a uniform field of color, was enlarged into a recognizable formal device in Lichtenstein's painting, and despite a further blowing up of the dots in the Castelli announcement, the image was still recognizable there as "Lichtenstein dots". But Hamilton so aggrandized this signature Pop art motif that at first sight it is unrecognizable except as pure pattern.

Another level of formal complexity in Hamilton's print arises from his use of screen-printing, which lays down an apparent flat surface of color, but the pressing of the ink through a fine fabric mesh actually separates the pigment into minute particles, so that a close-up view of one of his "larger-than-life" dots paradoxically approximates the color offset lithography of the comic strip.

Hamilton's print constitutes a kind of metaphysical examination of the mechanics of artistic creation and transformation. When Hamilton presented prints from the edition to colleagues and friends, he wrote the title with the name of the recipient—the Smart Museum impression was given to the influential art critic and curator Lawrence Alloway—and the handwritten legend at the bottom of the print assumes the role of a dedication.[3] However, the meaning of the notation is ambiguous, for what constitutes the "little bit of Roy Lichtenstein for Lawrence Alloway"? What has been presented after all is a print by *Hamilton*, not Lichtenstein, and its image is in reality a sophisticated paraphrase of a photographically-derived detail *after* a reproduction of a painting by Lichtenstein. A final irony, of course, is the sheer physical size of the sheet and the overblown scale of the depiction, both of which belie the designation "a little bit".

91

Richard Hamilton
Born 1922
The Solomon R. Guggenheim, 1965
Color screenprint, ed. of 50,
23 1/16 x 22 15/16
(58.6 x 58.3)
Waddington 60
Gift of Sylvia Sleigh,
1991.320

hamilton's prints are often related to projects in other media, and this screenprint is the outgrowth of a series of drawings and reliefs from 1965–66 of the Solomon R. Guggenheim Museum in New York. Hamilton was initially drawn to the subject because of a problem of perspective inherent in Frank Lloyd Wright's modernist building: the spiral form of the museum encourages a false reading as stacked concentric circles. The six wooden reliefs were identical except for the cellulose lacquer finish, always applied with an air-gun, that disembodied the building's dramatic three-dimensional form "by transposing it into a skin of colour and texture with quite independent associations and effects."[1]

While working on the screenprint version, Hamilton recalls that "two halftone screens [red and yellow] were made from the sprayed drawings on film" and that he had "hoped to use these directly as positives to make the screens but they were too fine."[2] In this process, the print is not necessarily an end result for Hamilton, but may help the resolution of problems in related works. In the words of the artist, "*Interior* and *Marilyn* were made as part of a programme of work on paintings of these subjects. To some extent they operate as studies for the painted work and they offer a facet of a theme." He continues, "I was then fabricating a wooden form of the Guggenheim Museum in false perspective. One of the things I learned from proofing the screenprint version was the ability of the form to contain any colour variation that was applied. Maybe that suggested the possibility of a series of treatments for the final group of moulded reliefs."[3]

91

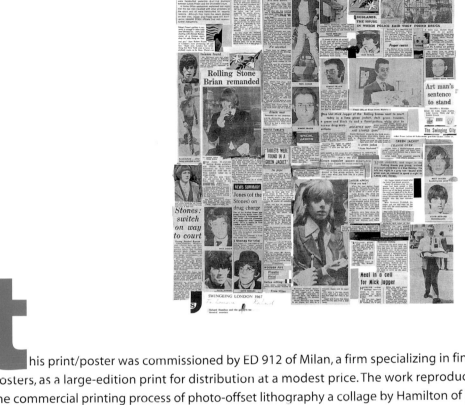

STONES: 'A STRONG, SWEET SMELL OF INCENSE'

92

92

Richard Hamilton
Born 1922
*Swingeing London
67–poster*, 1968
Color photo-offset
lithograph, ed. 6/1000,
27 7/8 x 19 11/16
(70.8 x 50)
Waddington 67
Gift of Sylvia Sleigh,
1991.321

his print/poster was commissioned by ED 912 of Milan, a firm specializing in fine-art posters, as a large-edition print for distribution at a modest price. The work reproduces in the commercial printing process of photo-offset lithography a collage by Hamilton of press clippings concerning the arrests of his art dealer, Robert Frazer, and the rock star Mick Jagger of the Rolling Stones. As shown here, the two were handcuffed together after their arrest on 12 February 1967 for possession of a controlled substance while at a party in the home of fellow Rolling Stone Keith Richards. Their arrest and prosecution were front-page news for weeks. The secretary at Frazer's gallery received a vast collection of press clippings from an agency the gallery employed to collect exhibition reviews. She agreed to Hamilton's request to give him this material, from which the original collage was fabricated.[1]

The spelling of "swingeing" in the title of the print is a play on words that adds several levels of meaning to this work:

"Swingeing" is a word infrequently encountered in America. It denotes a cutting or stinging physical rebuke. Hamilton has invoked this meaning as well as that of the then-popular phrase, "Swinging London," in reference to Robert Frazer who was, appropriately, featured in a *Time* article [15 April 1966] on London's swinging set. The judge presiding over the Jagger-Frazer hearing was known to have remarked that "these are times when a swingeing sentence can act as a deterrent."[2]

Always knowledgeable about the properties of the various print processes he employs, Hamilton chose consciously to use photo-offset lithography for its technical capacity to make a believable facsimile, or "straight reproduction" in Hamilton's words, of the original collage.[3] In choosing this process, he perhaps intended to distance this work from too close an association with fine-art printmaking and the traditional aesthetic premises it engenders. Hamilton commented on this print:

"Swingeing London 67" investigates the subject first at the level of pure information... A major difficulty with painting is that the very nature of the medium demands a degree of resolution in the formal rendering. The point is pressed home in the "poster" because it is apparent that the compilation of seemingly factual reports is full of contradictions. Form and color are elusive. Choice is arbitrary. Decision becomes whim.[4]

1955

LONDON-PARIS-NEW YORK: GESTURAL ABSTRACTION AND COLOR FIELD PAINTING

In 1956, the Tate Gallery presented the exhibition *Modern Art in the United States*, and the following year the Institute of Contemporary Arts exploited the growing interest in American painting in the London art world by offering a program liberally sprinkled with lectures, discussions, and exhibitions devoted to recent American art. Among these activities was a screening of Hans Namuth's film about Jackson Pollock, which documented the artist executing one of his "drip" paintings, with the canvas laid flat on the ground. The cultural attaché at the American Embassy, Stefan Munsing, also provided an important visual resource for Independent Group members by making available the embassy's extensive library, with its glossy magazines and books on American art. By the end of the decade recent French art, including the expressionistic abstract paintings of Georges Mathieu and the event-based works of Yves Klein, was also being shown with greater frequency in London.

The effects of the meetings of the Independent Group held between 1952 and 1955 reverberated both inside and outside the Institute of Contemporary

Arts. In 1958, for example, Richard Hamilton created an exhibit for the *Daily Mail's Ideal Home Exhibition.* This project typified the interest among vanguard British artists for recent American and French developments in art and design: featured in the large window at the entrance was a streamlined car, and inside were works by Eduardo Paolozzi, Sam Francis, and Yves Klein; the gallery furniture was designed by Harley Earl, chief stylist at General Motors. Connections between the Institute of Contemporary Arts and the Royal College of Art were likewise important for developments in British art in the next decade. Royal College students like Robyn Denny frequented the Institute, and Hamilton was a part-time tutor at the College, for instance.

Among the younger generation of painting students at the Royal College such as Denny there was considerable experimentation with the techniques of American and French gestural abstract painting and the informal methods associated with Jean Dubuffet's *art brut.* They participated in group exhibitions—*Place* in 1959 and *Situation* in 1960—that proclaimed a new generation of abstract painters. As the decade ended, direct exchanges among British and American artists became more frequent through travel to the United States. In 1957, for example, William Turnbull—one of the original Independent Group participants—visited the United States, where he met many of the leading New York Abstract Expressionist painters, and that year he also made his first nonfigurative, nearly monochromatic paintings.

1965

93

William Turnbull
Born 1922
Untitled, circa 1957–58
Brush and ink on wove
paper, 22 x 30 1/8
(55.9 x 76.5)
Gift of Sylvia Sleigh,
1991.305

94

William Turnbull
Untitled, circa 1957–58
Brush and ink on rice
paper, 25 1/2 x 34 1/4
(64.8 x 87)
Gift of Sylvia Sleigh,
1991.306

the direction in Turnbull's work before 1956 shows a steady move away from representational imagery, for example, in the *Head* paintings and drawings where a layered system of paint marks increasingly dematerialized the motif in the painting process. In 1956, these ideas were reinforced when Turnbull saw an exhibition at the Tate Gallery of recent American Abstract Expressionist paintings. Turnbull's abandonment of figurative content coincides with this event: in early 1957 the brushmarks became autonomous in several nearly monochromatic paintings completed before his first visit to the United States that year. In New York he met a number of the major Abstract Expressionists, although he was as yet unaware of Barnett Newman. He responded most strongly to the work of Mark Rothko and Clyfford Still, and to the all-over drip paintings of Jackson Pollock. Turnbull was also familiar with the gestural abstractions of Georges Mathieu, Yves Klein, and other French action- and event-based painters, whose work was increasingly shown in London at the end of the fifties. Remarks made by Turnbull in 1957 capture the essence of this new abstract direction in his painting:

…the absorption of nature and the act of painting are two activities reconciled during the act of painting.…It is impossible to pre-plan—it is a live performance.…It can stem from the deepest respect for things, from the belief that one does not attempt to imitate them or recreate them in their own terms. The artist attempts to create a new object, participating as a parallel activity.[1]

The oil in Turnbull's work of 1957 and 1958 was applied in different ways: sometimes there is a limited gestural stroke that lays the pigment down quickly and thickly as clotted scribbles, sometimes the strokes coalesce into simple, large shapes, with the paint more uniformly set down in thinner layers. Both approaches—and the resulting nonrepresentational imagery—are seen in the two Smart Museum drawings.

The more gestural brush-and-ink drawing also reveals Turnbull's interest in Zen calligraphy, especially in the so-called "flying white" technique—where the inked hairs of the

93

94

brush separate, revealing the white of the paper, when quickly dragged over the surface of the sheet—and in the splotches and spattered ink where the loaded brush hits the paper with great force and speed. In the other work from 1957–58, the brushstrokes are more mediated, and the structure is more formal. Turnbull has also consolidated the imagery to a single broad vertical band flanked by ovals forming a composition reminiscent of Robert Motherwell or Still.

95
William Turnbull
Born 1922
17-1963 (Mango), 1963
Oil on canvas, 73 1/2 x 100
(186.7 x 254)
Gift of Sylvia Sleigh, 1991.3

during 1959, Turnbull's painting became less concerned with gestural marks and more with flat surface. These abstract paintings comment on the process of their own making; and in the monochromatic canvases, approached chromatically rather than tonally, their identity arises in the brushing of successive thin layers of paint that achieve a rich colorism. Furthermore, the painter's resistance at this time to pronounced distinctions within the composition made him conceive any single painting as a coloristic whole. In his introduction to the catalogue of an exhibition of paintings held in London in 1960, Lawrence Alloway examined Turnbull's new painterly approach:

He covers his canvas in one, with diluted paint, and covers it again and again, each time completely. By this process the colour is intensified and brought under control, neither watery and patchy.... The method of applying flat, even, all-over washes is frankly visible, but its traces are reticent and tranquil. Materiality in painting has often been identified with the weight of paint laying thickly encrusted on the canvas. To Turnbull, however, who is like Rothko in this respect, materiality is a function of the ground itself, of the canvas. To achieve this colour must be flat and bodiless as a dye so

that the tangibility of the cloth is preserved. There is a paradoxical interplay of the colour washes and the constituent ground The whole painting becomes a unique sign, a field of colour.[1]

For the artist, these paintings are perceptual and intuitive rather than conceptual or theoretical works.

Also, the paintings of the late 1950s and early 1960s became increasingly large. There is a hidden reference to popular culture—the overwhelming size of CinemaScope movie screens—in these broad, horizontal, thinly painted surfaces. Turnbull was an avid movie-goer and often sat in the front row at the movies so that the sweep of the enormous image enveloped him. He was particularly impressed by those moments when the wide screen was filled with a single field of one color. Turnbull projected this environmental experience to the viewer in the sheer size of the flat, non-illusionistic picture surface.[2]

During a trip to Singapore in the winter of 1962–63, Turnbull was struck by the vigor of jungle vegetation and the uniformity of its color and texture, broken only by a river's winding course, when viewed from the air. In this canvas and several others executed after this experience, the white gap between single-color areas of paint is analogous to the aerial views of the jungle and river.[3] But the artist reduced to a minimum any reading of this internal articulation as a line dividing independent shapes. Instead, it acts as a positive element, a fracture that unifies the feathery edges of the very thinly painted color fields (that were at times rubbed also with rags for a soft, organic quality), and inflects the monochromatic surface without suggesting illusionism or depth between shapes.

95

96
Robyn Denny
Born 1930
Untitled, 1959
Gouache on wove paper,
21 13/16 x 22 (55.7 x 55.9)
Gift of Sylvia Sleigh,
1991.300

97
Robyn Denny
Untitled, 1959
Gouache on wove paper,
22 3/4 x 32 3/16
(57.8 x 81.8)
Gift of Sylvia Sleigh,
1991.301

98
Robyn Denny
Untitled, 1959
Gouache on wove paper,
32 3/16 x 22 3/4
(81.9 x 57.8)
Gift of Sylvia Sleigh,
1991.302

the growing confrontation in the mid- to late 1950s between mainstream British modernism and a new sensibility belonging to a younger generation in their mid-twenties was embodied in a vituperative event at the Royal College of Art in November 1956. John Minton, a senior neo-Romantic painter and Royal College tutor (see cat. no. 22), delivered an embittered critique of student work at one of the "Sketch Club" sessions, in which he decried the rising influence of recent American and French art, in particular the painting techniques associated with New York action painting and the informal methods of Dubuffet's *art brut*. During his hour-long diatribe, he singled out a large abstract painting by Robyn Denny as symptomatic of this new tendency. Subsequently given the title of *Eden Come Home* (collection of the artist), the work consists of puddles and smears of partially scorched bitumen brutally applied over a board surface.[1]

The large gouaches from 1959 in the Smart Museum, made nearly three years after this now legendary incident, show Denny's continued engagement with the aesthetics of gestural abstract painting, but significant changes have moderated the rawness of the student work. In each sheet, individual strokes are less overt, having coalesced into elementary shapes, some with soft edges, others with the regularity of geometric forms. Large individual elements are restricted to no more than three or four per work. There is a mood of restraint in the reasoned positioning of these flatish fields inside the edges of the sheet, which is very different from the all-over composition and coarse smears on the edges of works like *Eden Come Home*.

All the formal shifts in these drawings, as well as the use of a restricted palette of saturated hues, are especially noteworthy in the context of the paintings that followed in 1960. In those generally large-scaled pieces, Denny achieved an ordered harmony of squares, rectilinear oblongs, and other hard-edged shapes fused in symmetric, rectangular designs. The painted surfaces are now impeccable, flat planes of different colors, all within the same tonal range. The self-assertiveness lingering in the Smart Museum gouaches has been replaced by an unrhetorical control of proportion, color, and spatial mutability.

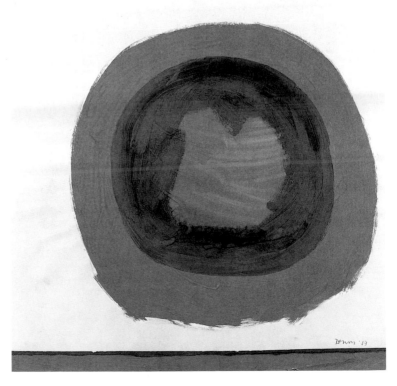

96

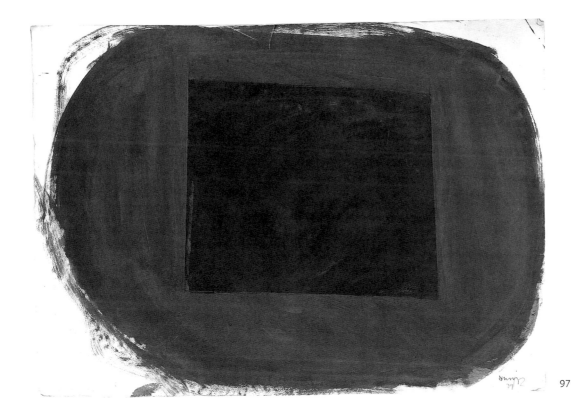

97

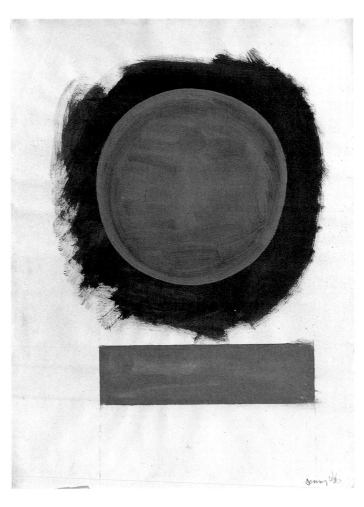

98

99
Robyn Denny
Born 1930
Untitled, 1959
Gouache on wove paper,
9 5/8 x 8 1/4 (24.4 x 21)
Gift of Sylvia Sleigh,
1991.303

his 1959 gouache is of considerable historic interest for it is a small version, perhaps a preliminary study, of the large 1959 painting *Place Painting* (collection of the artist). Measuring seven by six feet, the latter was included in the provocative *Place* exhibition mounted in 1959 at the Institute of Contemporary Arts.[1] In this exhibition, three painters—Ralph Rumney, Richard Smith, and Denny—assembled clusters of large abstract paintings in maze formation, set upright directly on the floor. The text for the show referred to the American abstract paintings of Barnett Newman, Jackson Pollock, Mark Rothko, and Clyfford Still as important stimuli for the participants. Although the exhibitors' primary expressed interest was in the large size of their canvases and the environmental quality they projected, the critical language of the text follows Clement Greenberg's formulation of New York School action and field painting as an event, in which the artist's activity—preserved by the traces of paint on the surface of the canvas—is of paramount importance.[2]

The restricted palette within these works is the consequence of one of the rules laid down for the show: a color control—red, green, black, and white—designed to unify the exhibition while clarifying the individual painters' styles. A comparison with other gouaches from 1959 (see cat. nos. 96–98) reveals that the hues here are more broadly defined as chromatic fields, covering the surface from edge to edge, and there is greater compositional rigor in the stacking of the red, green, and white segments. This shift in style is critical to the austere geometry of Denny's paintings of the next decade.

99

100
John Latham
Born 1921
Skoob, circa 1960
Altered printed book,
Dr. Eustace Chesser,
l. 1 9/16 (4)
Gift of Sylvia Sleigh in
memory of Lawrence
Alloway, 1994.68

orn in Zimbabwe (then Northern Rhodesia), Latham attended the Chelsea School of Art, London from 1946 to 1950. Originally a painter, he developed a technique of using atomized paint from an electrical spray gun to develop his images. In 1958, Latham began using books as leitmotifs in his paintings and sculptures. Their deployment was not only physical, but also metaphoric. He coined the term "skoob" for these objects, one of many reversals of spelling used by the artist to denote his elaborate metaphysical system, developed around the "event-structure" concept.[1]

Latham's art theories were profoundly influenced by the investigations, published in 1959, of his friends Clive Gregory and Anita Kohsen, an animal behaviorist and an astronomer, respectively, who had founded the Institute for the Study of Mental Images in 1954. Concerned by the lack of connections among individual scientific disciplines, religions, and technologies, they sought to define a new comprehensive, universal system based on the "language of events". For them, the fundamental unit of the universe was an event, not atomic structure. Latham's painted assemblage reliefs followed this principle of integration, in their use of books from different disciplines within a fine arts context. The temporal relativism of the Kohsens' cosmology found expression in Latham's Skoob Tower ceremonies, begun in 1954, in which tall stacks of books were ritually burned. The books were not altered by the artists before burning, but the selection of titles was symbolic: for example, encyclopedias were used for a Skoob Tower event at London University, and *The Metropolitan Museum Seminar in Art* series for another in front of the British Museum. For Latham, these events were not anti-intellectual attacks but affirmations of his belief that the foundations of Western culture, symbolized by the printed word, had ceased to have meaning for modern life.

The first "skoob" reliefs had been followed in 1960 by works called "soft skoobs", individual books that had been altered by the artist. This "skoob" is a more intimate example, a gift of the artist to the critic Lawrence Alloway: although it is small enough to be held in the hand and used in a normal way, the sides and spine have been trimmed into fanciful curves. This alteration undermines any conventional "reading" of the disrupted flow of printed text and emphasizes instead the sculptural qualities of the object. In such hand-held works, Latham forces a more active participation on the part of the spectator, an "event-structure" strategy in which the significance of the object is revealed by the passage of time, as here by the act of thumbing through the pages of the volume.

100

NOTES

FROM BLAST TO POP

1. The use of the words "England" and "English" in this essay is quite specific, since English art is distinct from Scottish, which has a history of its own. Later in the essay (see n. 9) "British" is used to describe the art and artists of the whole of the United Kingdom.

2. Wyndham Lewis, "Long Live the Vortex," in *Blast: Review of the Great English Vortex*, no. 1, June 1914 (London and New York: John Lane, 1914), 7.

3. Seven and Five manifesto quoted in Charles Harrison, *English Art and Modernism 1900–1939*, 2nd ed. (New Haven and London: Paul Mellon Centre for Studies in English Art by Yale University Press, 1994), 164–165.

4. Naum Gabo, J.L. Martin, and Ben Nicholson, "Editorial," in *Circle: International Survey of Constructive Art* (New York: E. Weyhe, 1937; reprint London: Faber and Faber, 1971), vi.

5. Naum Gabo contributed two essays to *Circle*: "The Constructive Idea in Art" and "Sculpture–Carving and Construction in Space;" Walter Gropius published "Art Education and State;" László Moholy-Nagy "Light Painting;" and Piet Mondrian "Plastic Art and Pure Plastic Art (Figurative and Non-Figurative Art)." Other contributions came from Winifred Dacre (the wife of Ben Nicholson), Herbert Read, Le Corbusier, Ben Nicholson, Barbara Hepworth, Henry Moore, J.D. Bernal, J.M. Richards, Maxwell Fry, Marcel Breuer, Richard Neutra, Alberto Sartoris, J.L. Martin, Siegfried Giedion, Léonide Massine, Jan Tschichold, Karel Honzíg, and Lewis Mumford.

6. London, New Burlington Galleries, *The International Surrealist Exhibition*, 11 June–4 July 1936. The organizing committee for the exhibition was made up as follows: In England—Hugh Sykes Davies, David Gascoyne, Humphrey Jennings, McKnight Kauffer, Rupert Lee (Chairman), Henry Moore, Paul Nash, Roland Penrose (Hon. Treasurer), Herbert Read; in France—André Breton, Paul Eluard, Georges Hugnet, Man Ray; in Belgium—E.L.T. Mesens; in Scandinavia—Vilh. Bjerke Petersen; and in Spain—Salvador Dalí.

7. London, New Burlington Galleries, *Exhibition of Twentieth Century German Art*, July 1938.

8. Graham Sutherland "discovered" Pembrokeshire in 1934 and was immediately fascinated by its secret lanes, hidden by high bands and hedges, and by the gnarled branches of the sea-blown trees. He wrote about it in a letter published in the magazine *Horizon* (5 [April 1942]: 225–235): "I wish I could give you some idea of the exultant strangeness of this place—for strange it certainly is, ... and I cannot but admit that it possesses an element of disquiet.... The whole setting is one of exuberance—of darkness and light—of decay and life. Rarely have I been so conscious of the contrasting of these elements in so small a compass."

9. The word "British" is used here, first because two of the artists to be discussed in this section, Eduardo Paolozzi and William Turnbull, are Scottish (even though they have lived and worked in London since the late 1940s), and second because the Arts Council and British Council promoted art from the whole of Britain, rather than from England alone.

10. The Arts Council of Great Britain was set up in 1945 to promote the arts within Great Britain. It assumed these responsibilities from the Council for the Encouragement of Music and the Arts (CEMA) which had been founded in 1939, a few months after the outbreak of war. The British Council was set up in 1934 with the "official responsibility for cultural and social relations between the United Kingdom and peoples of other lands."

11. The British Council either organized or supported the following exhibitions of Moore's work after the war: the Museum of Modern Art, New York (1946); the Art Institute of Chicago and the San Francisco Museum of Art (1947); the State Galleries of Australia (1947–48); the twenty-fourth Venice Biennale, where Moore won the International Sculpture Prize (1948); the Palais des Beaux-Arts, Brussels and the Musée d'Art Moderne, Paris (1949); the Stedelijk Museum, Amsterdam, the Hamburger Kunsthalle, the Städtischen Kunstsammlungen, Düsseldorf, and the Kunsthalle, Berne (1950), among others. The Arts Council commissioned a sculpture from Moore, *Reclining Figure* (Scottish National Gallery of Modern Art, Edinburgh), for the 1951 Festival of Britain and also organized an exhibition of his work to coincide with the Festival at the Tate Gallery in London.

12. Between 1948 (the first postwar Biennale in Venice) and 1960 the British Council organized the following shows in the British Pavilion: 1948, J.M.W. Turner and Henry Moore (awarded the International Sculpture Prize); 1950, John Constable, Barbara Hepworth, and Matthew Smith; 1952, Graham Sutherland (awarded the acquisition prize of the São Paulo Museu de Arte Moderna, Brazil) and *New Aspects of British Sculpture*, including Robert Adams, Kenneth Armitage, Reg Butler, Lynn Chadwick, Geoffrey Clarke, Bernard Meadows, Henry Moore, Eduardo Paolozzi, and William Turnbull; 1954, Ben Nicholson (awarded the Ulisse Prize), Francis Bacon, Lucian Freud, and Reg Butler (works relating to his *Unknown Political Prisoner* monument), and lithographs by Allin Braund, Geoffrey Clarke, Henry Cliffe, Robert Colquhoun, William Gear, Henry Moore, Eduardo Paolozzi, Ceri Richards, William Scott, and Graham Sutherland; 1956, Ivon Hitchens, Lynn Chadwick (awarded the International Sculpture Prize), and *Four Young Painters*, consisting of John Bratby, Derrick Graves, Edward Middleditch, and Jack Smith; 1958, Kenneth Armitage (awarded the David E. Bright Foundation Prize for a sculptor under forty-five), S.W. Hayter (awarded first prize for a religious work), William Scott, and Sezione Giovanni, including Sandra Blow, Anthony Caro, and Alan Davie; 1960, Geoffrey Clarke, Henry Cliffe, Merlyn Evans, Eduardo Paolozzi (awarded the David E. Bright Foundation Prize for a sculptor under forty-five), and Victor Pasmore. For a detailed history of the British Pavilion at the Venice Biennale, see Sophie Bowness and Clive Phillpot, eds., *Britain at the Venice Biennale 1895–1995* (London, 1995).

13. The phrase "geometry of fear" was coined by Herbert Read in his catalogue introduction to *New Aspects of British Sculpture* for the British Pavilion at the 1952 Venice Biennale. Read describes the work of these young sculptors thus: "They are all under forty, for the most part born during or immediately after the First World War. Two of them were only sixteen at the beginning of the Second World War. It would be unreasonable, therefore, to look for the classical images that an earlier generation had seen reflected in the untroubled waters of their childhood. These new images belong to the iconography of despair, or of defiance; and the more innocent the artist, the

more effectively he transmits the collective guilt. Here are images of flight, or ragged claws 'scuttling across the floors of silent seas,' or excoriated flesh, frustrated sex, the geometry of fear." This is a re-statement of Wilhelm Worringer's aesthetic theory that artists who fear the outside world, who live in a hostile environment, tend toward abstraction in their work, seeking a safe anchor in inner geometry rather than face the chaos of appearances. Artists who live in happier surroundings, such as the Mediterranean countries, tend to mirror the outer world in a more organic artistic expression. For further discussion of Worringer's influence on Read and others see below.

14. Herbert Read, *"New Aspects of British Sculpture" in The British Pavilion. . . The XXVI Biennale, Venice 1952* (exhibition catalogue).

15. The English artists who were shown in the 1936 *International Surrealist Exhibition* were Eileen Agar, John Banting, Jogn Selby Bigge, Edward Burra, Cecil Collins, P. Norman Dawson, Merlyn Evans, David Gascoyne, S.W. Hayter, Charles Howard, Humphrey Jennings, Rupert Lee, Len Lye (originally from New Zealand), Robert Medley, Reuben Mednikoff, Henry Moore, Grace Pailthorpe, Roland Penrose, Graham Sutherland, and Julian Trevelyan.

16. Francis Bacon's early, prewar work shows his debt to Picasso very clearly. See for example his painting *Crucifixion* of 1933 which Herbert Read illustrated in his book *Art Now—An Introduction to the Theory of Modern Painting and Sculpture* (1933) opposite Picasso's painting *Baigneuse aux bras levées* of 1929 (Zervos, VII, no. 255).

17. Boiffard's extraordinary close-up photographs of a big toe (*Untitled,* 1929) and of an open mouth (*Untitled*, 1930) were both used in George Bataille's renegade Surrealist magazine *Documents* to illustrate two of Bataille's key entries for his "critical dictionary": "Le Gros Orteil" (*Documents* 1, no. 6 [November 1929], 297–302) and "La Bouche" (*Documents* 2, no. 5 [1930], 299–300). See also Dawn Ades, "Web of Images," in *Francis Bacon* [exh. cat.] (London: Tate Gallery, 1985), 13, for a discussion of the importance of Boiffard and Bataille for Bacon.

18. The figures in Bacon's seminal work *Three Studies for Figures at the Base of a Crucifixion* (1944, Tate Gallery, London) owe a clear debt to Picasso's metamorphic bathers of the late 1920s.

19. See R.B. Kitaj, "School of London," in *The Human Clay: An Exhibition Selected by R.B. Kitaj* [exh. cat.] (London: Arts Council of Great Britain, 1976).

20. Michael Fried, *Three American Painters: Kenneth Noland, Jules Olitski, Frank Stella* (Cambridge, Massachusetts: Fogg Art Museum, Harvard University, 1965), 4–10; reprinted in Francis Frascina and Charles Harrison, eds., *Modern Art and Modernism: A Critical Anthology* (London: Harper and Row, 1982), 115–121, this quote, p. 115.

21. See Lawrence Alloway, "The Development of British Pop," in Lucy R. Lippard, *Pop Art* (London: Praeger, 1966), 28: "A potent preliminary move in the direction of Pop Art in England occurred from 1949 to 1951, the period in which Francis Bacon began using photographs in his work . . . Bacon's use of mass-media quotations differs from earlier uses by painters, in that recognition of the photographic origin of the image is central to his intention."

22. The Independent Group was a loose group of artists, architects, critics, and writers who met together under the umbrella of the Institute of Contemporary Arts in London from 1952–53 and in a second session from 1954–55 to discuss aspects of contemporary life, culture, art, science, and technology, as wide ranging as helicopter design, the machine aesthetic, and advertising and fashion.

The members included Lawrence Alloway, Reyner Banham, Magda Cordell, Richard Hamilton, Nigel Henderson, John McHale, Eduardo Paolozzi, Toni del Renzio, Alison and Peter Smithson, and William Turnbull.

23. See Alloway, "Development of British Pop," 32.

24. Paolozzi gave the first "lecture" of the newly-formed Independent Group: a series of epidiascope projections, without verbal commentary, of seemingly random images from popular magazines, postcards, advertisements, and diagrams in the spirit of the collages he was then making. Many of the images he used formed the basis of his later suite of silkscreen prints *Bunk* (1972), which was the name Paolozzi had give to his legendary "lecture".

25. See David Robbins, ed., *The Independent Group: Postwar Britain and the Aesthetics of Plenty* [exh. cat.] (Cambridge, Massachusetts and London: MIT Press, 1990), 94.

26. Ibid.

27. James Lingwood, "Nigel Henderson," in Robbins, *The Independent Group*, 76.

28. According to the compiler of *Nigel Henderson: Paintings, Collages and Photographs* [exh. cat.] (London, Anthony D'Offay, 1977)), Henderson lent Hamilton his own copy of Duchamp's *Green Box* for twenty years. Hamilton has recalled: "It was Nigel . . . who drew my attention to a copy of Marcel Duchamp's *Green Box*. He suggested one day that, since we were near, we might drop into the Penroses for tea, and there made free of Roland's library for my benefit" (*Richard Hamilton, Collected Words 1953–1982* [London and New York: Thames and Hudson, 1983], 10).

29. For information on Toni del Renzio, see David Robbins, "Critical Writings," in Robbins, *The Independent Group*, 178–179. Only one edition of *Arson* was published, in March 1942 in London, with articles by André Breton, Nicolas Calas, Pierre Mabille, Robert Melville, and Toni del Renzio.

30. The Independent Group and Toni del Renzio in particular were very interested in the refusal of the Dadaists to accept Aristotelian logic and all phenomena on equal terms. They seemed to have come upon the idea of non-Aristotelian logic through their reading of science fiction. For example, Graham Williams writes: "In its attempt to reassess Dada, the Independent Group connected it with non-Aristotelian logic, drawing upon Alfred Korzybski's weighty volume *Science and Sanity* (1933), as well as A.E. van Vogt's SF [science fiction] novel *The World of Null-A* [serialized in *Astounding Science Fiction* during 1945]. Korzybski's belief that semantic adherence to an Aristotelian view—an either-or logic—inevitably led to unlogic, then illogic, prompted the IG [Independent Group] to interpret Dada as a manifestation of Non-Aristotelian ('Null-A') thought." See Graham Whitham, "Science Fiction," and Diane Kirkpatrick, "The Artists of the IG: Backgrounds and Continuities," in Robbins, *The Independent Group*, 61 and 209, respectively.

31. The library and archive of Roland Penrose are now in the Scottish National Gallery of Modern Art, Edinburgh. For information on Penrose, see Roland Penrose, *Roland Penrose Scrapbook 1900–1981* (New York: Rizzoli, 1981).

32. The list of things that "we love" and "we hate" is printed in the third section of the catalogue of *This is Tomorrow*. This section was devoted to a collaborative work by the artists J.D.H. Catleugh, James Hull, and Leslie Thornton. Other "loves" included: "built-in helps, 1,132 miles per hour, organised chaos, noise, sex, American cars, scientific smells, comfortable beds, deep penetration, Eartha Kitt;" other "hates"

included: "beauty of refinement, church, beauty, fine furniture, in bed, alone, the English way of life, country-fresh, character." In the Vorticists' publication *Blast*, the "Blasted" list included: "(from politeness) England," "France … Sentimental Gallic Gush… Parisian parochialism," "The Britannic aesthete, cream of the snobbish earth," "the amateur, sciolast, art-pimp, journalist, self man, no-organ man," "humour, quack English drug for stupidity and sleepiness… sport, humour's first cousin and accomplice," "years 1837 to 1900;" the "blessed" list included: "England for its ships which switchback on blue, green and red seas all around the pink earth-ball," "all ports … restless machines of scooped out basins, heavy insect dredgers, monotonous cranes… England, industrial island machine, pyramidal workshop, its apex at Shetland, discharging itself on the sea," "the hairdresser. He attacks Mother Nature for a small fee," "English humour. It is the great barbarous weapon of the genius among races… Shakespeare, for all his bitter Northern rhetoric of humour," "France for its bushels of vitality… masterly pornography…combativeness, great human sceptics…."

33. The Tate Gallery retrospective, which included works by other Vorticists and contemporaries, was toured by the Arts Council to Bristol, Glasgow, Leeds, and Manchester later in 1956. A book, *The Art of Wyndham Lewis*, edited by Charles Handley-Read and with a critical evaluation by Eric Newton, had been published in London in 1951.

34. For an extended discussion of the ideas expressed in *Blast*, see Richard Cork, *Vorticism and Abstract Art in the First Machine Age*, 2 vols. (Berkeley and Los Angeles: University of California Press, 1976). Several of the articles published in *Blast* are reprinted in Karin Orchard, ed., *Blast: Vorticismus—Die erste Avantgarde in England 1914–1918* [exh. cat.] (Hanover: Sprengel Museum; Munich: Haus der Kunst, 1996).

35. Having fallen out with Roger Fry, Wyndham Lewis, together with the nucleus of what was to become the Vorticist group, left the Omega Workshops in October 1913 and formed the Rebel Art Centre in March 1914. The impetus behind the launching of the magazine *Blast* and the formation of the Vorticist group was the attempt by Filippo Marinetti and Richard Nevinson to coerce them into joining the Futurists, when the latter two issued what amounted to an English Futurist manifesto in June 1914. The names of Lawrence Atkinson, David Bomberg, Jacob Epstein, Frederick Etchells, Cuthbert Hamilton, Lewis, William Roberts, and Edward Wadsworth were attached to the manifesto without their knowledge or permission.

36. Quoted in Cork, *Vorticism*, I:137, as are all subsequent quotes from this catalogue.

37. See *Manifesto* (No. 2), par. III, 1; reprinted in Orchard, *Blast: Vorticismus*, 285.

38. See *Manifesto* (No. 2), par. IV, 1; reprinted in ibid.

39. Wilhelm Worringer, *Abstraktion und Einfühlung* (Munich, 1908); first published in English as *Abstraction and Empathy* (New York: International Universities Press, 1953).

40. See n. 13.

41. T.E. Hulme was also a poet, who was closely associated with Ezra Pound before the First World War and who wrote for the magazine *The New Age*. Worringer's ideas on aesthetics were first drawn to Hulme's attention in the winter of 1911, when he heard Worringer speak at the Berlin Aesthetic Congress. For a discussion of Hulme's ideas and of Worringer's influence on him, see Cork, *Vorticism*, I:138–144.

42. Fry's "An Essay in Aesthetics" was first published in *New Quarterly* (1909) and reprinted in Roger Fry, *Vision and Design* (London: Chatto and Windus, 1920); quoted in Frascina and Harrison, *Modern Art and Modernism*, 80–81.

43. Clive Bell, *Art* (London, 1931); quoted in ibid., 72.

44. "These relations and combinations of lines and colours, these aesthetically moving forms, I call 'significant form'; and 'significant form' is the one quality common to all works of visual culture." Ibid., 68.

45. Moore quoted in Philip James, ed., *Henry Moore on Sculpture* (London: MacDonald, 1966), 33; first published in John and Vera Russell, "Conversations with Henry Moore," *The Sunday Times* (London), 17 and 24 December 1961.

46. Ibid., 49; first published in James Johnson Sweeney, "Henry Moore," *Partisan Review* 14, no. 2 (March–April 1947).

47. Read's first published writing on Moore was a review of an exhibition in *The Listener* in 1931. Some of these views were used again that year in his highly influential and popular *The Meaning of Art* (London, 1931) where Read wrote (p. 149): "We may say without exaggeration that the art of sculpture has been dead in England for four centuries; equally without exaggeration I think we may say that it is reborn in the work of Henry Moore." Read expanded what he wrote here in *Art Now: An Introduction to the Theory of Modern Painting and Sculpture* (London: Faber and Faber, 1933). His first monograph on the artist, *Henry Moore, Sculptor: An Appreciation* (London: A. Zwemmer), followed in 1934. He went on to write numerous articles and chapters on Moore, but the most important individual books are: *Henry Moore* (London: Lund Humphries, 1957), the first volume of the catalogue raisonné of the sculpture, for which Read wrote the introduction, and the monograph *Henry Moore: A Study of his Life and Work* (New York: Praeger, 1965).

48. Read's bibliography is extensive. In the early 1930s, he wrote regular reviews and articles for *The Listener*, but also published books on aesthetics (*The Meaning of Art*, 1931), contemporary art (*Art Now*, 1933), industrial art (*Art and Industry*, 1934), and the relationship between art and society (*Art and Society*, 1937). For a detailed bibliography and discussion of his writings, see the excellent Benedict Read and David Thistlewood, eds., *Herbert Read: A British Vision of World Art* [exh. cat.] (Leeds: Leeds City Art Galleries, 1993).

49. T.E. Hulme's papers were edited posthumously by Read in *Speculations, Essays on Humanism and the Philosophy of Art* (London, 1924). For a discussion of Hulme's influence on Read, see Andrew Causey, "Herbert Read and the Northern Tradition 1921–33," in Read and Thistlewood, *Herbert Read*, 38–53.

50. Herbert Read, *Meaning of Art*, 27, par. 25.

51. While working in the Department of Ceramics at the Victoria and Albert Museum in London in the early 1920s, Read became acquainted with the eminent German art historian Max Sauerlandt, who was then director of the Museum of Applied Arts in Hamburg. Sauerlandt was a great champion of the German Expressionists, in particular the Brücke artists and Emil Nolde.

52. "…a given form is broken down, allowed to suggest associative forms and fantasies. If the first process may be called *crystallization*, this might be called *improvisation*. It is another aspect of the opposition between constructivism and super-realism [Read's preferred term for Surrealism] which [Moore] is always seeking to synthetise." Herbert Read, "Henry Moore" (1944), republished as chap. 11 in *The Philosophy of Modern Art: Collected Essays* (London: Faber and Faber, 1952), 209; quoted in David Thistlewood, "Herbert Read's Paradigm: A British

Vision of Modernism," in Read and Thistlewood, *Herbert Read*, 86.

53. Moore quoted in James, *Henry Moore on Sculpture*, 72; first published by Moore in *Unit One: The Modern Movement in English Architecture, Painting and Sculpture* (London: Cassell, 1934).

54. Ibid., 67; first published in Henry Moore, "The Sculptor Speaks," *The Listener* 18, no. 449 (18 August 1937).

55. Herbert Read, *Meaning of Art*, 159, par. 90.

56. Charles Baudelaire, "The Painter of Modern Life," originally published in *Figaro* (Paris), 26 and 28 November and 3 December 1863; quoted in Frascina and Harrison, *Modern Art and Modernism*, 23.

57. Wyndham Lewis, "Our Vortex" in *Blast*, no. 1 (1914).

58. Toni del Renzio, "Pioneers and Trendies," first published in *Art and Artists* (February 1984); reprinted in part in Robbins, *The Independent Group*, 179.

59. Harold Rosenberg, "The American Action Painters," *Art News* (December 1952): 22–23, 55–56; quoted by del Renzio (ibid.).

60. Lawrence Alloway, "Development of British Pop," 36, 38.

CAT. NO. 1

1. Richard Cork, *Vorticism and Abstract Art in the First Machine Age* (Berkeley and Los Angeles: University of California Press, 1976), II:424.

2. The rare occurrence among Saunders's extant oeuvre of a preparatory drawing for *Island of Laputa* may reflect the special circumstances of its execution for monochromatic reproduction. The study is reproduced in Cork, *Vorticism*, 424–425.

3. Wyndham Lewis, "Notes on Some German Woodcuts," in *Blast: Review of the Great English Vortex*, no. 1, June 1914 (London and New York: John Lane, 1914), 136.

4. See, for example, Arts Council of Great Britain, *Vorticism and Its Allies* [exh. cat.] (London: Hayward Gallery, 1974), cat. no. 415; and Cork, *Vorticism*, 562, n. 51.

CAT. NO. 2

1. Richard Shone, *Vanessa Bell, 1879–1961: A Retrospective Exhibition* [exh. cat.] (New York: Davis and Long in association with Anthony D'Offay, 1980), 25.

CAT. NO. 3

1. See Alan G. Wilkinson, *Henry Moore Remembered: The Collection at the Art Gallery of Ontario in Toronto* [exh. cat.] (Toronto: Art Gallery of Ontario, 1987), 27–28.

2. Moore quoted in Philip James, ed., *Henry Moore on Sculpture* (London: MacDonald, 1966), 49.

3. Alan G. Wilkinson, "Henry Moore," in William Rubin, ed., *"Primitivism" in 20th Century Art: Affinity of the Tribal and the Modern* (New York: Museum of Modern Art, 1984), II:602.

4. Ibid., 599.

5. Moore quoted in James, *Henry Moore on Sculpture*, 48.

6. Wilkinson, "Henry Moore," 603. See also Penelope Curtis, "Barbara Hepworth and the Avant Garde of the 1920s," in Penelope Curtis and Alan G. Wilkinson, *Barbara Hepworth: A Retrospective* [exh. cat.] (London: Tate Gallery, 1994), 16.

7. Moore quoted in Alan G. Wilkinson, *Gauguin to Moore: Primitivism in Modern Sculpture* [exh. cat.] (Toronto: Art Gallery of Ontario, 1981), 281.

8. Alan G. Wilkinson, *The Drawings of Henry Moore* (London: Garland, 1984), 118, 137, 147.

9. Moore quoted in James, *Henry Moore on Sculpture*, 164–165.

10. Alan G. Wilkinson, *The Drawings of Henry Moore* [exh. cat.] (London: Tate Gallery in association with Art Gallery of Ontario, 1977), fig. 128.

11. Ibid., 50.

CAT. NO. 4

1. In 1924, Underwood began teaching evening classes at the Royal College of Art; *The Island* was the school's magazine. The four issues published contained wood engravings by Underwood and his students.

2. 1934 is sometimes seen as the high-water mark of Underwood's modernism, and according to one commentator, "his work after that never even verged on the modern"; see Benedict Read, "Introduction," in Benedict Read and Peyton Skipwith, *Sculpture in Britain Between the Wars* [exh. cat.] (London: Fine Art Society, 1986), 20.

3. Underwood employed other surfaces embellishments for this bronze: in one version, the nipples and navel were inlaid in silver, in another the torso was not incised.

CAT. NO. 5

1. The relation of Picasso's curvilinear Cubist style to Moore's drawings around 1930, including the drawing in the Art Gallery of Ontario, is examined in Alan G. Wilkinson, *Henry Moore Remembered: The Collection at the Art Gallery of Ontario in Toronto* [exh. cat.] (Toronto: Art Gallery of Ontario, 1987), 60 61.

2. Marlborough Fine Arts Limited, London, *Watercolours and Drawings by Oskar Kokoschka, Henry Moore, Graham Sutherland*, January–February 1964, no. 33, illustrated.

CAT. NO. 6

1. Alan G. Wilkinson, *The Moore Collection in the Art Gallery of Ontario* (Toronto: Art Gallery of Ontario, 1979), 45.

CAT. NO. 7

1. A *Seated Figure* is included in the ongoing catalogue raisonné of Moore's sculpture but not reproduced in *Henry Moore: Sculpture and Drawings*, 4th rev. ed. (London: Lund Humphries, 1957), no. 129. However, the medium and dimensions are the same as the Pritzker maquette, and given the rarity of seated figures in Moore's sculptures of the 1930s, it is probable that these two pieces are the same work. The Lund Humphries listing had also questioned the 1932 dating assigned to *Seated Figure*.

2. Moore quoted in Philip James, ed., *Henry Moore on Sculpture* (London: MacDonald, 1966), 264.

CAT. NO. 8

1. Although this bronze is not recorded in the addendum to the catalogue raisonné of Moore's sculpture published by Lund Humphries, another cast is reproduced in John Hedgecoe and Henry Moore, *Henry Moore* (New York: Simon and Schuster, 1968), 404, no. 3. For a reclining figure from this group, see Alan G. Wilkinson, *Henry Moore Remembered: The Collection at the Art Gallery of Ontario in Toronto* [exh. cat.] (Toronto: Art Gallery of Ontario, 1987), fig. 39.

2. Moore quoted in Philip James, ed., *Henry Moore on Sculpture* (London: MacDonald, 1966), 68.

CAT. NO. 9

1. Moore quoted in Alan G. Wilkinson, *Gauguin to Moore: Primitivism in Modern Sculpture* [exh. cat.] (Toronto: Art Gallery of Ontario, 1981), 283.

2. Moore quoted in Philip James, ed., *Henry Moore on Sculpture* (London: MacDonald, 1966), 115.

3. Moore quoted in Richard Cork, *Art Beyond the Gallery in Early 20th Century England* (New Haven and London: Yale University Press, 1985), 277–278.

4. Alan G. Wilkinson, "Henry Moore," in William Rubin, ed., *"Primitivism" in 20th Century Art: Affinity of the Tribal and the Modern* (New York: Museum of Modern Art, 1984), II:603.

5. It is possible that the artist's interest in natural forms in the transformation drawings of 1932 was also a factor; see David Sylvester, *Henry Moore* [exh. cat.] (London: Arts Council of Great Britain, 1968), 93.

CAT. NO. 10

1. Herbert Read, "A Nest of Gentle Artists," in Marlborough Fine Art, *Art in Britain 1930–1940 Centered Around Axis, Circle, Unit One* [exh. cat.] (London: Marlborough Fine Art and Marlborough New London Gallery, 1965), 6–7.

2. Moore quoted in Philip James, ed., *Henry Moore on Sculpture* (London: MacDonald, 1966), 67.

3. On the organization of this historic exhibition and Surrealist activities in England in the 1930s, see Anna Gruetzner, "Some Early Activities of the Surrealist Group in England," *Artscribe* 10 (1978): 22–25.

4. Moore quoted in Alan G. Wilkinson, *The Moore Collection in the Art Gallery of Ontario* (Toronto: Art Gallery of Ontario, 1979), 47.

5. James Johnson Sweeney, *Henry Moore* [exh. cat.] (New York: Museum of Modern Art and Simon and Schuster, 1946), no. 64.

CAT. NO. 11

1. Moore quoted in Alan G. Wilkinson, *The Drawings of Henry Moore* [exh. cat.] (London: Tate Gallery in association with Art Gallery of Ontario, 1977), 25.

2. Moore quoted in Philip James, ed., *Henry Moore on Sculpture* (London: MacDonald, 1966), 149.

CAT. NO. 12

1. The Smart Museum's terracotta is reproduced in *Henry Moore: Sculpture and Drawings*, 3rd rev. ed. (London: Lund Humphries and Co., 1949), no. 70o. The maquette is extremely close to no. 70m, reproduced on the same page. In the 1957 revised edition of the book, no. 70o is not illustrated, but it is in all likelihood L.H. 245: the medium and dimensions are the same, and it immediately follows the piece identified as 70m in the 1949 edition. If L.H. 245 is the Smart Museum maquette, the piece was incorrectly noted as destroyed in the 1957 edition. The inscription by Moore on the reverse of a photograph of the Smart Museum's sculpture (on file at the Smart Museum) gives the same title as L.H. 245.

2. Alan G. Wilkinson, *The Drawings of Henry Moore* [exh. cat.] (London: Tate Gallery in association with Art Gallery of Ontario, 1977), no. 190.

3. Moore quoted in Philip James, ed., *Henry Moore on Sculpture* (London: MacDonald, 1966), 264.

4. Ibid., 265.

5. Although Moore may have seen a reproduction of the pre-Columbian carving as early as 1922, as recorded in two sketches in his *No. 2 Notebook* (Henry Moore Foundation, Much Hadham, England), its impact, stylistically as well as thematically, was not felt in his sculpture until 1928.

6. James, *Henry Moore on Sculpture*, 58.

CAT. NO. 13

1. Roland Penrose, *Roland Penrose Scrapbook 1900–1981* (New York: Rizzoli, 1981), 108.

2. Some of the legends on the picture postcards are preserved, and these permit the identification of the image here as the gambling casino at Monte Carlo. The implied circular rotation in the placement of the three postcard elements and the drawn schema of disks and crossed rotating belts seem to be visual analogues to the activity of the roulette wheel pictured in the postcards. One is tempted to ask whether there was any intended reference to Marcel Duchamp's *Obligations pour la Roulette de Monte Carlo (Monte Carlo Bond)* of 1924. Duchamp's print had begun as a photo-collage, and a prominent motif is the artist's head (covered in foam) pasted over a stylized roulette wheel like the one on the postcards used by Penrose.

3. It is not possible to determine whether the Smart Museum collage-drawing was among those shown. See *London Bulletin* 17 (15 June 1939): 3.

4. René Magritte and Paul Nougé, "Colour–Colours *or* An Experiment by Roland Penrose," *London Bulletin* 17 (15 June 1939): 9.

5. Ibid., 11. The italics are Magritte's and Nougé's.

6. David Gascoyne, "Roland Penrose," in *Roland Penrose: Collages récents* [exh. cat.] (Paris, Galerie Henriette Gomès, 1982), n.p.

CAT. NOS. 14–15

1. P.M.S. Hacker, ed., *The Renaissance of Gravure: The Art of S.W. Hayter* (Oxford: Clarendon Press, 1988), 84.

CAT. NO. 16

1. John Russell Taylor, "John Copley," in Gordon Cooke and John Russell Taylor, *John Copley 1875–1950* [exh. cat.] (New Haven, Connecticut: Yale Center for British Art, 1990), 3–5.

2. A comprehensive overview of this phenomenon is presented in Frances Carey and Antony Griffiths, *Avant-Garde British Printmaking 1914–1960* [exh. cat.] (London: British Museum, 1990), 9–15.

CAT. NO. 18

1. Jeremy Lewison, "English Painting and the Metropolis in the Twenties," in Jean Clair, ed., *The 1920s: Age of the Metropolis* [exh. cat.] (Montreal: Montreal Museum of Fine Arts, 1991), 420–424.

2. Nevinson quoted in Frances Carey and Antony Griffiths, *Avant-Garde British Printmaking 1914–1960* [exh. cat.] (London: British Museum, 1990), 50.

3. Ibid., 61.

CAT. NOS. 19–20

1. Evelyn Silber, *The Sculpture of Epstein with a Complete Catalogue* (Oxford: Phaidon Press, 1986), 38.

2. Ibid., 39.

CAT. NO. 21

1. Richard Morphet, *et al.*, *Richard Hamilton* (London: Tate Gallery, 1992), 142.

2. Sylvia Sleigh, conversation with the author, 10 February 1997.

CAT. NO. 22

1. Minton quoted in David Mellor, "Existentialism and Post-War British Art," in Frances Morris, ed., *Paris Post War: Art and Existentialism 1945–55* [exh. cat.] (London: Tate Gallery, 1993), 55.

CAT. NO. 23

1. Russell Bowman and Dennis Adrian, "Sylvia Sleigh: An Original," in Milwaukee Art Museum, *Sylvia Sleigh: Invitation to a Voyage and Other Works* [exh. cat.] (Milwaukee, Wisconsin: Milwaukee Art Museum, 1990), 3–4.

2. Sylvia Sleigh, conversation with the author, 10 February 1997.

3. Sleigh quoted in Kevin Eckstrom, *Sylvia Sleigh* [exh. cat.] (St. Louis, Missouri: Gallery 210, University of Missouri, 1981), n.p.

CAT. NO. 24

1. Dawn Ades, "Figure and Place: A Context for Five Post-War Artists," in Susan Compton, ed., *British Art in the 20th Century: The Modern Movement* [exh. cat.] (London: Royal Academy of Arts; Munich: Prestel Verlag, 1986), 78.

2. David Cohen, "'Grand Living and Quirky Forms:' Six Painters of the London School," in Richard Calvocoressi and Philip Long, eds., *From London: Bacon, Freud, Kossloff, Andrews, Auerbach, Kitaj* [exh. cat.](London: British Council in association with Scottish National Gallery of Modern Art, 1995), 19.

3. Richard Shone, *The Century of Change: British Painting since 1900* (Oxford, England and New York: Phaidon Press, 1977), 38.

4. Whether from necessity or by design, Bratby painted *Kitchen Table* on a fragment of a commercial sign board. The original billboard letters are faintly revealed as raised surfaces under the composition.

CAT. NO. 25

1. This sculptural project and Moore's commission are discussed in Richard Cork, *Art Beyond the Gallery in Early 20th Century England* (New Haven and London: Yale University Press: 1985), 249–296.

2. Alan G. Wilkinson, *The Drawings of Henry Moore* [exh. cat.] (London: Tate Gallery in association with Art Gallery of Ontario, 1977), 76. Two-thirds of Moore's sculptures of full-length figures are reclining, and with the exception of a carving from 1924, all are female images, most of which are nudes.

3. Alan G. Wilkinson, *Gauguin to Moore: Primitivism in Modern Sculpture* [exh. cat.] (Toronto: Art Gallery of Ontario, 1981), 272.

CAT. NO. 26

1. An instructive overview of Moore's drawings is Ann Garrould, "Henry Moore's Drawings," in Columbus Museum of Art, *Henry Moore: The Reclining Figure* [exh. cat.] (Columbus, Ohio: Columbus Museum of Art, 1984), 20–24.

2. Alan G. Wilkinson, *The Drawings of Henry Moore* [exh. cat.] (London: Tate Gallery in association with Art Gallery of Ontario, 1977), 52.

CAT. NO. 27

1. Alan G. Wilkinson, "Henry Moore," in William Rubin, ed., *"Primitivism" in 20th Century Art: Affinity of the Tribal and the Modern* (New York: Museum of Modern Art, 1984), II:600.

2. Ibid.

3. Moore's interest in paleolithic and ancient figurines and the Great Mother motif is examined in Herbert Read, *Henry Moore: Mother and Child* (n.p.: Collins in association with UNESCO, 1966), 22–23.

4. Moore quoted in Alan G. Wilkinson, *The Moore Collection in the Art Gallery of Ontario* (Toronto: Art Gallery of Ontario, 1979), 53.

CAT. NO. 28

1. Ann Garrould, conversation with the author, April 1984.

2. Moore quoted in Jeanne L. Wasserman, *Six Sculptors and Their Drawings* [exh. cat.] (Cambridge, Massachusetts, Fogg Art Museum, Harvard University, 1971), n.p.

CAT. NO. 30

1. Moore quoted in Philip James, ed., *Henry Moore on Sculpture* (London: MacDonald, 1966), 212–216.

2. For a comprehensive discussion of the shelter drawings, see Alan G. Wilkinson, *The Drawings of Henry Moore* [exh. cat.] (London: Tate Gallery in association with Art Gallery of Ontario, 1977), 28–36.

3. Ibid., 32.

CAT. NOS. 31–32

1. Moore quoted in Philip James, ed., *Henry Moore on Sculpture* (London: MacDonald, 1966), 218.

2. Ibid.

CAT. NO. 33

1. Moore quoted in Ann Garrould, "Henry Moore's Drawings," in Columbus Museum of Art, *Henry Moore: The Reclining Figure* [exh. cat.] (Columbus, Ohio: Columbus Museum of Art, 1984), 22.

2. Moore quoted in Alan G. Wilkinson, *The Drawings of Henry Moore* [exh. cat.] (London: Tate Gallery in association with Art Gallery of Ontario, 1977), 25.

3. Ibid., 127.

CAT. NO. 34

1. Moore quoted in Ann Garrould, "Henry Moore's Drawings," in Columbus Museum of Art, *Henry Moore: The Reclining Figure* [exh. cat.] (Columbus, Ohio: Columbus Museum of Art, 1984), 22.

CAT. NO. 35

1. David Sylvester, *Henry Moore* [exh. cat.] (London: Arts Council of Great Britain, 1968), 85.

2. Moore quoted in Alan G. Wilkinson, *Gauguin to Moore: Primitivism in Modern Sculpture* [exh. cat.] (Toronto: Art Gallery of Ontario, 1981), 286.

3. Ibid., 288.

4. Alan G. Wilkinson, *Henry Moore Remembered: The Collection of the Art Gallery of Ontario in Toronto* [exh. cat.] (Toronto: Art Gallery of Ontario, 1987), 125–126.

5. Henry Moore and Gemma Levine, *Henry Moore: Wood Sculpture* (London: Sidgwick and Jackson; New York: Universe Books, 1983), 26.

6. The drawings are reproduced in Wilkinson, *Gauguin to Moore*, no. 120 and fig. 91.

7. Ibid., 267.

8. Moore quoted in John Hedgecoe and Henry Moore, *Henry Moore* (New York: Simon and Schuster, 1968), 56.

9. The helmet head at the bottom left is the most sketchy of the earliest drawings of the internal-and-external form of this motif, all from 1939. One of the designs in the other two (both in private collections) was the study for the first helmet head sculpture (L.H. 212), executed in 1939–40, which was also the first internal-and-external sculpture. The two sheets are reproduced in Alan G. Wilkinson, *The Drawings of Henry Moore* [exh. cat.] (London: Tate Gallery in association with Art Gallery of Ontario, 1977), 100 and no. 128.

10. Wilkinson, *Gauguin to Moore*, 288.

CAT. NO. 36

1. Moore quoted in Henry Moore and Gemma Levine, *Henry Moore: Wood Sculpture* (London: Sidgwick and Jackson; New York: Universe Books, 1983), 25.

2. Alan G. Wilkinson, *Gauguin to Moore: Primitivism in Modern Sculpture* [exh. cat.] (Toronto: Art Gallery of Ontario, 1981), 288.

3. Moore and Levine, *Henry Moore: Wood Sculpture*, 25.

CAT. NO. 37

1. Alan G. Wilkinson, "Henry Moore," in William Rubin, ed., "Primitivism" in 20th Century Art: Affinity of the Tribal and the Modern (New York: Museum of Modern Art, 1984), II:604–605. The artist's fascination with New Ireland sculpture is documented in the 1933 drawing Page from Sketchbook B: Forms Inside Forms (The Henry Moore Foundation, Much Hadham, England). The pencil study at the lower left of the sheet shows a protective outer skeletal framework of vertical and horizontal struts, and is almost certainly based on a carving in the British Museum. The study at the top represents the figure inside the richly ornamented upright female cult statue. In the larger drawing on the right side of the sheet, Moore transformed the tribal carving into an idea for his own sculpture.

2. The drawings are reproduced, respectively, in Wilkinson, "Henry Moore," 605, and Alan G. Wilkinson, The Drawings of Henry Moore [exh. cat.] (London: Tate Gallery in association with Art Gallery of Ontario, 1977), no. 217.

CAT. NO. 38

1. This process is described in Steven Rosen, "Henry Moore: The Reclining Figure," in Columbus Museum of Art, Henry Moore: The Reclining Figure [exh. cat.] (Columbus, Ohio: Columbus Museum of Art, 1984), 13–14.

CAT. NO. 39

1. Moore quoted in Philip James, ed., Henry Moore on Sculpture (London: MacDonald, 1966), 67.

CAT. NO. 41

1. On this group of drawings and the quote by Moore, see Alan G. Wilkinson, The Moore Collection in the Art Gallery of Ontario (Toronto: Art Gallery of Ontario, 1979), 86.

2. On Moore's "neo-classical" period, see ibid., 120.

3. Moore quoted in Philip James, ed., Henry Moore on Sculpture (London: MacDonald, 1966), 231.

CAT. NO. 42

1. Moore quoted in Philip James, ed., Henry Moore on Sculpture (London: MacDonald, 1966), 48.

2. Alan G. Wilkinson, Henry Moore Remembered: The Collection at the Art Gallery of Ontario in Toronto [exh. cat.] (Toronto: Art Gallery of Ontario, 1987), 200.

CAT. NO. 43

1. Moore quoted in Philip James, ed., Henry Moore on Sculpture (London: MacDonald, 1966), 266.

2. Ibid., pls. 119, 120, 125. See also Alan G. Wilkinson, Henry Moore Remembered: The Collection at the Art Gallery of Ontario in Toronto [exh. cat.] (Toronto: Art Gallery of Ontario, 1987), 193.

CAT. NO. 44

1. Moore quoted in Alan G. Wilkinson, Henry Moore Remembered: The Collection at the Art Gallery of Ontario in Toronto [exh. cat.] (Toronto: Art Gallery of Ontario, 1987), 203.

CAT. NO. 45

1. Claude Allemand-Cosneau, et al., eds., Henry Moore: From the Inside Out, Plasters, Carvings and Drawings [exh. cat,] (Munich and New York: Prestel Verlag, 1996), 146.

CAT. NOS. 46–48

1. This commission is discussed by Moore in Philip James, ed., Henry Moore on Sculpture (London: MacDonald, 1966), 253–257. See also Alan G. Wilkinson, Henry Moore Remembered. The Collection at the Art Gallery of Ontario in Toronto [exh. cat.] (Toronto: Art Gallery of Ontario, 1987), 158–165.

2. Alan G. Wilkinson, "Henry Moore," in William Rubin, ed., "Primitivism" in 20th Century Art: Affinity of the Tribal and the Modern (New York: Museum of Modern Art, 1984), II:603–604.

3. James, Henry Moore on Sculpture, 253.

4. This work is reproduced in Sandy Nairne and Nicholas Serota, eds., British Sculpture in the Twentieth Century [exh. cat.] (London: Whitechapel Art Gallery, 1981), 76.

5. Moore quoted in James, Henry Moore on Sculpture, 253.

6. Wilkinson, Henry Moore Remembered, 162–163.

CAT. NO. 49

1. Hepworth quoted in Alan G. Wilkinson, "Cornwall and the Sculpture of Landscape: 1939–1975," in Alan G. Wilkinson and Penelope Curtis, Barbara Hepworth: A Retrospective [exh. cat.] (London: Tate Gallery, 1994), 82.

2. The relationship of Hepworth's abstract string sculptures to mathematical models and Gabo's work is examined in Martin Hammer and Christina Lodder, "Hepworth and Gabo: A Constructive Dialogue," in David Thistlewood, ed., Barbara Hepworth Reconsidered, Critical Forum Series, vol. 3 (Liverpool: Liverpool University Press and Tate Gallery Liverpool, 1996), 109–133.

3. Alan G. Wilkinson, "The 1930s: Constructive Forms and Poetic Structure," in Wilkinson and Curtis, Barbara Hepworth: A Retrospective, 66.

4. On this question, see Alun R. Graves, "Casts and Continuing Histories: Material Evidence and the Sculpture of Barbara Hepworth," in Thistlewood, Barbara Hepworth Reconsidered, 173–183, esp. 179–182.

CAT. NO. 50

1. Hepworth quoted in Alan G. Wilkinson, "Cornwall and the Sculpture of Landscape: 1939–1975," in Alan G. Wilkinson and Penelope Curtis, Barbara Hepworth: A Retrospective [exh. cat.] (London: Tate Gallery, 1994), 80.

2. Hepworth quoted in Alan Bowness, The Drawings of Barbara Hepworth," Barbara Hepworth: Drawings from a Sculptor's Landscape (London: Cory Adams and MacKay, 1966), 19–20.

CAT. NO. 51

1. Patmos is an Aegean island near the Turkish coast.

2. Hepworth quoted in Alan G. Wilkinson, Barbara Hepworth: The Art Gallery of Ontario Collection [exh. cat.] (Toronto: Art Gallery of Toronto, 1991), 20.

CAT. NO. 52

1. Alan G. Wilkinson, "Cornwall and the Sculpture of Landscape: 1939–1975," in Alan G. Wilkinson and Penelope Curtis, Barbara Hepworth: A Retrospective [exh. cat.] (London: Tate Gallery, 1994), 104.

CAT. NO. 53

1. Alastair I. Grieve, The Sculpture of Robert Adams (London: Lund Humphries in association with Henry Moore Foundation, 1992), 71–73. A photograph of the completed relief is also reproduced in the brochure of the British Pavilion of the 1962 Venice Biennale: J.P. Hodin, "Robert Adams," in Ceri Richards, Robert Adams, Hubert Dalwood [exh. cat.] (London and Bradford: Lund Humphries, n.d.), n.p. A cast of Maquette for Architectural Screen was among the sculptures exhibited.

2. For a discussion of Group Ten and photographs of the exhibit, see Graham Whitman, "Exhibitions," in David Robbins, ed., *The Independent Group: Postwar Britain and the Aesthetics of Plenty* [exh. cat.] (Cambridge, Massachusetts and London: MIT Press, 1990), 135–137, 144–145, 157.

POSTWAR BRITISH SCULPTURE

1. Read cited in Dennis Farr and Eva Chadwick, *Lynn Chadwick Sculptor: With a Complete Illustrated Catalogue 1947–1988* (Oxford: Clarendon; New York: Oxford University Press, 1990), 8.

CAT. NO. 55

1. Alan Bowness, "Introduction," *Kenneth Armitage* [exh. cat.] (London: British Council, 1959), 8.

CAT. NO. 57

1. On Butler's commission and the political context of the competition, see Robert Burstow, "Butler's Competition Project for a Monument to 'The Unknown Political Prisoner': Abstraction and Cold War Politics," *Art History* 12, no. 4 (December 1989): 472–496.

2. Richard Calvocoressi, "Reg Butler: The Man and the Work," *Reg Butler* [exh. cat.] (London: Tate Gallery, 1983), 24.

3. Ibid., 20.

4. Ibid., 24.

CAT. NO. 58

1. Although Butler is here discussing his project for a tower construction on the Cornish coast, the reference is to the photographs taken in Suffolk. Butler's remark is quoted in Richard Calvocoressi, "Reg Butler: The Man and the Work," *Reg Butler* [exh. cat.] (London: Tate Gallery, 1983), 23.

2. Ibid., 19.

3. Ibid., 26, for an illustration of this sculpture.

CAT. NO. 59

1. Addison Franklin Page, *Reg Butler, A Retrospective Exhibition* [exh. cat.] (Louisville, Kentucky: J.B.V. Speed Art Museum, 1963), no. 51.

CAT. NO. 60

1. Richard Calvocoressi, *Reg Butler* [exh. cat.] (London: Tate Gallery, 1983), no. 49.

2. Addison Franklin Page, *Reg Butler, A Retrospective Exhibition* [exh. cat.] (Louisville, Kentucky: J.B.V. Speed Art Museum, 1963), no. 65.

3. Pierre Matisse Gallery, *Reg Butler* [exh. cat.] (New York: Pierre Matisse Gallery, 1959), no. 10.

CAT. NO. 61

1. Meadows had written the text for Bryan Robertson, who quoted it in his introduction to Meadows's one-person exhibition at Gimpel Fils Gallery, London in March 1959. The statement is cited in Alan Bowness, "Meadows and 'The Geometry of Fear'," in Alan Bowness, *Bernard Meadows: Sculpture and Drawings* (London: Henry Moore Foundation in association with Lund Humphries, 1995), 15.

2. The photograph of the studio is reproduced in Bowness (ibid., 13).

CAT. NO. 62

1. Herbert Read's text is cited in Dennis Farr and Eva Chadwick, *Lynn Chadwick Sculptor: With a Complete Illustrated Catalogue 1947–1988* (Oxford: Clarendon; New York: Oxford University Press, 1990), 8.

2. Diane Kirkpatrick, "Modern British Sculpture at the University of Michigan Museum of Art," *Bulletin: Museums of Art and Archaeology, the University of Michigan* 6 (1981): fig. 8.

LONDON–PARIS–NEW YORK I

1. Hamilton cited in Frederick Gore, "Introduction", in Susan Compton, ed., *British Art in the 20th Century: The Modern Movement* [exh. cat.] (London: Royal Academy of Arts; Munich: Prestel Verlag, 1986), 12.

CAT. NO. 64

1. Richard Morphet, *William Turnbull: Sculpture and Painting* [exh. cat.] (London: Tate Gallery, 1973), 24.

2. Ibid.

3. Ibid., 26.

4. Ibid., 27.

5. Patrick Elliott, "William Turnbull: A Consistent Way of Thinking," in David Sylvester and Patrick Elliott, *William Turnbull: Sculpture and Paintings* [exh. cat.] (London: Merrell Holberton in association with Serpentine Gallery, 1995), 18.

CAT. NOS. 68–69

1. Patrick Elliott, "William Turnbull: A Consistent Way of Thinking," in David Sylvester and Patrick Elliott, *William Turnbull: Sculpture and Paintings* [exh. cat.] (London: Merrell Holberton in association with Serpentine Gallery, 1995), 29.

2. Turnbull quoted in David Mellor, "Existentialism and Post-War British Art," in Frances Morris, ed., *Paris Post War: Art and Existentialism 1945–55* [exh. cat.] (London: Tate Gallery, 1993), 53.

3. On Turnbull's relation to Existentialism, see ibid., 53–54.

CAT. NO. 70

1. Richard Morphet, *William Turnbull: Sculpture and Painting* [exh. cat.] (London: Tate Gallery, 1973), 28. Blow-ups of Muybridge's sequential photographic studies of walking nudes were included in the 1953 Institute of Contemporary Arts exhibition *Parallel of Art and Life*.

CAT. NOS. 71–72

1. Patrick Elliott, "William Turnbull: A Consistent Way of Thinking," in David Sylvester and Patrick Elliott, *William Turnbull: Sculpture and Paintings* [exh. cat.] (London: Merrell Holberton in association with Serpentine Gallery, 1995), 26.

CAT. NO. 73

1. Patrick Elliott, "William Turnbull: A Consistent Way of Thinking," in David Sylvester and Patrick Elliott, *William Turnbull: Sculpture and Paintings* [exh. cat.] (London: Merrell Holberton in association with Serpentine Gallery, 1995), 33, where he compares the "busty, broad-hipped" figures by Turnbull to ancient fertility goddess figurines and also to Marilyn Monroe and Jayne Mansfield. Turnbull was an avid fan of movies, especially the CinemaScope films from Hollywood. During the 1950s he participated in many of the informal meetings of the Independent Group, where contemporary American film, as an art form and a medium of popular culture, was a frequently debated topic. Also, other Independent Group members, especially Turnbull's friends Richard Hamilton and Eduardo Paolozzi, appropriated Hollywood imagery from the printed ephemera of the film industry.

2. According to Patrick Elliott, Turnbull rarely makes maquettes for his paintings or sculptures (Patrick Elliott, "William Turnbull," 26–29). In the catalogue of Turnbull's one-person exhibition at the Institute of Contemporary Arts in 1957, checklist number 25 lists

"four small figures," all from 1956, ranging in size from five to six and one-half inches in height. This suggests that the artist produced a number of such small pieces, in all likelihood standing figures like the Smart Museum bronze, as independent sculptures. However, the catalogue does not reproduce these works. See Institute of Contemporary Arts, *William Turnbull* [exh. cat.] (London: Institute of Contemporary Arts, 1957), n.p.

CAT. NOS. 74–75

1. David Thistlewood, "The Independent Group and Art Education in Britain 1950–1965," in David Robbins, ed., *The Independent Group: Postwar Britain and the Aesthetics of Plenty* [exh. cat.], (Cambridge, Massachusetts and London: MIT Press, 1990), 216.

2. For a discussion of Klee's importance to contemporary British art, see ibid., 215.

3. Turnbull quoted in Richard Morphet, *William Turnbull: Sculpture and Painting* [exh. cat.] (London: Tate Gallery, 1973), 33.

CAT. NOS. 76–77

1. Turnbull himself refers to the potential of his heads being read as glyphs ("head as ideogram") in a written statement from 1960. See Richard Morphet, *William Turnbull: Sculpture and Painting* [exh. cat.] (London: Tate Gallery, 1973), 33.

CAT. NOS. 78–79

1. Frances Carey and Antony Griffiths, *Avant-Garde British Printmaking 1914–1960* [exh. cat.] (London: British Museum, 1990), 221, 236–237.

2. There is some confusion as to the sizes of these editions: see Carey and Griffiths, *Avant-Garde British Printmaking*, 237, and British Council, *Out of Print: British Printmaking 1946–1976* [exh. cat.] (London: Rizzoli, 1994), 60.

CAT. NO. 80

1. There was considerable debate in Britain in the 1940s and 1950s about the value of the commercially-printed lithograph as a true "fine-art" original in relation to auto-lithography, in which there was direct artistic intervention by the artist rather than the careful translation of artists' designs by lithographic technicians. See Frances Carey and Antony Griffiths, *Avant-Garde British Printmaking 1914–1960* [exh. cat.] (London: British Museum, 1990), 17–21.

CAT. NOS. 81–82

1. Winfried Konnertz, *Eduardo Paolozzi* (Cologne: DuMont Buchverlag, 1984), 87.

2. Diane Kirkpatrick, *Eduardo Paolozzi* (Greenwich, Connecticut: New York Graphic Society, 1971), 29.

CAT. NO. 83

1. Winfried Konnertz, *Eduardo Paolozzi* (Cologne: DuMont Buchverlag, 1984), 48–49, fig. 42.

2. In 1953, Paolozzi, the architects Peter and Alison Smithson, and the photographer Nigel Henderson had organized the exhibition *Parallel of Life and Art* at the Institute of Contemporary Arts. Shown were pages from engineering manuals, biology and ethnographic books, and photographs from the popular press. This assembly of commercial and technical images explored the relationship between mechanical and biological processes, as expressed in the popular media of commercial and industrial design and sales advertisements. See Graham Whitman, "Exhibitions," in David Robbins, ed., *The Independent Group: Postwar Britain and the Aesthetics of Plenty* [exh. cat.] (Cambridge, Massachusetts and London: MIT Press, 1990), 124–129.

3. Konnertz, *Eduardo Paolozzi*, 88.

4. Paolozzi's text is reproduced in Diane Kirkpatrick, *Eduardo Paolozzi* (Greenwich, Connecticut: New York Graphic Society, 1971), 33.

5. Press release cited in Whitman, "Exhibitions," 131.

6. Ibid., 133.

CAT. NO. 85

1. James Lingwood, "Nigel Henderson," in David Robbins, ed., *The Independent Group: Postwar Britain and the Aesthetics of Plenty* [exh. cat.] (Cambridge, Massachusetts and London: MIT Press, 1990), 76–77, no. 33.

2. Ibid., no. 32.

3. For an account of Group Six's participation in the exhibition, see Graham Green, "Exhibitions," in Robbins, *The Independent Group*, 134–137, 140–141, 155.

CAT. NO. 86

1. For a discussion of the impact of abstract British painting on Dalwood during this period, see Norbert Lynton, *Hubert Dalwood: Sculptures and Reliefs* [exh. cat.] (London: Arts Council of Great Britain, 1979), 15–16.

CAT. NO. 87

1. Herbert Read's introduction is cited and discussed in Norbert Lynton, *Hubert Dalwood: Sculptures and Reliefs* [exh. cat.] (London: Arts Council of Great Britain, 1979), 18.

2. See, for example, Norbert Lynton's essay in the brochure for the British Pavilion at the 1962 Venice Biennale: Norbert Lynton, "Hubert Dalwood," in *Ceri Richards, Robert Adams, Hubert Dalwood* [exh. cat.] (London and Bradford: Lund Humphries, n.d.), n.p. Casts of *Open Form* and *The City* were exhibited at the Biennale.

CAT. NO. 88

1. Reprinted in *Peter Blake* [exh. cat.] (Bristol: City Art Gallery, 1969), 18.

2. In 1956–57, Blake received a research scholarship to study the folk art of Holland, Belgium, France, Italy, and Spain.

CAT. NO. 89

1. Jones quoted in Marco Livingstone, "Jones the Printmaker," in Marco Livingstone and Richard Lloyd, *Allen Jones: Prints* (Munich and New York: Prestel Verlag, 1995), 9.

2. For example, the early color lithographs *Space Race* (1961) and *Aeroplane* (1963).

3. See David Robbins, ed., *The Independent Group: Postwar Britain and the Aesthetics of Plenty* [exh. cat.] (Cambridge, Massachusetts and London: MIT Press, 1990), 131.

4. Livingstone, *Allen Jones*, 10–14. The childlike drawing manner of the early prints and the motif of a speeding car in the Smart Museum lithograph recall Dubuffet's style and imagery in the *Paris Circus* paintings and drawings from 1961–62.

CAT. NO. 90

1. See David Robbins, ed., *The Independent Group: Postwar Britain and the Aesthetics of Plenty* [exh. cat.] (Cambridge, Massachusetts and London: MIT Press, 1990), 69.

2. Hamilton quoted in Richard S. Field, *The Prints of Richard Hamilton* [exh. cat.] (Middletown, Connecticut: Davison Art Center, Wesleyan University, 1973), 27.

3. Hamilton's habit of signing the edition in this way is described in Field (ibid.).

CAT. NO. 91

1. Richard Morphet *et al., Richard Hamilton* [exh. cat.] (London: Tate Gallery, 1992), 162.

2. Hamilton quoted in Richard S. Field, *The Prints of Richard Hamilton* [exh. cat.] (Middletown, Connecticut: Davison Art Center, Wesleyan University, 1973), 33.

3. Ibid.

CAT. NO. 92

1. Richard Morphet *et al., Richard Hamilton* [exh. cat.] (London: Tate Gallery, 1992), 166.

2. Richard S. Field, *The Prints of Richard Hamilton* [exh. cat.] (Middleton, Connecticut: Davison Art Center, Wesleyan University, 1973), 39.

3. Hamilton quoted in Field (ibid.).

4. Ibid.

CAT. NOS. 93–94

1. Turnbull quoted in Patrick Elliott, "William Turnbull: A Consistent Way of Thinking," in David Sylvester and Patrick Elliott, *William Turnbull: Sculpture and Paintings* [exh. cat.] (London: Merrell Holberton in association with Serpentine Gallery, 1995), 40.

CAT. NO. 95

1. Lawrence Alloway, "Introduction," *William Turnbull: Paintings* [exh. cat.] (London: Molton Gallery, 1960), n.p.

2. Patrick Elliott, "William Turnbull: A Consistent Way of Thinking," in David Sylvester and Patrick Elliott,

William Turnbull: Sculpture and Paintings [exh. cat.] (London: Merrell Holberton in association with Serpentine Gallery, 1995), 51.

3. Richard Morphet, *William Turnbull: Sculpture and Painting* [exh. cat.] (London: Tate Gallery, 1973), 58.

CAT. NOS. 96–98

1. The Royal Academy incident is documented in David Mellor, *The Sixties Art Scene in London* [exh. cat.] (London: Phaidon Press in association with Barbican Art Gallery, 1993), 11–14, 28.

CAT. NO. 99

1. A color plate of the painting and an installation photograph of the 1959 *Place* exhibition are reproduced in David Mellor, *The Sixties Art Scene in London* [exh. cat.] (London: Phaidon Press in association with the Barbican Art Gallery, 1993), 62–63. The plate image is reversed from the original.

2. For the full text that accompanied the exhibition, see ibid., 72.

CAT. NO. 100

1. On Latham's concept of "event-structure," see Richard Cork, "The Emancipation of Modern British Sculpture," in Susan Compton, ed., *British Art in the 20th Century: The Modern Movement* [exh. cat.] (London: Royal Academy of Arts; Munich: Prestel Verlag, 1986), 46. See also Ina Conzen-Meairs, *John Latham: Art After Physics* [exh. cat.] (Oxford: The Museum; Stuttgart and London: Edition Hansjörg Mayer, 1991).

SELECTED BIBLIOGRAPHY

GENERAL

Alloway, Lawrence. "The Development of British Pop." In Lippard, Lucy R. Pop Art. London: Praeger, 1966.

Bowness, Sophie, and Clive Phillpot, eds. Britain at the Venice Biennale 1895–1995 [exh. cat.]. London: British Council, 1995.

Carey, Frances, and Antony Griffiths. Avant-Garde British Printmaking 1914–1960 [exh. cat.]. London: British Museum, 1990.

Compton, Susan, ed. British Art in the 20th Century: The Modern Movement [exh. cat.]. Munich: Prestel Verlag; London: Royal Academy of Arts, 1986.

Cork, Richard. Art Beyond the Gallery in Early 20th Century England. New Haven and London: Yale University Press, 1985.

_____. Vorticism and Abstract Art in the First Machine Age. 2 vols. Berkeley and Los Angeles: University of California Press, 1976.

Gruetzner, Anna. "Some Early Activities of the Surrealist Group in England." Artscribe 10 (1978): 22–25.

Hamburg, Kunstverein in Hamburg. Pop Art In England: Beginnings of a New Figuration 1947–63 [exh. cat.]. Braunschweig: Waisenhaus, 1976.

Harrison, Charles. English Art and Modernism 1900–1939. London: Allen Lane; Bloomington, Indiana: Indiana University Press, 1981.

Hartley, Keith. Scottish Art Since 1900 [exh. cat.]. London: Lund Humphries in association with National Galleries of Scotland, 1989.

Lewison, Jeremy. "English Painting and the Metropolis in the Twenties." In Clair, Jean, ed. The 1920s: Age of the Metropolis [exh. cat.]. Montreal: Montreal Museum of Fine Arts, 1991.

_____, ed. Circle: Constructive Art in Britain, 1934–1940 [exh. cat.]. Cambridge, England: Kettle's Yard Gallery, 1982.

Livingstone, Marco, ed. Pop Art: An International Perspective [exh. cat.]. London: Royal Academy of Arts, 1991.

London, Arts Council of Great Britain. Vorticism and Its Allies [exh. cat.]. London: Hayward Gallery, 1974.

London, The Contemporary Art Society. British Contemporary Art 1910–1990: Eighty Years of Collecting by The Contemporary Art Society. London: Herbert Press in association with Contemporary Art Society, 1991.

London, Hamet Gallery. Britain's Contribution to Surrealism of the 30's and 40's [exh. cat.]. London: Hamet Gallery, 1971.

Mellor, David. "Existentialism and Post–War British Art." In Morris, Francis. Paris Post War: Art and Existentialism 1945–55 [exh. cat]. London: Tate Gallery, 1993.

_____. The Sixties Art Scene in London [exh. cat.]. London: Phaidon Press in association with Barbican Art Gallery, 1993.

Nairne, Sandy, and Nicholas Serota, eds. British Sculpture in the Twentieth Century [exh. cat.]. London: Whitechapel Art Gallery, 1981.

Orchard, Karin, ed. Blast: Voticismus—Die erste Avantgarde in England 1914–1918 [exh. cat.] Hanover: Sprengel Museum; Munich: Haus der Kunst, 1996.

Palazzo Reale. English Art Today 1960–76 [exh. cat.]. Milan: Electra Editrice; New York: Rizzoli, 1977.

Read, Benedict, and Peyton Skipwith. Sculpture in Britain Between the Wars [exh. cat.]. London: Fine Art Society, 1986.

Read, Benedict, and David Thistlewood, eds. Herbert Read: A British Vision of World Art [exh. cat.]. Leeds: Leeds City Art Galleries, 1993.

Read, Herbert. "British Art 1930–1940" and "A Nest of Gentle Artists." In London, Marlborough Fine Art. Art in Britain 1930–1940 Centred Around Axis, Circle, Unit One [exh. cat.]. London: Marlborough Fine Art and Marlborough New London Gallery, 1965.

Robbins, David, ed. The Independent Group: Postwar Britain and the Aesthetics of Plenty [exh. cat.]. Cambridge, Massachusetts and London: MIT Press, 1990.

Robertson, Bryan. Out of Print: British Printmaking 1946–1976. London: British Council, 1994.

Shone, Richard. The Century of Change: British Painting Since 1900. Oxford: Phaidon Press, 1977.

Spalding, Frances. British Art Since 1900. London: Thames and Hudson, 1986, reprint 1992.

Tickner, Lisa. "Men's Work? Masculinity and Modernism." In Bryson, Norman, Michael Ann Holly, and Keith Moxey, eds. Visual Culture: Images and Interpretations. Hanover, New Hampshire and London: University Press of New England, 1994.

Wilcox, Tim, ed. The Pursuit of the Real: British Figurative Painting from Sickert to Bacon [exh. cat.]. London: Lund Humphries in association with Manchester City Art Galleries, 1990.

ROBERT ADAMS

Grieve, Alastair I. The Sculpture of Robert Adams. London: Lund Humphries in association with Henry Moore Foundation, 1992.

KENNETH ARMITAGE

Bowness, Alan. "Introduction." In Kenneth Armitage [exh. cat.]. London: British Council, 1959.

VANESSA BELL

Shone, Richard. Vanessa Bell, 1879–1961: A Retrospective Exhibition [exh. cat.]. New York: Davis and Long in association with Anthony D'Offay, 1980.

PETER BLAKE

City Art Gallery Bristol. Peter Blake [exh. cat.]. Bristol: City Art Gallery Bristol, 1969.

JOHN BRATBY

Hartnoll, Julian. The Kitchen Sink Painters: John Bratby, Peter Cook, Derrick Greaves, Edward Middleditch, Jack Smith [exh. cat.]. London: Mayor Gallery in association with Julian Hartnoll, 1991.

REG BUTLER

Burstow, Robert. "Butler's Competition Project for a Monument to 'The Unknown Political Prisoner'; Abstraction and Cold War Politics." Art History 12, no. 4 (December 1989): 472–496.

Calvocoressi, Richard. "Reg Butler: The Man and the Work." In Reg Butler [exh. cat.]. London: Tate Gallery, 1983.

Page, Addison Franklin. Reg Butler: A Retrospective Exhibition [exh. cat.]. Louisville, Kentucky: J.B.V. Speed Art Museum, 1963.

LYNN CHADWICK

Farr, Dennis, and Eva Chadwick. *Lynn Chadwick Sculptor: With a Complete Illustrated Catalogue 1947–1988*. Oxford: Clarendon Press; New York: Oxford University Press, 1990.

JOHN COPLEY

Cooke, Gordon, and John Russell Taylor. *John Copley 1875–1950*. New Haven, Connecticut: Yale Center for British Art, 1990.

HUBERT DALWOOD

Lynton, Norbert. *Hubert Dalwood: Sculptures and Reliefs* [exh. cat.]. London: Arts Council of Great Britain, 1979.

JACOB EPSTEIN

Silber, Evelyn. *The Sculpture of Epstein: With a Complete Catalogue*. Oxford: Phaidon Press, 1986.

RICHARD HAMILTON

Field, Richard S. *The Prints of Richard Hamilton* [exh. cat.]. Middletown, Connecticut: Davison Art Center, Wesleyan University, 1973.

Morphet, Richard, David Melior, Sarat Maharaj, and Stephen Snoddy. *Richard Hamilton* [exh. cat.]. London: Tate Gallery, 1992.

Waddington Graphics. *Richard Hamilton Prints 1939–83: A Complete Catalogue of Graphic Works* [exh. cat.]. Stuttgart and London: Hansjörg Mayer, 1984.

STANLEY WILLIAM HAYTER

Black, Peter, and Désirée Moorhead. *The Prints of Stanley William Hayter: A Complete Catalogue*. London: Phaidon Press, 1992.

Hacker, P.M.S., ed. *The Renaissance of Gravure: The Art of S.W. Hayter*. Oxford: Clarendon Press, 1988.

BARBARA HEPWORTH

Hodin, J.P. *Barbara Hepworth*. London: Lund Humphries, 1961.

Tate Gallery. *Barbara Hepworth* [exh. cat.]. London: Tate Gallery, 1968.

Thistlewood, David, ed. *Barbara Hepworth Reconsidered*. Critical Forum Series, vol. 3. Liverpool: Liverpool University Press and Tate Gallery Liverpool, 1996.

Wilkinson, Alan G. *Barbara Hepworth: The Art Gallery of Ontario Collection* [exh. cat.]. Toronto: Art Gallery of Ontario, 1991.

_____, and Penelope Curtis. *Barbara Hepworth: A Retrospective* [exh. cat.]. London: Tate Gallery, 1994.

ALLEN JONES

Livingstone, Marco, and Richard Lloyd. *Allen Jones: Prints*. Munich and New York: Prestel Verlag, 1995.

JOHN LATHAM

Conzen-Meairs, Ina. *John Latham: Art After Physics* [exh. cat.]. Oxford: The Museum; Stuttgart and London: Edition Hansjörg Mayer, 1991.

BERNARD MEADOWS

Bowness, Alan. *Bernard Meadows: Sculpture and Drawings*. London: Henry Moore Foundation in association with Lund Humphries, 1995.

JOHN MINTON

Oriel Gallery. *John Minton, 1917–1957: A Selective Retrospective* [exh. cat.]. Newtown, Powys: Oriel Gallery, 1993.

Yorke, Malcolm. *The Spirit of Place: Nine Neo-Romantic Artists and Their Times*. London: Constable, 1988.

HENRY MOORE

Allemand-Cosneau, Claude, Manfred Fath, and David Mitchinson, eds. *Henry Moore: From the Inside Out, Plasters, Carvings and Drawings* [exh. cat.]. Munich and New York: Prestel Verlag, 1996.

Columbus Museum of Art. *Henry Moore: The Reclining Figure* [exh. cat.]. Columbus, Ohio: Columbus Museum of Art, 1984.

Compton, Susan. *Henry Moore* [exh. cat.]. New York: Charles Scribner's Sons in association with Royal Academy of Arts, London, 1988.

James, Philip, ed. *Henry Moore on Sculpture*. London: MacDonald, 1966.

Lichtenstern, Christa. "Henry Moore and Surrealism." *The Burlington Magazine* 123, no. 944 (November 1981): 645–658.

Sweeney, James Johnson. *Henry Moore* [exh. cat.]. New York: Museum of Modern Art and Simon and Schuster, 1946.

Sylvester, David. *Henry Moore* [exh. cat.]. London: Arts Council of Great Britain; New York: Praeger, 1968.

Wilkinson, Alan G. *The Drawings of Henry Moore* [exh. cat.]. London: Tate Gallery in association with Art Gallery of Ontario, 1977.

_____. *The Drawings of Henry Moore*. New York and London: Garland Publishing, 1984.

_____. *Henry Moore Remembered: The Collection at the Art Gallery of Ontario in Toronto* [exh. cat.]. Toronto: Art Gallery of Ontario, 1987.

EDUARDO PAOLOZZI

Kirkpatrick, Diane. *Eduardo Paolozzi*. Greenwich, Connecticut: New York Graphic Society, 1971.

Konnertz, Winfried. *Eduardo Paolozzi*. Cologne: DuMont Buchverlag, 1984.

Miles, Rosemary. *The Complete Prints of Eduardo Paolozzi: Prints, Drawings, Collages, 1944–77*. London: Victoria and Albert Museum, 1977.

SYLVIA SLEIGH

Milwaukee Art Museum. *Sylvia Sleigh: Invitation to a Voyage and Other Works* [exh. cat.]. Milwaukee, Wisconsin: Milwaukee Art Museum, 1990.

WILLIAM TURNBULL

Morphet, Richard. *William Turnbull: Sculpture and Painting* [exh. cat.]. London: Tate Gallery, 1973.

Sylvester, David, and Patrick Elliott. *William Turnbull: Sculpture and Paintings* [exh. cat.]. London: Merrell Holberton in association with Serpentine Gallery, 1995.

LEON UNDERWOOD

Wolseley Fine Arts. *Pure Plastic Rhythm: Leon Underwood 1890–1975, Drawings, Watercolours and Sculpture 1922–1939* [exh. cat.]. London: Wolseley Fine Arts in association with Redfern Gallery, 1993.

Neve, Christopher. *Leon Underwood*. London: Thames and Hudson, 1974.